# PHOTOGRAPHIC PRINTMAKING TECHNIQUES

# PHOTOGRAPHIC PRINTMAKING TECHNIQUES

## BY DELI SACILOTTO

WATSON-GUPTILL PUBLICATIONS / NEW YORK

*For*
*Olivo Sacilotto and*
*Alemanna Milan Sacilotto*

Copyright © 1982 by Watson-Guptill Publications

First published 1982 in New York by Watson-Guptill Publications,
a division of Billboard Publications, Inc.,
1515 Broadway, New York, N.Y. 10036

**Library of Congress Cataloging in Publication Data**

Sacilotto, Deli.
  Photographic printmaking techniques.

  Bibliography: p.
  Includes index.
  1. Photography—Printing processes.   I. Title.
TR330.S2      686.2'32     81-24120
ISBN 0-8230-4006-2      AACR2

Manufactured in U.S.A.

First Printing, 1982

1  2  3  4  5  6  7  8  9  /  87  86  85  84  83  82

# ACKNOWLEDGMENTS

Of the numerous individuals who offered advice, encouragement, and vital information, I would like to express thanks to the following: Cathan Brown of Crown Point Press, Oakland, California; Sidney Felsen and Stanley Grinstein of Gemini G.E.L., Los Angeles, California; Pat Branstead of Aero Press, New York; and Audi Rischner of Styria Studio, New York—all of whom provided photographs of works they have printed; Norman Lassiter, who allowed me to photograph him at work making direct emulsion screens; Penny Rich and John Krawczuk of TDC Color, Inc., who helped in photographing the Autoline and Ulano indirect photo-screen procedures; Diane Hunt and Richard Graf, who shared their experiences in making halftones with nonglare glass and who let me use photographs of their work; Joseph Petruzzelli of Siena Studios, New York, for allowing me to photograph him making wipe-on plates; James Rosenquist for providing the original prints and information regarding some of his new lithographs; Karen McCready and Joe Maloney of Pace Editions, New York, for allowing me to photograph completed works at the gallery; Jim Dine and Robert Rauschenberg for allowing me to photograph completed works and works in progress; George Keleshian of VanAllyn Graphics, Inc., New York, for his enthusiasm and help in using photo-engraver's (fish glue) enamel, a process he still remembers well since he last used it, over thirty years ago; and my wife, Diane, and daughter, Mia, whose understanding and patience helped see me through yet another ordeal.

My special thanks to Donald, Ruth, Stephen, and Jeffrey Saff for their hospitality on my numerous stays in Florida, and to Donald in particular, who, during a critical phase in the preparation of the manuscript, provided me with an office at the University of South Florida where I could work in quiet isolation away from the distractions of New York and who also provided me with a photograph of one of his works; and to my editors, Dorothy Spencer and Barbara Wood, who tied all the loose ends together and whose encouragement and gentle prodding assisted my completion of the work only a year behind schedule.

# CONTENTS

# PREFACE

The idea of writing a book on photographic processes in printmaking originated more than five years ago. I found that both my own interest and that of my students in a wide variety of photographic techniques in etching, lithography, and screen printing prompted me to concentrate more and more of my activities in this area. In my own studio, I began working with photogravure and used the process not only for photographic work but also for directly translating drawings made on vellum and frosted Mylar. A series of etchings I made for Jim Dine started out in this manner. I soon became convinced that this process and several others that I began to work with had unlimited potential, both for the artist who has worked with more traditional techniques and for the photographer who wishes to explore alternate means of expression. From this point I decided that a book dealing specifically with photographic techniques in a detailed and comprehensive manner would be a valuable reference source for the advanced printmaking student and a useful aid for the professional workshop.

I have assumed that my readers, for the most part, have a basic knowledge of printmaking techniques; therefore, I have not outlined any elemental procedures, such as how to make a traditional etching or lithograph, or described the use of tools, except when they are directly related to the photographic process described. Many excellent books that cover these areas thoroughly already exist. Those processes that I have included, however, are described step by step as much as possible. I have also tried to explain the chemical and physical nature underlying each technique in the belief that a thorough understanding of these elements gives the artist an edge in the creative manipulation of the process.

One of the questions that presented itself in the initial stages of writing the manuscript was how many of the processes that are decidedly "photographic" should be included. There seemed to be considerable interest among both photographers and traditional printmakers in many of the older, esoteric processes as well as in contemporary innovations. Two considerations helped me decide. One was my own experience and training as a

printmaker in the arts of intaglio, lithography, and screen printing. The other consideration was that several recent books on early photographic processes—by photographers—cover that area quite thoroughly. I have tried to isolate those purely photographic procedures, both silver and nonsilver, that seem to have the greatest flexibility and potential for combined use.

Because the development of photography and that of photographic reproduction processes parallel each other, I have included a brief historical section at the beginning of the book. In this I hope not only to reflect the achievements of the past and their continuity with the present, but also to reiterate the great importance of visual imagery and the ability to reproduce it to our way of seeing and understanding. Prints have the capability of reaching a large audience because of the fact that they become multiples of the same image, yet they retain their integrity as individual works of art.

The next chapter, on basic camera work, is intended to supply a background for the negative, positive, and halftone techniques that have a direct bearing on subsequent procedures. The chapter is brief by design; in it I have attempted to provide a review of the terminology of photography without straying too far afield from the purpose of the book.

Three chapters—"Photolithographic Techniques," "Photo-Etching," and "Photo-Screen Techniques"—cover three main areas of printmaking. I have treated photogravure in a separate chapter, although technically it is a photo-etching procedure, for several reasons. First, I feel it is one of the few truly continuous-tone methods of printing which not only can reproduce the detail and subtlety of the photographic image but can also enhance it. Second, the archival qualities of ink on fine paper are unquestioned, and the result is as permanent as a Rembrandt etching. Third, photogravure necessitates a knowledge of both etching and photography and as a result bridges the gap between these two art forms. Because I have spent (or so it seems) several years of my life unraveling some of the intricacies of photogravure, it holds a special place in my repertoire of techniques.

*Deli Sacilotto*

# PHOTOGRAPHIC
# PRINTMAKING
# TECHNIQUES

# CHAPTER ONE

# HISTORY OF PHOTOGRAPHIC PRINTMAKING

From prehistoric times, the ability to record images in a tangible and permanent form took on a magical quality and provided mankind with the visual metaphors that sparked his imaginative and creative development. From the cave paintings of Altamira, Spain, throughout recorded history, the recording of visual imagery became not only a means of establishing domination over the objective and spiritual nature of what was recorded, but also a tool that could be used for educational and historic documentation.

Centuries before Niepce and Daguerre made their discovery, many light-sensitive materials had been known to exist, such as certain dyes and pigments that changed with the degree of exposure to sunlight. By 1727, Johann Heinrich Shultze, a German physician, noted that chloride of silver became darkened in the presence of light. The images, however, remained short-lived; there was no way to fix the results before the silver chloride turned black. Attempts were made to translate photographic images into a permanent form, such as creating an image on a copper plate which could be etched and then printed. And it was indeed an etched photographic plate that provided the first instance of a permanent image created by the action of light, Later, even when Talbot and others had perfected the purely photographic image and a way had been found to make photographic images permanent, its use in lithography and other graphic art forms took on increasing importance,

By the time Joseph Nicéphore Niepce was experimenting with the light-sensitive qualities of asphaltum (bitumen), in the years 1815–16, lithography had already gained a strong foothold in France. This new printing process, imported from Munich,

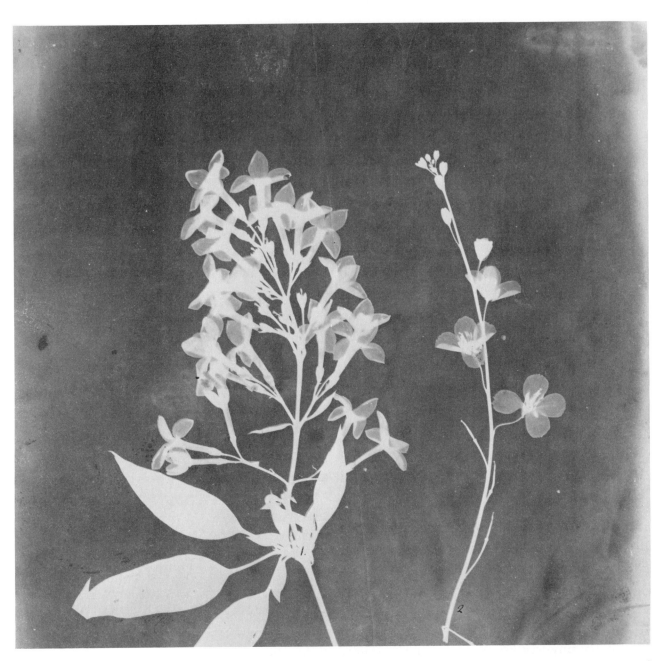

Henry Fox Talbot, photogenic drawing of field flowers. The Metropolitan Museum of Art, Harris Brisbane Dick Fund, 1936.

became popular through the efforts of Count Lasteyrie and Dominique Vivant-Denon, both of whom practiced the new art and promoted it with great success. Niepce became interested in lithography and experimented with limestone he obtained locally. He used an asphaltum ground to engrave through, and therefore made etchings in the traditional manner on both stone and metal; but he abandoned the use of stone when he began to experiment with the light sensitivity of asphaltum. His first successful photographic image was apparently captured on a sheet of glass which he had coated with a thin layer of asphaltum. He put a thin, semitransparent image on paper in contact with the asphaltum coating and exposed the plate to sunlight for a long time. The image appeared on the glass after the surface was washed with a solvent that dissolved the unexposed areas but did not affect the areas hardened by the sunlight.

By 1822 Niepce used sunlight to make some of his first photo-etchings—heliographs, as they were called, from the Greek *helios*, "the sun," and *graphos*, "to write." Using the asphaltum process, he made copies of copper engravings by contacting a polished pewter plate coated with asphaltum with an engraving on thin paper made more transparent with wax. The engraving was placed face down on the coated plate and exposed to the sun for several hours. Everywhere, except under the engraved lines where the sunlight failed to reach, the asphaltum coating remained hard and would not dissolve in its original solvent. The unexposed lines, however, dissolved easily in mineral spirits, leaving them open to the mordant action of the acid while the asphaltum protected the remainder of the plate. By 1826 Niepce had perfected this new method. Although several decades later the asphaltum process was used successfully to make some of the first photolithographs, it was superseded by coatings for photo-engraving made with bichromated colloids.

In 1839 Mungo Ponton, the secretary of the Bank of Scotland and an amateur photographer, discovered the light-sensitive qualities of potassium bichromate on paper and published his discovery in the *Edinburgh New Philosophical Journal*. A year later the French physicist Edmond Becquerel established that the light sensitivity of potassium bichromate was greatly affected by the starch used as sizing in paper. This observation led to the study of the effect of bichromates on various colloids, and in 1852 Henry Fox Talbot discovered the effectiveness of a mixture of potassium bichromate and gelatin. He took out a patent in the same year for making etchings on steel using this mixture. From his work with bichromatized gelatin, Talbot noted that the solubility of the coating varied in relation to the amount of exposure it received. This led him directly to the development of photogravure, a completely tonal method of photoreproduction.

Talbot had already been experimenting for several decades with photosensitive materials; by 1835 he had made the first

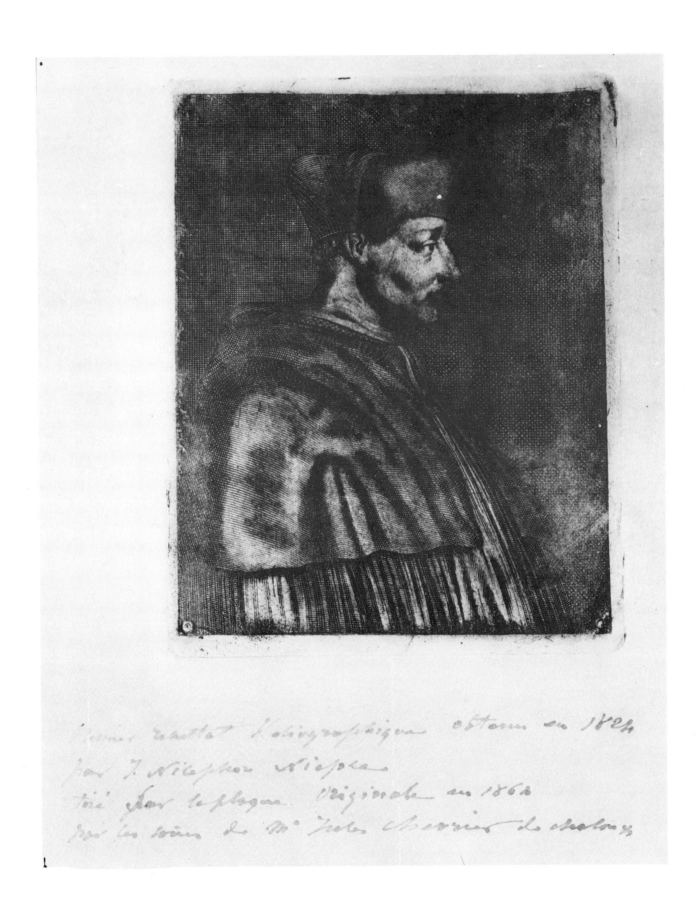

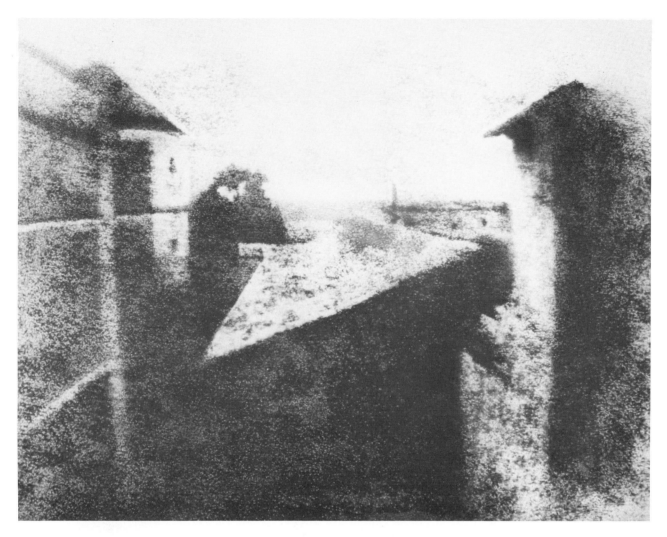

Joseph Nicéphore Niepce, *View from the Window at Gras* (1826). Impression from a plate made by exposing light-sensitive bitumen on pewter directly in the camera. The plate was then washed out, etched, and printed. Gernsheim Collection, Humanities Research Center, The University of Texas at Austin.

Opposite: Joseph Nicéphore Niepce, *Cardinal d'Amboise*. Photograph of the pewter heliographic plate made by exposing an engraving on paper to bitumen-sensitized pewter, then etching in acid. The Metropolitan Museum of Art, Gift of R. P. Talman, 1921.

photographic negatives in a camera by exposing paper coated with silver chloride. Later, Talbot published a method of making a negative by exposing paper coated with silver iodide, then developing it in a solution of silver nitrate and gallic acid. This formed the basis of the "wet collodion" process developed by F. Scott Archer in 1851 in which a glass plate was coated with iodized collodion, then sensitized with a solution of silver nitrate and exposed in the camera while still wet. Talbot used this process to make continuous-tone positives from which he made photogravures of excellent quality.

In developing the photogravure process, Talbot first used the colloid gelatin, which he made light-sensitive with potassium bichromate. This he flowed onto a copper plate in a thin layer and allowed to dry. After exposing the positive to the coating, he etched the plate in a solution of platinic chloride. This etched the soft, unexposed gelatin first, then slowly broke through the other, more light-hardened parts of the coating. In order to assist in the creation of tonalities, Talbot eventually introduced a resin "aquatint" grain which he dusted onto the surface of the gelatin. This allowed the etching to take place around each particle and form a series of wells in the plate which would hold ink over a large area. Talbot eventually switched from platinic chloride to ferric chloride, which had a more controlled effect on both the gelatin and the metal and was much less expensive. He also noted that as the ferric chloride was diluted with water, it broke through the successive layers of gelatin faster, allowing him to carefully monitor the etching and therefore the range of tonalities. Using the "wet collodion" process for making photographic positives, Talbot made many photogravures of excellent quality. He patented the process in 1858.

Two other developments improved Talbot's photogravure process. One was the invention of carbon tissue, a heavily pigmented layer of gelatin on a paper base, by Joseph Swann in 1864. The other was the innovation of graining the plate with resin or bitumen particles fused directly to the surface of the metal by means of heat instead of resin placed on the gelatin surface.

In this improved method, the tissue was sensitized in potassium bichromate, exposed under the continuous-tone positive, then transferred to the grained copper plate. After the adhered tissue was "developed" in hot water, the paper backing was removed and all unexposed gelatin washed away. This left a layer of gelatin on the plate whose thickness varied in direct proportion to the amount of light that came through the positive. The pigment in the gelatin allowed all tones to be clearly visible. The latter innovation was perfected in Vienna by Karl Klic, who by 1879 had brought the process to commercial prominence for all types of quality reproduction.

Klic later substituted a special "halftone" screen for the grain, which had a grid of clear lines on an opaque background. This

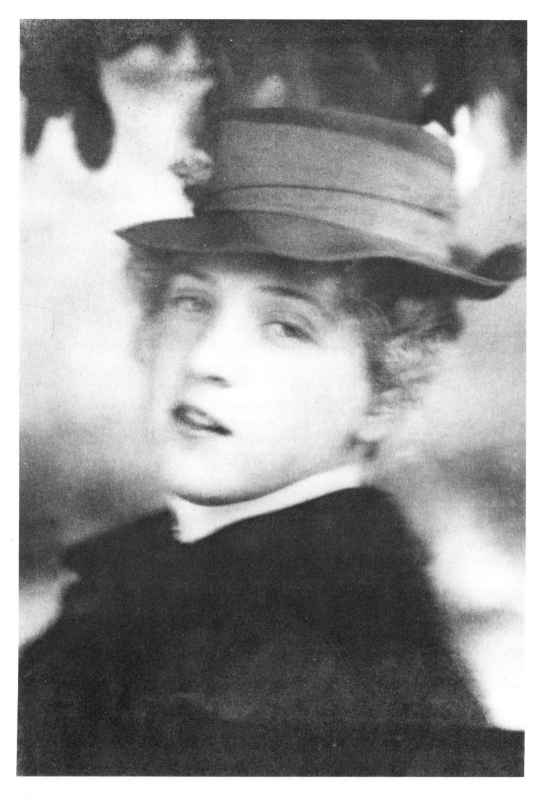

Alfred Stieglitz, *Miss S.R.* Photogravure. The Metropolitan Museum of Art, Gift of
J. B. Neumann, 1958.

screen was exposed to the carbon tissue first, then the carbon tissue was exposed to the continuous-tone positive. The screen formed a grid on the carbon tissue which resisted etching so that the ferric chloride etched between the lines of the grid to form wells of varying depth but of almost uniform diameter. Klic went on to etch copper cylinders for rotary printing, which later became known as rotogravure. By the early 1900s rotogravure became increasingly used for quality printing in both black-and-white and color.

The application of photogravure to cylinders meant the process could now be done by high-speed presses. By the early 1930s, the wet collodion process and Klic's photogravure process for making individual flat plates were still being used, but they had given way almost entirely to rotogravure. A printer could make only 50 or 60 prints per day from a large flat plate by hand, but rotogravure was soon capable of a rate in excess of 30,000 impressions per hour.

It was no longer feasible to print flat photogravure plates by hand, and most firms in switching to rotogravure usually scrapped their hand presses to make way for the new rotogravure machinery. From the turn of the century until more recently, however, several important artistic statements executed in photogravure have been undertaken.

In 1903 Alfred Stieglitz founded *Camera Work*, a magazine dedicated to artistic photography. Of the 544 illustrations published during the publication's life span, 416 were printed by photogravure. By the time the last issue of *Camera Work* was printed in 1917, another, even more ambitious project was well under way. This was Edward Curtis's *The North American Indian*—a project that lasted from the late nineteenth century until 1930, when the effects of the Great Depression brought it to an end. Curtis spent more than thirty years photographing the Indians of North America. Out of over forty thousand photographs, he made more than two thousand photogravure plates that richly documented the lives and rituals of a vanishing civilization.

In 1922 Georges Rouault, encouraged by the Parisian art dealer Ambroise Vollard, began a series of etchings entitled the *Miserere*. These began as drawings and paintings, which were then photographed and etched onto copper plates by the photogravure process. By doing so, Vollard thought he could simplify the etching process for the artist and thus publish the editions quickly. Rouault, however, worked back into each plate with aquatint, engraving, and roulette work and by scraping and burnishing to achieve the quality he wanted. In 1927, five years after he had begun, the plates were completed and printed by Vollard in an edition of 450.

In 1940 a portfolio of twenty photogravures by Paul Strand in an edition of 250 were printed at the Photogravure and Color Company in New York. This was Strand's *Photographs of Mexico*,

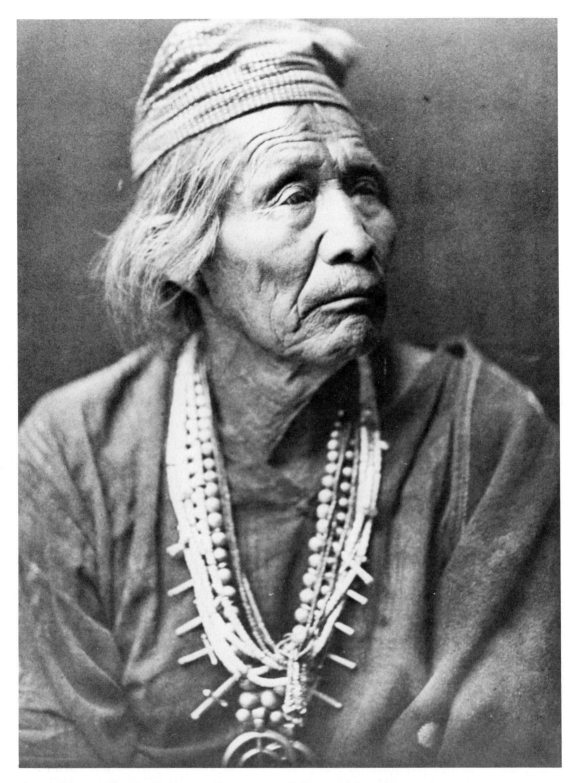

Edward Curtis, *Nesjaja Hataĺĭ*, Navajo. Photogravure. Collection of the author.

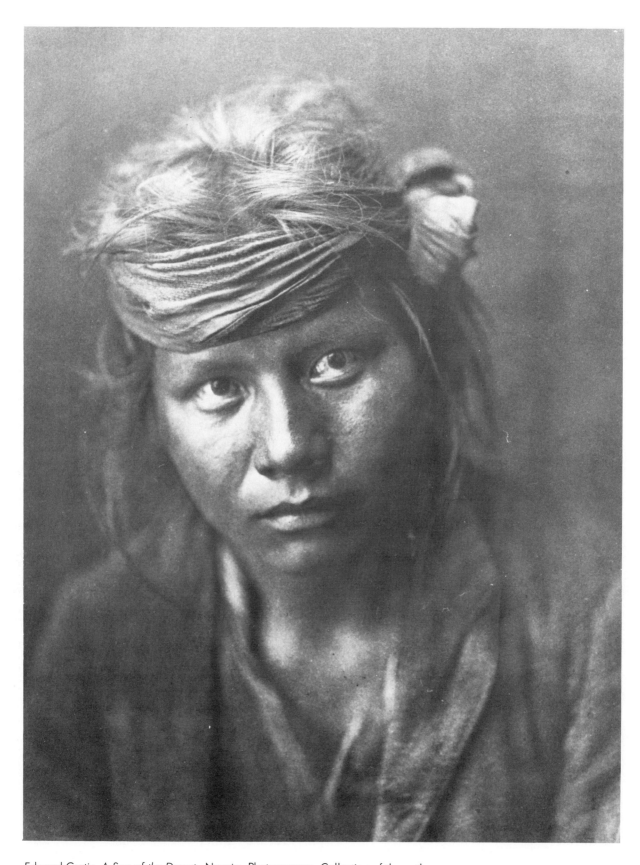

Edward Curtis, *A Son of the Desert*, Navajo. Photogravure. Collection of the author.

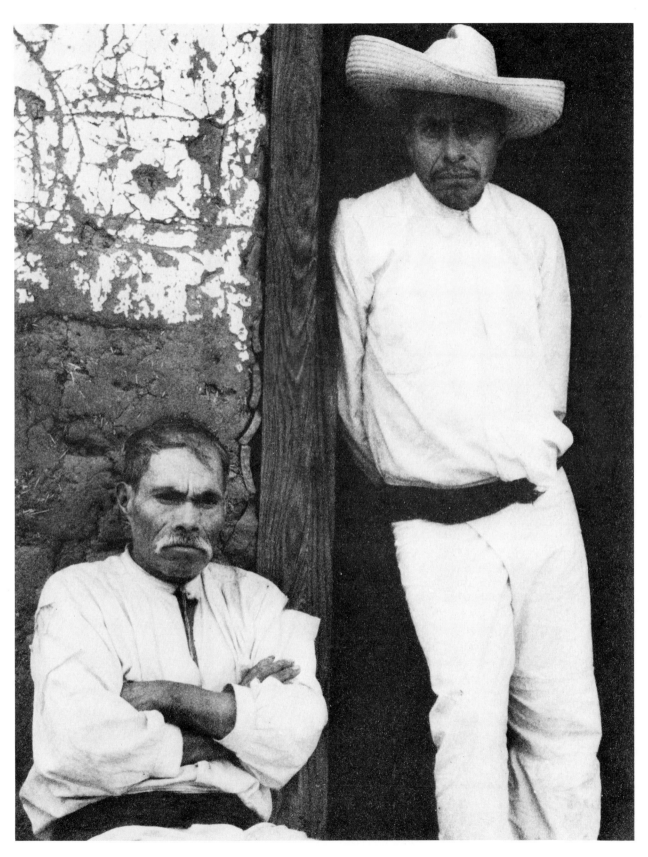

Paul Strand, *Two Men*. Photogravure. The Metropolitan Museum of Art, David
Hunter McAlpin Fund, 1940.

later reissued in 1967 by the Da Capo Press in an edition of 1,000 and printed by Anderson and Lamb of Brooklyn, New York. (The Photogravure and Color Company had meanwhile moved to New Jersey and no longer printed gravures by hand.)

Currently, considerable interest in reviving the photogravure process has surfaced in many workshops around the country. Atelier Editions, Inc., New York, founded by the author in 1979, now works exclusively in the making of photogravure plates and hand printing of limited editions.

The early nineteenth century was perhaps the greatest era of artistic lithography on stone. The process grew from its meager beginnings with Aloys Senefelder's experiments in "chemical printing" on Kelheim limestone, from 1796 to 1798, until by 1815 there were lithographic workshops in St. Petersburg, Madrid, and Philadelphia, as well as innumerable other establishments throughout Europe. The process was unique. It did not have the coarseness associated with relief printing, nor did it require the painstaking skill needed for metal engraving. It was direct and more related to drawing with a pen or crayons than any other reproducible medium.

During the aftermath of the French Revolution, when there was an insatiable demand for printed matter, attempts to record visual images by the action of light took on increasing importance. Newly developed steam-driven letterpress machines, like the Koenig press put into operation by the *Times* of London in 1814, could print in excess of 1,100 impressions per hour. The creation of visual images remained slow, however, until photographic processes were developed at the same rate. Of course, the demands of production were often at odds with artistic excellence. As the speed of printing presses increased, so did the pressure on the visual artist to keep pace. In the first few decades after the invention of lithography some of the finest examples of artistic lithography on stone were created. During this period, artists such as Géricault, Bonington, Delacroix, Isabey, and others created a lasting monument to Senefelder's invention.

Change was inevitable, however, and experiments with photographic processes fixed the direction visual imagery was to take. This development was apparent in the major publishing venture by Baron Taylor, *Voyages pittoresques et romantiques dans l'Ancienne France*, a series of twenty volumes of topographical illustrations begun in 1820 and completed in 1878. Louis Daguerre was a frequent contributor of drawings to the early volumes, before he turned his attention to the process that was to bear his name. By 1839, when Daguerre made his invention public, the photograph was gaining importance, and it became common to translate images by hand from daguerreotypes onto stone.

The asphalt process was successfully used to reproduce photographs on stone. Lemercier, one of the leading lithographers in Paris, received a medal of honor in 1849 for fixing a photographic

Georges Rouault, *Bella Matribus Detesta*, from *Miserere* (1922–27), plate 42. Photogravure plate reworked with burin, scraper, aquatint, and mezzotint roulette. Prints Division, New York Public Library, Astor, Lenox and Tilden Foundations.

image on stone and printing from it using the asphaltum process. In collaboration with the optician Lerebours, Lemercier applied a thin coating of asphaltum to a grained stone and exposed it to the sun through a paper negative. The areas that received no exposure washed completely away in turpentine, whereas those areas containing middle values left a thinner stratum of asphaltum on the stone. The stone was then etched in the usual fashion; the grain of the stone aided in breaking up the tonal values of the image.

By 1857 Lemercier, in association with Poitevin, began using a photolithographic process incorporating bichromated albumen, which Poitevin had invented. This process was to remain a standard procedure until our own time. Poitevin was also the inventor of collotype in 1855 and of several carbon processes. In the last two volumes of *Voyages pittoreques* (1863 and 1878), Lemercier used Poitevin's bichromated albumen process to make more than a dozen photolithographic images printed from stone.

Sensitizing a stone, however, was not a practical procedure; it was difficult to coat the stone uniformly as well as to make good contact during exposure. If photolithography was to survive, a new process was needed. This proved to be the photolithographic transfer process, developed by Eduard Isaac Asser in Amsterdam in 1857. He coated a piece of paper with starch paste sensitized with bichromate. The sensitized paper was then contacted to a negative image and exposed to light. Immediately after exposure, the surface was coated with a thin layer of greasy transfer ink. Next, the paper was immersed in water, where the unexposed areas of the starch coating dissolved, taking the transfer ink on top with it. The light-hardened image that remained was transferred under pressure to the stone, where the transfer ink embedded itself in the grained surface crisply and evenly. This transfer process was improved considerably over the years but remained the dominant method of printing photolithographic images on stone. Later, as zinc and aluminum plates began to replace stone for lithographic printing, the transfer method was abandoned, as Poitevin's bichromated albumen process was ideal for flexible metal surfaces.

By the 1880s three main forms of printing existed: lithography, letterpress (relief), and intaglio (etching, engraving, photogravure). Of these processes only photogravure was capable of photographically translating a full range of tonal values accurately onto a plate. Because photogravure was slow and costly, however, it was used only when the finest reproductions were needed and the production costs could be justified. Tonal pictorial work in lithography still relied on the artist, who by this time translated images by hand directly onto stone or plates, often working from photographs. Letterpress printing remained the dominant form of printing, primarily because of the speed at which the steam-driven presses could operate, and wood engravings made on type-high end-grain boxwood could be printed simultaneously

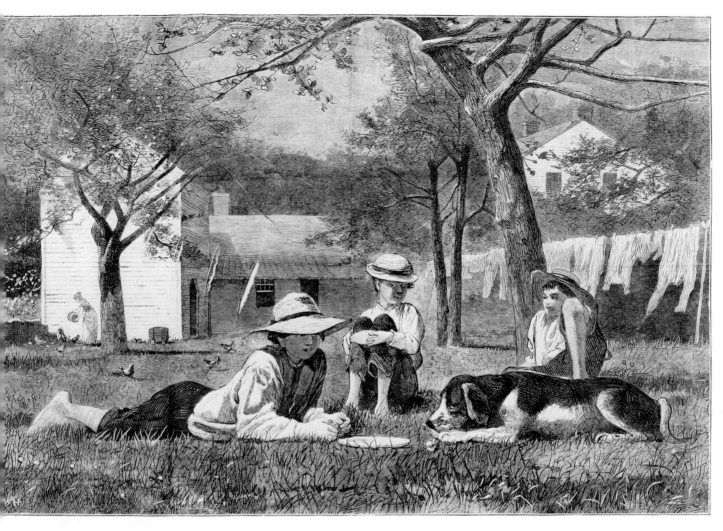

Winslow Homer, *The Nooning*. Woodcut. A total of twelve smaller engraving blocks were joined together to make the completed image. The Metropolitan Museum of Art, Harris Brisbane Dick Fund, 1929.

James Rosenquist, *Over*. Multiple-exposure photolithograph, printed on a flat-bed offset proofing press at Siena Studios, New York, from Western wipe-on plates. From the portfolio *High Technology and Mysticism: A Meeting Point*. Courtesy of the artist.

Opposite: Robert Rauschenberg, *Rookery Mounds—Crystal*. Three-color lithograph, 41 × 31 inches (104 × 79 cm). The collage was photographed and made into three photolitho plates, then printed in gray, blue black, and blue. Courtesy of Gemini G.E.L., Los Angeles.

with type. Beginning in the 1860s it was common practice to sensitize the surface of the wood block, then photographically superimpose an image. The engraver then engraved directly into the wood, translating the tonal image into line. Large images were made from several small blocks clamped together while the photographic imposition was made. Then the blocks were separated and given to different engravers in order to save time and have the engravings ready for press time. The closely engraved lines which the wood engraver used to create tonal images, along with steel and copper engravings, aquatints, and hand-drawn lithographic images, remained the predominant means by which tonal images were utilized in commercial printing.

The development of the halftone process radically altered the manner in which tonal images were made and printed. The idea was not new. Talbot had patented a screen process for photogravure in 1852 utilizing a dark fabric to break up the image into a series of dots. A few years later A. J. Berthold took out a patent for a line screen in Paris. It was not until 1866, however, when Frederic Eugene Ives of Philadelphia introduced the glass crossline screen, that many of the previous problems of tonal reproduction were solved. Ives's screen consisted of two sheets of glass, each with fine parallel lines engraved on one side. The engraved lines were filled with an opaque black substance, then the sheets were placed face to face with the lines at right angles to each other, creating a grid through which the tonal exposure was made. Each opening in the grid acted somewhat like a miniature lens, focusing slightly more light at the center and less toward the edges. Light was projected through the screen and onto a sheet of film placed in contact behind it; the size of each dot formed through the screen depended on how much light was projected. This screen, combined with recent technical improvements in photographic processes and materials and the development of flexible film, dry plates, anastigmatic lenses, and hand-held cameras, made possible the growth of a whole new era of pictorial reproduction in the graphic arts.

Letterpress was the first beneficiary of the halftone process, and photoengraving became the leading reproductive process, quickly replacing wood engraving and intaglio printing except for highly specialized jobs. By the turn of the century, photoengraving was the dominant force in printing, and black-and-white halftone as well as color process work had been adopted by the industry as a whole.

In this period when so many of the advances in photoengraving took place, lithography languished. Even though halftones could be printed using the photo-transfer method, the results were not as good or as predictable as those that could be photoengraved onto a zinc or copper plate. Three-color process printing was impractical on stone and seemed beyond the limits of the process. It was not until the development of the offset press, which

necessitated the use of grained metal sheets rather than stone, that lithography was eventually to compete favorably with letterpress printing and ultimately surpass it.

Today, all commercial printing processes rely on halftone photographic procedures for the production of tonal images. The reproduction of color work has evolved over the years to a point where the combined technology of making color separations, film-masking techniques for correct color balance between the three primary colors and black, and improved printing presses and techniques permit extremely accurate reproductions to be made from both film transparencies and artwork. In addition to the purely reproductive aspects of printing, more and more artists are turning to commercial printing processes for the creation of limited editions of original prints. This is particularly true of lithography and gravure, where the existing technology is flexible enough to accommodate innovative and unusual approaches.

Many contemporary artists, such as Robert Rauschenberg, James Rosenquist, Andy Warhol, and Jasper Johns, have not only made creative use of many commercial printing processes but have also incorporated photographic imagery in many of their works. Among photographers there is a resurgence of interest in older techniques such as cyanotype printing, photogravure, as well as other silver and nonsilver printmaking methods.

# COLOR GALLERY

James Rosenquist, *Sky*, from the portfolio *High Technology and Mysticism: A Meeting Point*. Multiple-exposure photolithograph, printed on a flat-bed offset proofing press at Siena Studios, New York, from Western wipe-on plates. Courtesy of the artist.

Right: James Rosenquist, *Somewhere*, from the portfolio *High Technology and Mysticism: A Meeting Point*. Multiple-exposure photolithograph, printed on a flat-bed offset proofing press at Siena Studios, New York, from Western wipe-on plates. Courtesy of the artist.

Below: C. J. Yao, *Bus*. Four-color photolithograph using a 150-line screen, printed in part on mirrored Mylar laminated to Arches 88 paper. 30 × 42 inches (76 × 107 cm). Courtesy of Styria Studio, New York.

Opposite: Edward Ruscha, *Sweets, Meats, Sheets*. Four-color process screen print using 65-line screens. Two additional colors, red and yellow, were printed with fluorescent inks. The final printing was done with a clear lacquer overprint varnish. 33 × 25 inches (84 × 64 cm). Courtesy of Gemini G.E.L., Los Angeles.

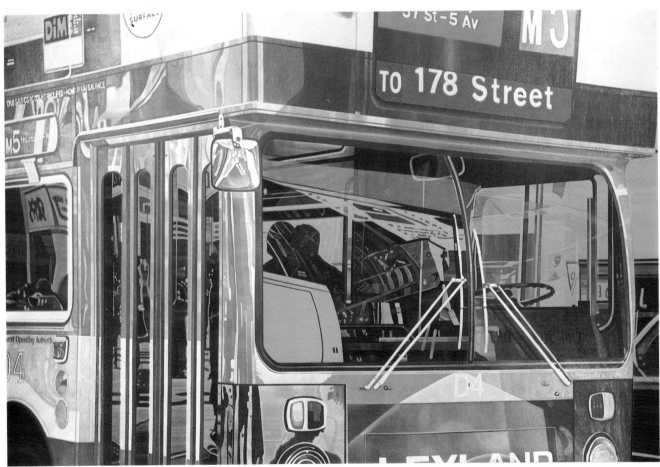

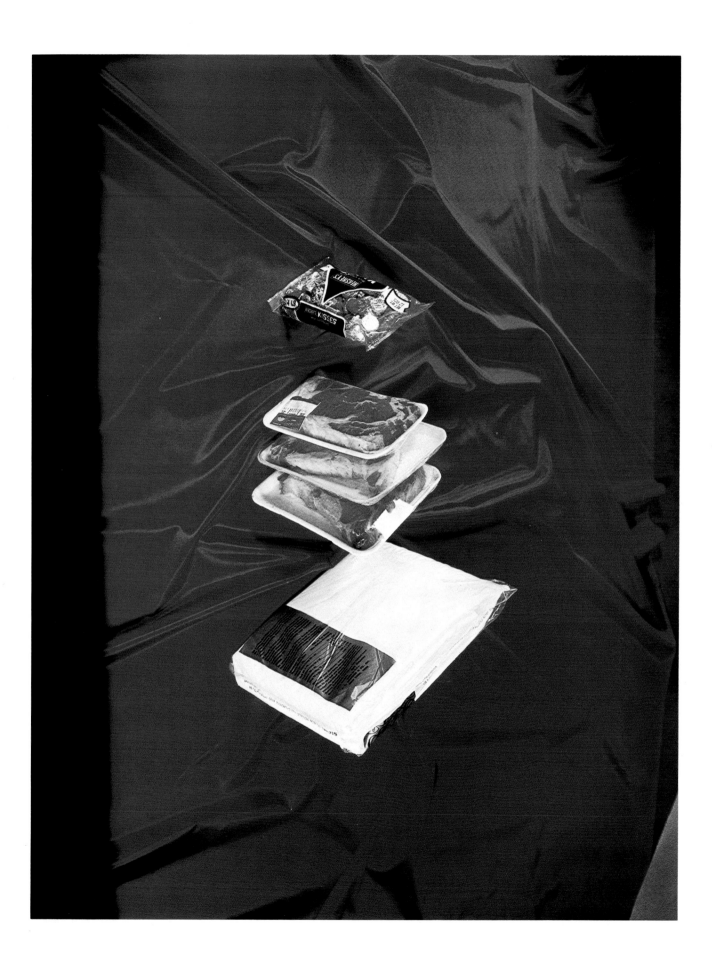

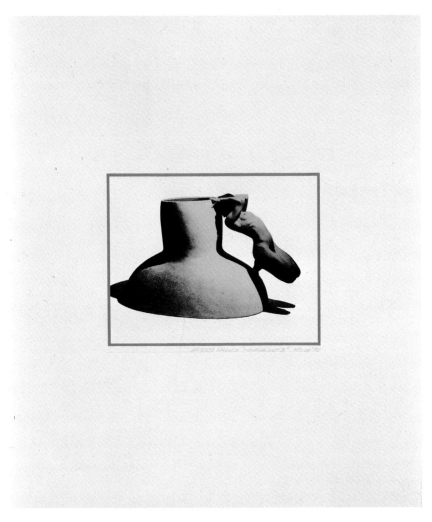

Ken Price, *Figurine 11*. Hand-printed from aluminum photolithographic plates. 22 × 18 inches (56 × 46 cm). Courtesy of Gemini G.E.L., Los Angeles.

Richard Graf, untitled. Screen print made with multiple tonal and line separations. 16 × 20 inches (41 × 51 cm). Courtesy of the artist.

Opposite: Deli Sacilotto, *Washington Street Series #6*. Five-color lithograph made by exposing hand-drawn Mylar positives onto Enco P-30 positive plates. Wash graduations made in a three-step exposure system on three separate plates, then printed in register on an offset press.

A.P. 11/40

D. Seiloff

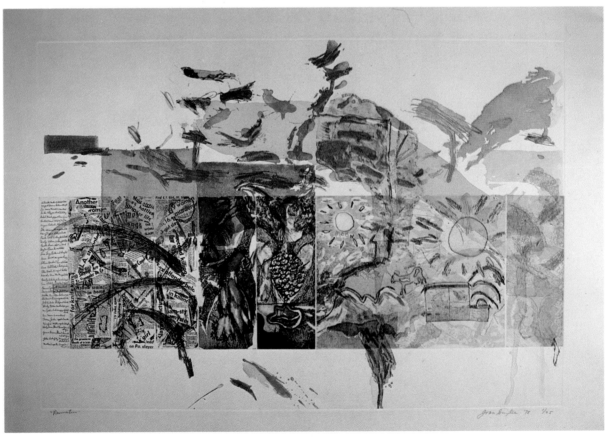

Opposite, top: John Cage, photo-etching from *Seventeen Drawings by Thoreau*. Drawings done by Henry David Thoreau in his journals. Cage photographed them and changed their size, colors, and arrangement to make the prints. Courtesy of Crown Point Press, Oakland, California.

Opposite, bottom: Joan Snyder, *Resurrection*. Sixteen-color intaglio print. Four plates made photographically using the KPR process. 24 × 36 inches (61 × 91 cm). Courtesy of Aero Press, New York, and Joan Snyder.

This page, top: Robert Rauschenberg, *Rookery Mounds—Night Tork*. Three-color lithograph; dark brown printed from stone, beige and blue from aluminum photographic plates. 41 × 31 inches (104 × 79 cm). Courtesy of Gemini G.E.L., Los Angeles.

This page, bottom: Donald Saff, *Marriage Contract*. Hand-colored etching made by combining line and tonal photogravure from hand-drawn positive images, with additional work done on the plates with conventional etching, mezzotint, and engraving. 18.5 × 22.5 inches (47 × 57 cm). Courtesy of the artist.

# CHAPTER TWO

# BASIC CAMERA WORK

Photography is a vast area of study. Each year new processes, emulsions, and specialized equipment add enormously to the complexity of this relatively new visual art form. This chapter will discuss only those procedures and the characteristics of films which have proved particularly responsive to creative image making. It will also explain procedures for making both negatives and positives—screened or unscreened—plus the basic functions of the enlarger, the process camera, and graphic arts films. All these techniques have been incorporated into the vocabulary of the printmaker for use in intaglio, lithography, and screen printing.

Opposite: Robert Rauschenberg, *Arcanum IX*. Eleven-color screen print combining photographic screens and hand-drawn screens, printed onto silk and cotton fabric laminated onto handmade paper. Courtesy of Styria Studio, New York.

## THE ENLARGER

The basic enlarger is composed of these principal elements: the light source, condensing lenses (or diffusion lens), the negative carrier, the enlarging lens, the focusing bellows, and the iris diaphragm, all of which make up what is called the enlarger head. The enlarger head is attached to a supporting column and can be adjusted vertically to change the size of the image on the baseboard below. Some enlargers, such as the Beseler MX series, can also be positioned so that they project horizontally onto a wall for extremely large blow-ups.

The most common enlargers are those designed for 35mm, 2¼, and 4-×-5 negative sizes. Enlargers that take only the 35mm format cannot accommodate larger-size negatives, whereas the 4-×-5 enlarger adapts to any negative size up to 4 × 5. Special negative carriers are available for a wide variety of negative sizes. These carriers hold the negative flat to avoid distortion as well as to facilitate masking of the nonimage areas. Enlargers that take 5-×-7 and 8-×-10 negatives are used mostly in specialized commercial work and are not practical for home use. It is important that the enlarger chosen be compatible with the camera used for making the initial negatives. The cost of an enlarger designed only for 35mm negatives would be less than the cost of an enlarger that can accommodate film up to 4 × 5. Remember that enlargers used for many negative sizes need a different lens for each format.

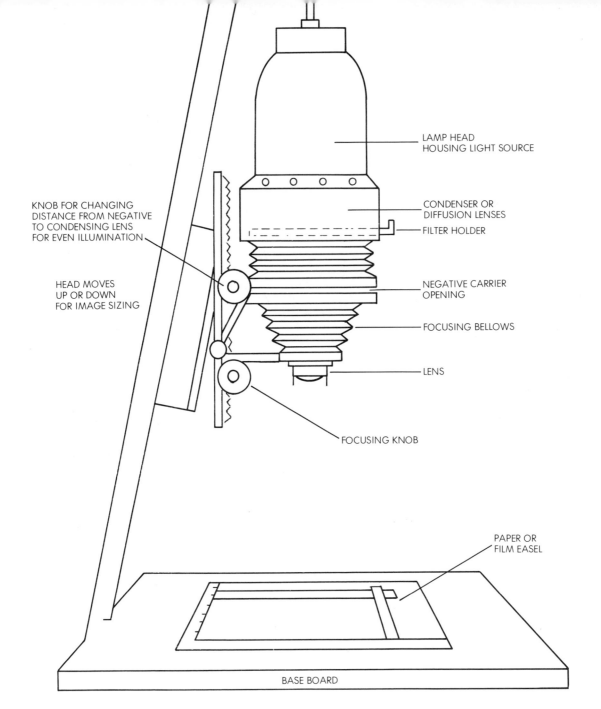

LAMP HEAD
HOUSING LIGHT SOURCE

KNOB FOR CHANGING
DISTANCE FROM NEGATIVE
TO CONDENSING LENS
FOR EVEN ILLUMINATION

CONDENSER OR
DIFFUSION LENSES

FILTER HOLDER

HEAD MOVES
UP OR DOWN
FOR IMAGE SIZING

NEGATIVE CARRIER
OPENING

FOCUSING BELLOWS

LENS

FOCUSING KNOB

PAPER OR
FILM EASEL

BASE BOARD

Basic enlarger.

The quality of the enlarging lens must be at least equal to that of the camera lens; otherwise, it will be impossible to achieve good results even with the sharpest negatives. An enlargement to 16 × 20 from a 35mm negative represents an increase in size of almost 250 times. There is understandably a loss in critical sharpness with enlargements of this magnitude, but the enlarged grain structure can often result in a pleasing textural effect in the final work. It is a good idea to purchase an enlarging lens that has a flat field and edge-to-edge sharpness. The slightly higher cost of a high-quality lens will be well justified.

Enlarging lenses come in a variety of focal lengths; the size you use depends on the size of film. A 50mm lens, designed for 35mm film, will only partially cover a 4-×-5 area; conversely, a 135mm lens designed for 4-×-5 film, although it will cover the 2¼ format

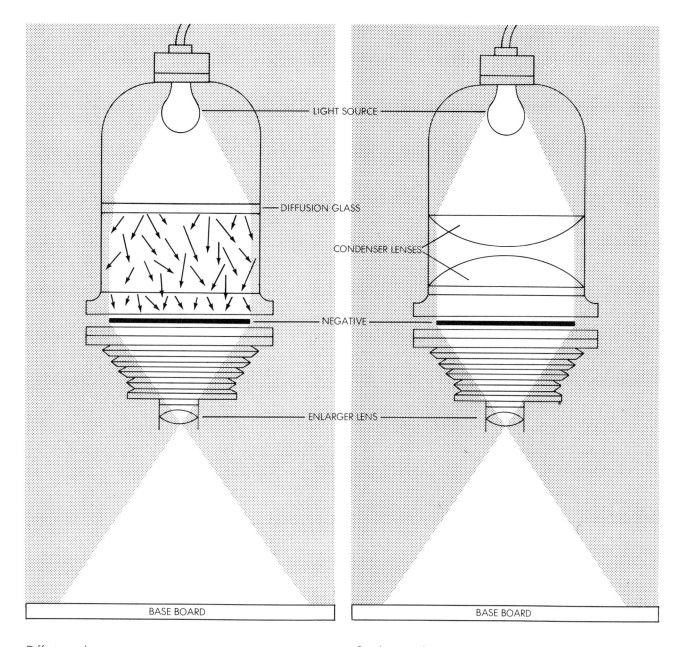

LIGHT SOURCE

DIFFUSION GLASS

CONDENSER LENSES

NEGATIVE

ENLARGER LENS

BASE BOARD

BASE BOARD

Diffusion enlarger.

Condenser enlarger.

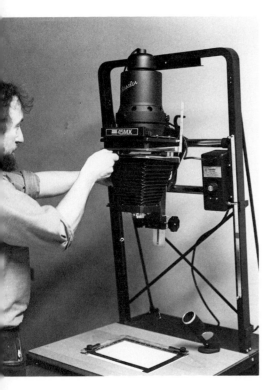

The negative carrier is placed in the enlarger.

quite well, is inadequate for small negative sizes if a considerable enlargement is needed. Use the following chart to determine the ideal focal length for good coverage of the film area:

| Negative size | Lens focal length |
| --- | --- |
| 35mm (24 × 36mm) | 50mm |
| 2¼ × 2¼ | 75–80mm |
| 2¼ × 3¼ | 90–100mm |
| 4 × 5 | 135–150mm |

There are two main types of enlargers, the diffusion enlarger and the condenser enlarger, which have two distinct systems for allowing light to pass through the negative and lens for projection. The condenser enlarger is more versatile and practical for general use; it provides efficient use of light and gives sharp definition overall. The diffusion enlarger creates a soft-focus effect which is ideal for some areas of portraiture where diffused light can be used to advantage.

Enlargers made to accommodate a variety of film sizes and lenses of different focal lengths have an arrangement for repositioning the condenser lenses in the enlarger head for each size of film. This repositioning ensures even lighting over the entire film area and avoids concentrating the light only in the center of the negative. Some types of enlargers have either a different set of condenser lenses or an additional lens that accomplishes the same purpose.

When you are ready to use the enlarger, place the film in the negative carrier, emulsion side down. Handle the film by the edges only. Once it has been placed in the carrier, remove any particles of dust with a soft clean brush, or by using an aerosol can of compressed gas which you can buy specifically for this purpose in any photographic supply store. The greater the enlargement of the negative, the more care should be taken to keep it clean; every speck of dust will become more apparent with the increase in image size.

## THE PROCESS CAMERA

The process camera is used professionally to make color separations, to copy line work, and to make halftones, reductions, and enlargements from both opaque copy and transparent film. Although more and more schools make use of this type of camera, its size and cost can be justified only if it is to be used a great deal and if the space is available to house it. These cameras come in several sizes. The smaller ones take a maximum film size of approximately 14 × 18; a large process camera takes film of 31 × 31, and in some cases as large as 48 × 72. One of the most popular sizes of process camera is the 20-×-24 model, which handles the size used for 75 percent of commercial printing jobs. Most of these cameras are mounted horizontally on the floor,

though some for larger film sizes are suspended from an overhead track. The light source is usually pulsed xenon, carbon arc, quartz iodine, or, in the case of simple cameras, photofloods.

The main sections of the process camera are the copy board, which holds the material to be photographed under glass either by pressure or with a vacuum device; the lens and bellows; and the camera back, which contains a ground-glass focusing screen and a suction back for holding the film. The backs of large process cameras are often built so that they project into a small room with safelights independent of the lens, copy board, and lights.

For making color separations, the process camera back has a special attachment where halftone screens are rotated at appropriate angles for each color. The lens for color work must also be color-corrected so that it reads each of the process colors—cyan, yellow, magenta, and black—with the correct color balance and focuses them on exactly the same plane.

The lights for opaque copy or artwork are placed at an angle of approximately 45 degrees on either side of the copy board so that they illuminate the work evenly. Diffracted and stray light can create hot spots on the film; they can also cause lens flare, which puts a slight fog over the film, causing uneven tonalities and loss of detail, particularly in shadow areas. To correct this, a lens hood with a matte black finish inside should be used. Lens flare can also be caused by dirty lenses, reflection from nearby light objects, or excessive white areas around the copy being photographed.

## BLACK-AND-WHITE FILMS

For many of the processes outlined in this book, the starting point for incorporating a photographic image into a screen image, lithographic plate, or intaglio plate is the initial negative of the 35mm or larger-format camera. The greater the intended enlargement, the more critical the quality and format of the negative.

There is a vast assortment of black-and-white films, each having specific applications in the graphic arts or commercial photographic market. They are classified by their spectral sensitivity, grain structure, speed, degree of contrast, and purpose for which they are best suited. For example, Kodak Tri-X and Plus-X films, which are commonly used for taking black-and-white photographs, are panchromatic, continuous-tone films. Panchromatic films are sensitive to all colors and render them accurately as black-and-white tones. They also have continuous gradations and reflect the tones of the original objects photographed. Orthochromatic films are sensitive to ultraviolet, blue, and green only and are unaffected by red light. This allows them to be used in the darkroom with red safelights without being exposed. Films characterized as blue-sensitive register only the ultraviolet and blue light transmitted by the object being photographed and are used mainly for copying other black-and-white work.

Spectral sensitivity of photographic films.

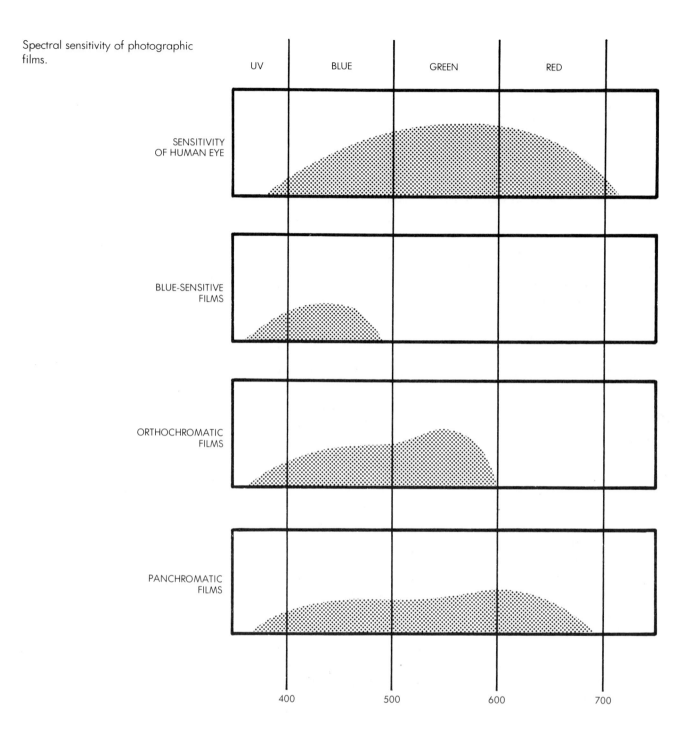

## LINE AND HALFTONE PHOTOGRAPHY

High-contrast orthochromatic film is used almost exclusively for line and halftone work. This film, when used with the appropriate developer, gives fast, consistent results. Black-and-white areas are sharply defined without intermediate gray tones. Images can be projected onto orthochromatic film with either the process camera or the enlarger, or the film may be used for making negatives and positives by contact.

## LINE PHOTOGRAPHY

All photography using orthochromatic film and its corresponding high-contrast developer that is not screened is referred to as line photography. Although line shots are made exclusively for type copy or other purely black-and-white work, they are also used for special effects with continuous-tone images. If a continuous-tone image, for example, is projected onto orthochromatic film and developed in high-contrast developer, the gradations of the original will be broken up into a stark black-and-white image with middle values, becoming an irregular, coarse black-and-white pattern.

## HALFTONE PHOTOGRAPHY

Halftones are made when tonal images are to be reproduced and printed in lithography, screen printing, or photoengraving. The printing plates used for these processes are sensitive only to black and white. For a range of tonalities to be printed, the continuous tone of the negative is broken up into a fine dot pattern which to the naked eye produces a full tonal range. In making the halftone, a negative or positive continuous-tone image is projected through a glass crossline screen or a contact screen onto orthochromatic film. The dots vary in size, depending on how much light is transferred from the original. Screens may be purchased that produce a coarse dot pattern of 45 to the inch, to ones that create more than 500 to the inch. Photographs in newspapers are printed with an 85-line screen, and most magazines use a screen of 133 to 150 lines per inch.

Glass crossline screens for making halftones and contact halftone screens produce similar results, but they operate on different principles. The glass crossline screen used by commercial photographers is fitted to the back of the process camera. With this screen, the resolution of highlight, middle tone, and shadow detail is affected by changes in exposure and lens aperture.

The contact screen is easier to use and has a lower initial cost. It can also be used with any type of enlarger or process camera, provided there is a means for achieving good contact between screen and film. Two types of contact screens are available—the gray contact screen and the magenta contact screen. Both result in a similar breakup of tonalities into dots. The magenta screen, however, is more versatile, because it can be used to make halftones from black-and-white copy as well as color separation negatives. The gray screen is used primarily for direct color separation work.

## MAKING A HALFTONE
## WITH THE PROCESS CAMERA

Tests should be made with a reflection gray scale to determine optimum exposure times and the best lens apertures. A reflection

gray scale is a series of opaque gradations. The scale is placed on the copy board and various exposures made on film; the film is then compared with the gray scale for balance and accuracy of rendition. As a rule, lenses produce the greatest sharpness when the aperture is set in the middle between the widest and smallest openings. The optimum halftone negative has a 90 percent dot in the highlight areas and a 10 percent dot in the darkest shadow areas. Both the shadow and highlight areas can be controlled with special flash techniques when using the magenta contact screen.

*Step 1.* Place the work to be photographed on the copy board. Make sure the glass covering the work is clean and clamped down firmly. Cover any excess white areas around the work with black paper to reduce unnecessary glare.

*Step 2.* Open the camera lens wide and, with the lights on, focus the image to size on the ground glass. The lights should illuminate

Step 1. The work to be photographed is placed on the copy board.

Step 2. A magnifying lens is used to check the focus on the ground glass.

the work evenly and be placed at approximately a 45-degree angle on either side of the copy board so that direct glare from the lights will bounce harmlessly to either side of the camera and not into the lens. After focusing, turn the lights off.

*Step 3.* Make sure before opening the box of orthochromatic film that all lights are off except the red safelight. Turn the camera back vacuum on and place the orthochromatic film in position so that the light (emulsion) side faces the lens when the back is closed.

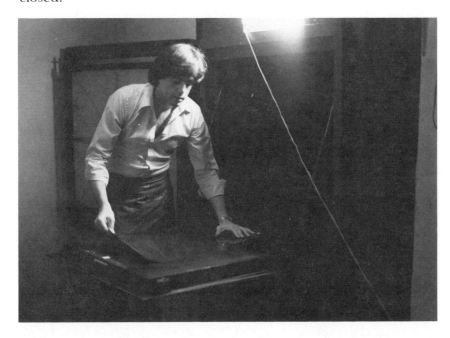

Step 3. The film is placed in position on the vacuum back.

*Step 4.* Next, place the contact screen over the film so that the emulsion side of the screen contacts the emulsion side of the film. The piece of film should be smaller all around than the screen so that the suction of the vacuum back holds both simultaneously. Smooth out any air bubbles with a soft, clean rubber roller or a clean chamois cloth.

*Step 5.* Unhinge the ground glass and swing it out of the way. Then place the vacuum back and film in position for exposure.

*Step 6.* Stop down the lens to the calculated aperture and set the timer.

*Step 7.* Expose the film for the proper time. Make the required flash exposures if necessary.

*Step 8.* Remove the film from the camera back and develop it. Handle the contact screen carefully at the edges only and avoid kinking it. Always keep it stored in its own box when it is not in use.

*Note.* This process is identical to the procedure for making a line shot, except that for line photography the contact screen is not used.

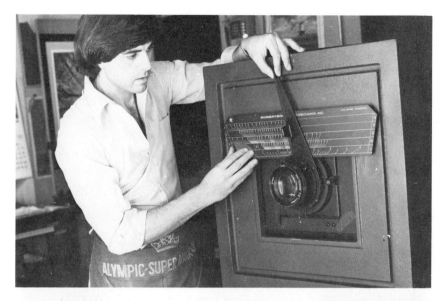

Step 6. The aperture is adjusted.

Step 7. The film is exposed.

## MAKING A HALFTONE
## WITH THE ENLARGER

There are two ways that halftones can be made with the enlarger: using a contact screen, or using Kodak Autoscreen film. Because Autoscreen film has a screened dot already built in, it is the simpler method to use and it gives excellent results. Autoscreen film is available in sizes from 4 × 5 to 11 × 14 with a built-in screen of 133 lines per inch.

To make a halftone with Autoscreen film, place the continuous-tone negative or positive in the enlarger and focus it to size on the baseboard easel. Because Autoscreen film is orthochromatic, a red safelight must be used. Place the sheet of film, emulsion side up, on the easel and expose it. To determine

the correct exposure time, make a step-wedge multiple-exposure test with a piece of the film. This is done by covering the film with an opaque sheet of paper or board, leaving only about ½ to 1 inch (12 to 25 mm) of the film exposed. After the first exposure, the opaque paper is moved and another exposure made. This is continued until about four or five exposures have been made. Each step should be exposed at timed intervals and a record kept so that results can be duplicated in relation to the best exposure.

Develop Autoscreen film in Kodalith A & B or similar developer.

Using the conventional magenta screen (or gray screen), the following arrangement is used:

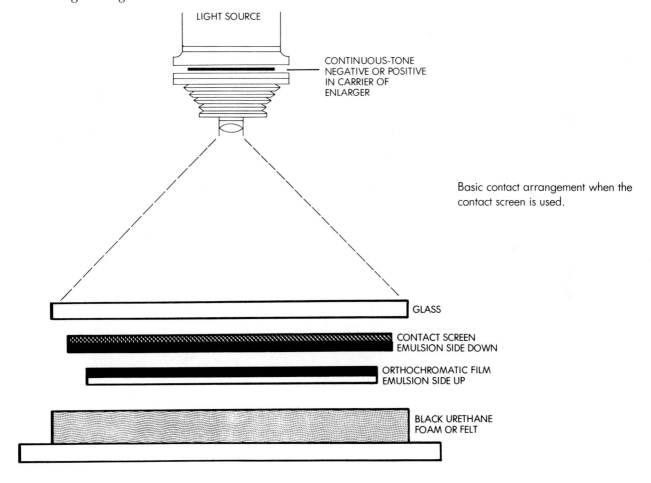

LIGHT SOURCE

CONTINUOUS-TONE
NEGATIVE OR POSITIVE
IN CARRIER OF
ENLARGER

Basic contact arrangement when the contact screen is used.

GLASS

CONTACT SCREEN
EMULSION SIDE DOWN

ORTHOCHROMATIC FILM
EMULSION SIDE UP

BLACK URETHANE
FOAM OR FELT

Good contact between the orthochromatic film and the contact screen is important. A portable vacuum frame provides the best contact. If this is not available, however, a piece of firm black polyurethane foam or black felt and a piece of clean plate glass with the film and contact screen sandwiched between will provide sufficient pressure to make good contact. If the glass is large enough, weights placed at the edges will provide a little extra pressure and help the contact. Note that the orthochromatic film is placed emulsion side (light side) up and the contact screen is placed on top so that its emulsion side faces down.

### SHADOW FLASH

This technique is used to retain detail in shadow areas of the halftone. It effectively extends the gray scale and helps prevent a merging of the dark tones of the image. For this procedure a yellow light (Wratten series 00 safelight, Wratten no. 4 gelatin filter) or similar yellow light is best. The filter should be illuminated with a 7½-watt bulb at least 5 or 6 feet (1½ to 1¾ m) from the film on the camera back. The average exposure is 10 seconds or more at this distance. This exposure should be made after the basic exposure while the film and contact screen are still in position at the camera back.

### HIGHLIGHT FLASH

To extend the tonalities from the middle to the highlight areas another technique is used, often called a bump exposure. After the main screen exposure, the camera back is opened and the contact screen removed carefully, without disturbing the position of the orthochromatic film. The camera back is then closed and a brief exposure given to the copy without the screen. This exposure, calculated at from 5 to 10 percent of the main screen exposure, superimposes light on the already heavily exposed latent negative image, causing the dots to spread slightly to approach the 90 percent level. Less light from the copy falls on the middle and darker tones, so little change takes place there.

## FILM DEVELOPMENT

Development of all films involves three basic steps: developing, fixing, and washing. A weak acidic stop bath is usually used between developing and fixing to stop the action of the developer and prolong the effectiveness of the fixer. Developers contain several different ingredients which affect contrast, grain structure, and resolution. They are always alkaline in nature. When the development time is up, the acidic stop bath neutralizes the alkaline developer, preventing further reaction. In the next bath, the fixer dissolves the unexposed silver and in doing so clears the film, leaving only the black metallic silver of the image.

The following steps are used in the development of all films:

1. Developing
2. Stop bath: acetic acid and water, approximately ½ ounce (15 ml) glacial acetic acid to 1 quart (1 liter), or 1½ ounces (45 ml) 28 percent acetic acid to 1 quart (1 liter)
3. Fixing: basic ingredient—sodium thiosulfate (hypo)
4. Washing in cool running water

The developer is extremely important to the character of the final negative or positive. For development of high-contrast film

such as Kodalith or similar orthochromatic films made by Dupont, Agfa-Gevaert, GAF, or Ilford, a special developer is made in two solutions (A and B) which are mixed in equal parts before use. In most cases these developers are interchangeable and produce the high-contrast results for which the films were designed. Of course, for those willing to experiment beyond the manufacturer's recommendations, many other developers may be substituted to achieve special effects.

## DEVELOPMENT AND CONTRAST

Besides the type of developer used, the manner in which the film is agitated during development helps dictate the contrast and resolution of the result. Orthochromatic films have a normal development time of 2½ to 3 minutes. When the film is agitated continuously for this length of time, contrast will be high. If development for this period takes place without any agitation, the negative will be flat and have poor gradation of tonalities. The ideal is to agitate the film briskly for half the development time and leave it alone for the balance. This is also true of all continuous-tone films and developers.

## UNUSUAL SCREENING PROCEDURES

The conventional halftone screen which produces the familiar, regular pattern of dots is the most widely used screen in the commercial printing industry. In addition, several special screens are available which give the tonal image a variety of textural effects. These range from circular or parallel line screens to screens having a burlap or basketweave pattern. Two companies that make special effects screens are the Beta Screen Corporation and the Caprock Company. A few of the screen patterns made by the Beta Screen Corporation are illustrated here.

Special-effects screens are available in a great variety of patterns as contact screens. Courtesy of Beta Screen Corp., Carlstadt, NJ.

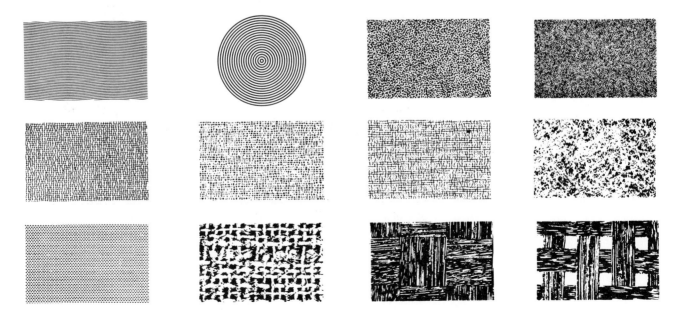

The mezzotint screen has found increasing application in lithography and screen printing and occasionally in commercial gravure printing. This screen has an irregular pattern of dots and tiny curved shapes. Its great advantage in color work is that when each separation is screened, the screen itself does not have to be angled because the irregularity of the screen pattern automatically prevents a moiré from being formed. In screen printing this factor is particularly helpful, as the screen fabric in combination with other regular patterns can create a moiré.

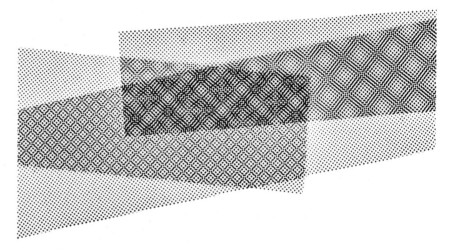

When regular patterns overlap, moiré patterns are formed. These can present a problem in both lithography and screen printing.

The mezzotint screen used for screening continuous-tone images in making posterizations can produce excellent results for both screen printing and lithography. For making photogravure plates for hand printing, the mezzotint screen is excellent; the results are almost identical to those of the rosin aquatint method, yet they are more consistent. Screens for photogravure, because they consist of a hard dot pattern, can easily be duplicated by contacting the mezzotint screen onto a sheet of orthochromatic film, emulsion to emulsion, then exposing and developing.

### NONGLARE GLASS AS A "MEZZOTINT" SCREEN
Light projected through a sheet of nonglare glass emerges from the other side in a fine, irregular light-and-dark pattern. There are two ways in which nonglare glass can be used for this effect: by placing the orthochromatic film, glass, and continuous-tone film positive directly in the vacuum frame and exposing, or by placing the continuous-tone negative or positive in the enlarger and projecting through a piece of nonglare glass onto orthochromatic film. In both cases, good contact between the glass and the film is important; otherwise the result will have a somewhat mottled appearance. If a vacuum frame is not available for either projecting or contacting the image, a reasonably good arrangement can be made with a piece of plate glass with weights placed along the edges to apply pressure to the film and nonglare glass underneath. A piece of black polyurethane foam about ½ to 1 inch (12 to 25 mm) thick or a piece of black felt underneath will

LIGHT SOURCE

Two separate arrangements for using nonglare glass to make halftone images from continuous-tone film. Top: Contact exposure method. Bottom: Enlargement exposure method.

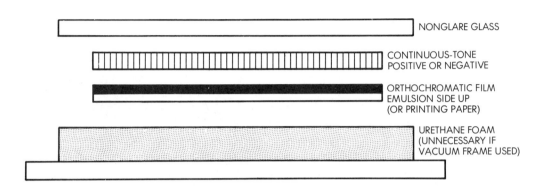

NONGLARE GLASS

CONTINUOUS-TONE
POSITIVE OR NEGATIVE

ORTHOCHROMATIC FILM
EMULSION SIDE UP
(OR PRINTING PAPER)

URETHANE FOAM
(UNNECESSARY IF
VACUUM FRAME USED)

LIGHT SOURCE

CONTINUOUS-TONE
NEGATIVE OR POSITIVE

WEIGHTS FOR
BETTER CONTACT

NONGLARE GLASS

ORTHOCHROMATIC FILM
EMULSION SIDE UP

URETHANE FOAM

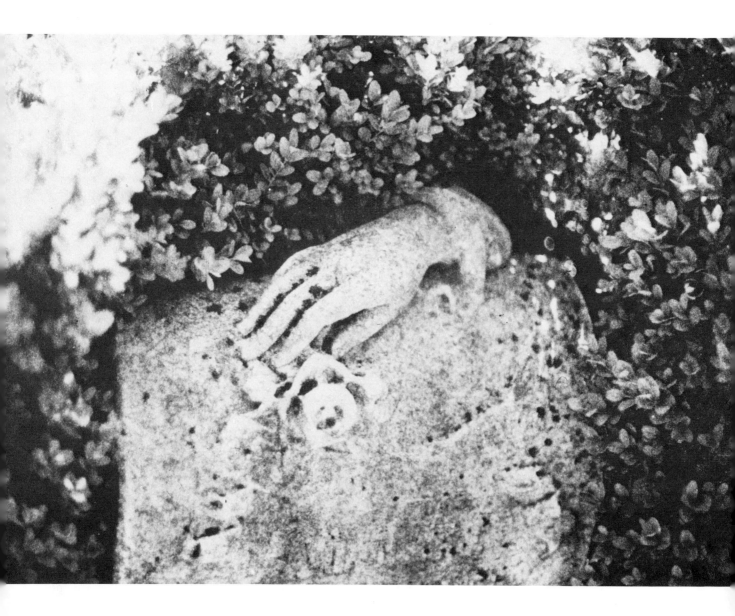

Richard Graf, untitled. Tritone lithograph printed from three plates made from images shot through nonglare glass. Different exposures were made to produce a short, medium, and long tonal range. The darkest plate was used to print the lightest gray and the lightest plate, the darkest tone. Courtesy of the artist.

give an added cushion and help equalize the overall pressure. Nonglare glass, because it is thin, cannot tolerate too much pressure along its edges; however, with smaller sizes of about 8 × 10 or so, this may be done without danger of breakage. In addition to good contact, it is important that the surface of the glass be free of dust and lint. Clean it with a glass cleaner and chamois or other lint-free cloth and then handle it at the edges only. Sharp edges can be rounded with fine emery cloth. No moisture should touch the film, and it should be handled only under proper safelight conditions.

## ENLARGED FILM GRAIN FOR MEZZOTINT EFFECTS

As a rule, the faster the film, the more pronounced the grain. Grain can be further emphasized by special developing and enlarging procedures so that the image has a definite irregular dot pattern similar to that produced by a fine mezzotint screen. The results of enlarging the grain, however, can produce even finer and more subtle gradations. Several films that work well in this technique are Kodak Recording Film 2475 (ASA 1000–3000); Agfa Isopan Record (ASA 400–2000), Kodak Tri-X (ASA 400–800), and Kodak Royal-X Pan (1250–2500). The first ASA number for these films is the one designated by the manufacturer, but by shooting at an even higher speed and prolonging the development time—that is, by underexposing and overdeveloping—you can make the film grain more pronounced. A high-energy developer such as Kodak DK-50 or Rodinal is recommended for work with these high-speed films.

Another factor is the degree of enlargement from the developed film; the greater the enlargement, the more pronounced the grain. By enlarging from 35mm or a portion of that format to 11 × 14, for example, you can make the grain more strongly evident. If the image is projected onto high-contrast orthochromatic film, the grain becomes more sharply defined and the contrast is increased. By contacting orthochromatic film to yet another piece of orthochromatic film and exposing and developing, the effect can be increased still further.

Enlarging for enhanced grain is impossible with the diffusion enlarger. A condenser enlarger fitted with a point-source illumination system gives the sharpest possible resolution of the grain and allows it to be projected to mural size if necessary with absolute clarity. Point-source systems often employ a quartz bromine lamp that is adjustable vertically for optimum uniformity of light over the entire film area.

## CONTINUOUS-TONE FILM ENLARGEMENTS

For photogravure and other processes, a fine-grain, continuous-tone image is necessary. The original negative that is to be used for this purpose should be fine-grained and developed with a solution that gives the best rendition of tonal values and minimizes grain structure. Films such as Kodak Panatomic-X,

Plus-X, Adox KB-14, and other fine-grain films, when processed with a fine-grain developer, allow enlargements with smooth transitory values and no visible grain. For moderate enlargements even a fast film like Tri-X, if developed with a fine-grain developer, produces a good range of values without the grain's becoming too objectionable. Of course, much depends on the format of the camera initially used. It is assumed that most of us will be shooting with 35mm, 2¼, or perhaps 4-×-5 and not 8-×-10 or 11-×-14 cameras. The smaller the negative you start with, the more critical the quality. Some excellent fine-grain developers are Kodak Microdol-X, Edwal Super 20, Edwal Minicol 2, FR X-22, Rodinal, and Ethol TEC.

For making continuous-tone enlargements, the negative is projected onto another, larger sheet of continuous-tone film. Two of the most versatile for this purpose are Kodak Commercial Film 4127 (thick base) and Cronar Gravure Commercial Film (Dupont). These may be ordered in sheet sizes from 4 × 5 to 30 × 40, and in rolls from 30 to 40 inches (76 to 102 cm) wide and 100 feet (30½ m) in length. Both films are blue-sensitive, so they may be handled under red safelight conditions (Kodak Safelight Filter No. 1 Red). They have excellent resolution, fine grain, and a wide tonal range, and the film surface can be retouched with dyes or pencils. Because of the current high cost of silver, large sheets of film are quite expensive, so it makes good economic sense to experiment on small test pieces first. Because these films are very slow compared with Tri-X or Plus-X, they afford considerable latitude in both exposure and developing times, and therefore greater control over image quality. In addition, the film can be monitored visually during development under red safelight.

## CONTINUOUS-TONE FILM CHARACTERISTICS

| Continuous-tone film | Characteristics | Developer | Development time |
|---|---|---|---|
| Kodak Commercial Film 4127 | Blue-sensitive medium projection speed for making continuous-tone positives for photogravure or other work. Can be retouched. | Kodak DK-50 | 3 minutes |
| | | HC-110 (dilution C) | 3 minutes |
| | | D-11 (for higher contrast, development time is increased) | 3—8 minutes |
| Dupont Cronar Gravure Commercial Film | Blue-sensitive medium projection speed film. Fine grain for photogravure positives or other applications. Both surfaces can be retouched. | Dupont Cronatone Continuous-Tone Developer (A & B) | 3—3½ minutes |

The usual procedure for enlarging onto these films is to place the camera negative in the enlarger so that the emulsion faces down, away from the light source, and projects onto the larger sheet of film, placed emulsion side up, facing the lens. This makes a film positive that will read correctly when the emulsion side faces the viewer. For photogravure, the film positive should read correctly when facing *away* from the viewer. The negative may therefore be placed in the projector with the emulsion side toward the light source. If a continuous-tone negative is needed rather than a positive for the final enlargement, the initial negative can

be contacted onto a piece of the continuous-tone commercial film and developed. This positive is then placed in the enlarger to make the larger negative.

## MEASUREMENT OF FILM DENSITY

The most accurate means of measuring the density of a film negative or positive is with a densitometer. This device measures the transmission of light through any selected portion of the film, scaled in terms of density units from 0.00 to 3.00 or higher. A density of 0.00 represents a completely transparent area; a density of 3.00 is almost opaque.

Density values are calibrated to a logarithmic scale in order to keep the numbers low and readily comparable. The density numbers are the logarithm of the ratio of the percentage of the incident light that is transmitted through the negative. An area with a density rating of 0.30, for example, transmits twice as much light as a 0.60 area, or five times as much as an area with a density reading of 1.00. The accompanying table gives the percentage of light transmission relative to densitometer readings.

| Density | Percent of light transmission |
| --- | --- |
| 0.0 | 100 |
| 0.3 | 50 |
| 0.6 | 25 |
| 1.0 | 10 |
| 2.0 | 1 |
| 3.0 | 0.1 |

Because the densitometer is an expensive tool for only occasional use in the small shop, a commercial calibrated gray-scale film strip can be used as a simple comparison densitometer for approximate values. When using the gray-scale film strip, both the positive and the film strip should be placed over a light table with uniformly diffused illumination.

Several gray scales are available for this comparison testing. The Kodak No. 2 Step Gray Scale has twenty-one steps, step 1 being almost completely clear and having a density of 0.05, and step 21 having a density of 3.05. Steps on the scale are in density increments of 0.15. The Graphic Arts Technical Foundation Sensitivity Guide and the Stouffer twenty-one-step sensitivity guide are similar to the Kodak No. 2 Gray Scale. The density of the numbered scale is as follows:

| Step no. | 1 | 2 | 3 | 4 | 5 | 6 | 7 | 8 | 9 | 10 | 11 | 12 | 13 | 14 | 15 | 16 | 17 | 18 | 19 | 20 | 21 |
| --- | --- | --- | --- | --- | --- | --- | --- | --- | --- | --- | --- | --- | --- | --- | --- | --- | --- | --- | --- | --- | --- |
| Density | 0.05 | 0.20 | 0.35 | 0.50 | 0.65 | 0.80 | 0.95 | 1.10 | 1.25 | 1.40 | 1.55 | 1.70 | 1.85 | 2.0 | 2.15 | 2.30 | 2.45 | 2.60 | 2.75 | 2.90 | 3.05 |

CLEAR                                    INCREASING OPACITY

In addition, Kodak makes a fourteen-step density scale (Kodak Control Scale T-14). The steps range from a density of 0.04 (step 1) to a density of 2.05 (step 14), with each step increasing in

density by 0.15. Dupont also makes a useful Transmission Gray Scale with thirty steps of 0.10 density increments.

The density of the continuous-tone positive used for photogravure is critical. The range of tones when measured on a densitometer should be between 0.3 and 0.4 for the highlight areas and between 1.7 and 1.8 in the darkest parts of the image. This range corresponds to the range of the sensitized carbon tissue and is important to the process. When the carbon tissue is used for line work, however, the minimum density for the blacks should be about 1.6 or greater.

Diane Hunt, *Slice Thrice* (detail). Photolithograph hand-printed from two negative wipe-on plates. The photographic negatives used for making the plates were made by shooting through nonglare glass. Courtesy of the artist.

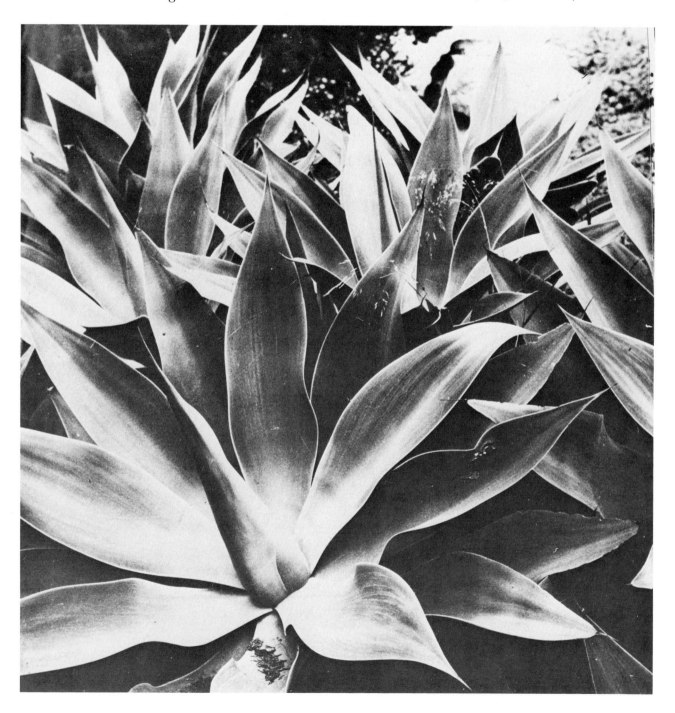

# CHAPTER THREE

# PHOTOLITHOGRAPHIC TECHNIQUES

Most lithographic processes today use grained aluminum plates for the printing surface instead of limestone. Graining the aluminum gives the surface of the plate "tooth," which improves its ability to retain water as well as photo emulsion.

The thickness of the aluminum generally increases with the size of the plate and varies from 0.008 inch to 0.020 inch (0.2 to 0.5 mm). For printing by hand, plates that have a thickness of 0.012 to 0.015 inch (0.3 to 0.38 mm) are sufficiently rigid to withstand the heavy pressure and generally rough treatment to which they are subjected. For offset printing, however, a thickness of 0.008 inch (0.2 mm) provides a sufficiently stable base for long press runs, even though the thinner metal is vulnerable to kinks and creases from careless handling.

Two types of photographic plates are readily available to artists: presensitized plates, which constitute the lion's share of those used in the commercial lithographic industry because of their convenience and standardization; and wipe-on plates, which are sensitized by hand with chemicals "wiped on" the plate.

The chemicals currently available for wipe-on plates are negative-working, which means a negative image on film is needed to produce a positive printing plate. With presensitized positive plates, a positive image is used to make the positive printing plate. This positive may be produced photographically as a line or halftone, or by drawing directly onto a translucent material such as frosted Mylar or acetate.

Because a variety of companies produce a vast array of presensitized plates, both positive and negative, only some of the most commonly available types will be discussed. Those which I feel have the greatest flexibility and potential for creative use will be described in step-by-step procedures. In general, these procedures are basic and can be applied to other brands. It is important, however, to take into consideration the fact that each manufacturer provides specific chemicals for its plates that may not be compatible with other brands.

All the photolithographic plates discussed in this chapter are surface plates that print from a planographic or flat surface. These plates, in addition to being presensitized or wipe-on, positive- or negative-working, may also be classified as subtractive or additive. Wipe-on plates as well as many presensitized diazo-based plates are considered additive plates because lacquer is added to the image areas in the development phase to form the printing base. Subtractive plates have a light-sensitive coating which remains in its entirety after exposure. It becomes the printing base in the image areas while the developer removes the nonprinting areas. Development is always followed by the application of a plate finisher. This desensitizes and protects the nonprinting areas with a thin film of gum while simultaneously increasing the affinity of the image areas to ink.

It is important to understand the chemical nature of lithography and the two elements that form the basis of the process. These two elements consist of the image areas which hold ink and repel water (called oleophilic), and the nonimage areas which hold a thin film of water and reject the greasy printing ink (called hydrophilic).

There are various ways to produce the image areas on the plate. Three of the most common are described below.

1. A light-sensitive emulsion made with diazo rosin, a derivative of coal tar, is used. This diazo emulsion is water-soluble except when exposed to an ultraviolet light source—then it becomes insoluble. Because the diazo coating alone is not sufficiently ink-receptive or wear-resistant, a lacquer that adheres to the light-hardened diazo must be added.

2. An even more durable photo emulsion can be made with either a photopolymer or a photomonomer. These photosensitive plastics form an extremely hard coating which is soluble in an organic solvent before exposure but, once exposed, becomes insoluble.

3. On presensitized positive plates, such as Enco P-30, P-150, and Polychrome Positive plates, ultraviolet light changes the molecular linking system of the emulsion, allowing the exposed areas to dissolve in a weak alkaline solution made with sodium hydroxide and water.

Once the photographic plate has been processed and the photo emulsion has been removed, the exposed nonimage areas must be treated with an acidified gum solution. This is usually the last solution applied to the plate before the actual printing begins. When the gum solution is correctly acidified, it is adsorbed by the aluminum on all nonimage areas. This allows water to be held in an unbroken film and prevents the greasy ink from the printing rollers to adhere to the plate. The gum molecules adhere best to the aluminum when the plate has been acidified to a pH of 2.7 to 3. If the pH is more than 4.5, the acidity will be too low for the gum to adhere well to the plate. If the pH is 2 or lower, the acidity

will be too high, causing the metal to oxidize. Although all manufacturers of presensitized and wipe-on plates have their own gum-etch solutions, a basic gum etch suitable for most plates (with the exception of anodized plates) can be made as follows:

Gum arabic (14° Baumé)     32 ounces (946 ml)
Phosphoric acid (85 percent)   1 ounce (29.6 ml)

Because the free acid in this solution attacks the oxide layer on an anodized plate, a gum solution having a pH of 4.5 is sufficient to desensitize the surface.

During the course of printing, a fountain solution is usually added to the dampening water. This helps the solution keep the nonprinting areas clear of ink and replenishes gum on the surface of the plate lost by wear in the normal course of printing. The fountain solution consists of gum and acid and is most effective when the combined pH of the solution is between 4.5 and 6. Concentrated preparations for making fountain solutions are available commercially. These contain, in addition to gum and phosphoric acid, a nitrate salt.

## PRESENSITIZED PLATES—NEGATIVE-WORKING

Presensitized negative-working plates are the most commonly used types in the commercial lithographic industry. This is because the film negative used to make them can readily be made in the camera, often in one step, and also because the negative can be retouched and corrected quickly.

### MATERIALS AND EQUIPMENT

A vacuum frame and a good-quality light source are essential for sharp professional photographic plates. Arc, mercury vapor, or pulsed xenon lamps are ideal light sources with the requisite high ultraviolet output. You should also have access to a sink with a hose attachment to a faucet, and table space nearby for developing and finishing the plates. The following supplies are needed for processing the plates:

Sponges (fine-pore cellulose)

Cotton wipes, paper towels, Kimwipes, or other soft absorbent wiping material, preferably lint-free

Rubber plate squeegee

Spring hand clamps with plastic end covers for clamping plates to a tabletop

Sheets of clean newsprint, blotters, or other absorbent paper for placing under the plate during processing

Enco N-50 pad for subtractive plates

Enco Subtractive Developer

Enco FPC (Finisher, Preserver, Cleaner)

## PROCESSING ENCO N-50, NEGATIVE-WORKING SUBTRACTIVE PLATES

To get an even exposure on the plate, I recommend using a vacuum frame and a light source high in ultraviolet output. Enco N-50 plates are sensitized on both sides. If only one side is to be used, the opposite side should be given a brief overall exposure to prevent the coating from breaking up while the plate is on the press.

To determine the correct exposure with the light source you are using, first make a test by cutting a small piece of the presensitized plate from a whole sheet; this sheet may be kept strictly for testing. Place the strip of plate in the vacuum frame in contact with a Stouffer twenty-one-step sensitivity guide (see page 60) so that the emulsion of the plate and the emulsion of the strip of film are in contact with each other. After exposure, process the piece of plate with the developer. Ideal exposure results when steps 1 to 6 appear solid. If step 6 is a tone rather than a solid, increase the exposure; if step 7 or higher is solid, decrease the exposure.

A change in the color of the plate takes place during exposure. Unexposed, the plate is a light green. Areas exposed to light become a pale blue color.

*Step 1.* Immediately after exposure, place the plate on a flat surface of heavy plastic or Formica so that it extends into the sink. A little water underneath the plate will create suction and keep it from sliding. The work area should be well ventilated, because the developer contains a volatile organic solvent. Avoid open flames and sparks. Using plastic or rubber gloves, pour some subtractive developer onto the Enco pad or a wad of cotton.

*Step 2.* With firm pressure on the pad and a circular motion, rub the plate until only the image areas remain. Examine the image closely, with a magnifying glass if necessary, and rub with more developer until all lines or halftones are completely clear and open.

*Step 3.* Rinse the plate with water and squeegee the plate surface to remove particles of coating and used developer. Squeegee the back of the plate as well.

*Step 4.* Remove the plate from the sink and blot excess water from the front and back with a slightly damp sponge. Place blotters, newsprint, or other absorbent paper under the plate and clamp it to a flat table. Pour some Enco FPC on a slightly damp sponge and spread it evenly over the surface, using light pressure.

*Step 5.* Buff the plate finisher down until it is almost dry with clean, dry paper towels, cotton wipes, Kimwipes, or cheesecloth. The plate may be printed immediately or stored for printing at a later date.

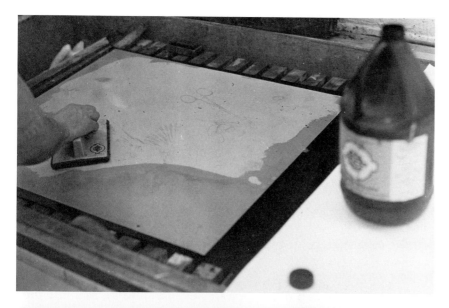

Step 2. Subtractive developer is rubbed on the plate.

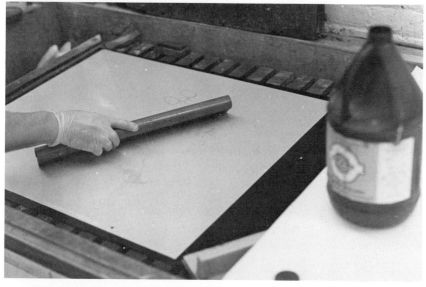

Step 3. The plate is rinsed and squeegeed to remove coating particles and used developer.

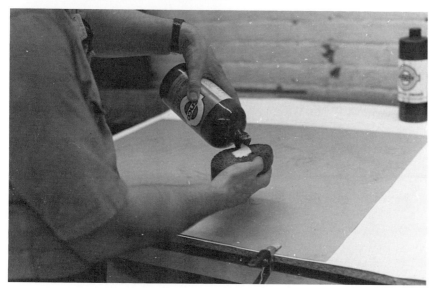

Step 4. Enco FPC is spread over the plate.

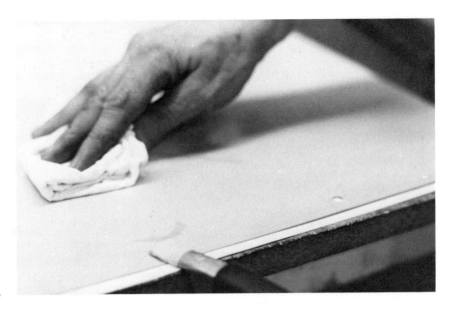

Step 5. The plate finisher is buffed down.

## NOTES ON PRINTING

For printing, the plate need only be dampened with water or fountain solution and inked. Deletions to the plate can be made with snake slip or powdered pumice or with Enco 3R Liquid Image Remover. Afterward, apply a little FPC to the area and buff down.

To store the plate for future printing, remove as much ink from the image as possible by sheeting. (Sheeting is a procedure whereby blank sheets of paper are run through the press without any inking of the plate. This removes excess ink from the plate evenly and facilitates washout and storage procedures.) Then apply some FPC to a slightly damp sponge and rub it lightly over the entire plate. This removes any ink remaining on the image and conditions both negative and positive areas. Buff down while the plate is still wet.

## PRESENSITIZED PLATES—POSITIVE-WORKING

Positive-working plates are the opposite of negative-working plates: a positive image, either on film or drawn by hand, reproduces a positive image on the plate. Light hitting the plate alters the structure of the sensitized coating and instead of hardening it, as on negative plates, allows it to be dissolved with the developer. The parts of the coated plate underneath the positive film image do not receive light and remain unchanged, thus becoming the printing areas.

Because these plates can produce a considerable degree of continuous-tone gradation, they are especially valuable for work with crayon, pencil, or tusche wash drawings on frosted Mylar or similar materials. Although this continuous-tone method of printing with positive plates is not practical for long-run commer-

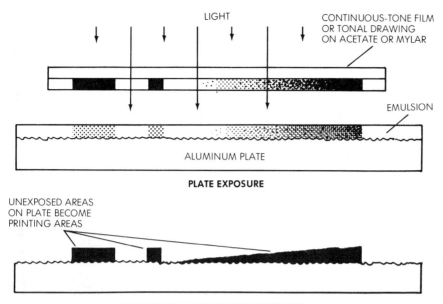

LIGHT

CONTINUOUS-TONE FILM
OR TONAL DRAWING
ON ACETATE OR MYLAR

EMULSION

ALUMINUM PLATE

**PLATE EXPOSURE**

UNEXPOSED AREAS
ON PLATE BECOME
PRINTING AREAS

**DEVELOPMENT** (GREATLY EXAGGERATED)

Extended exposure reduces the printing
area and shifts the tonal range toward
the dark areas.

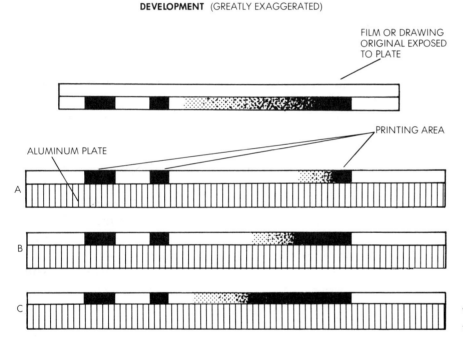

FILM OR DRAWING
ORIGINAL EXPOSED
TO PLATE

PRINTING AREA

ALUMINUM PLATE

A

B

C

With less exposure the shift takes place
toward the lighter areas.

cial printing because of its limited life span on the press, the use
of positive plates for limited-edition printing has proved to be of
immense value to the artist. When printed on an offset press,
editions of 300 or 400 are possible, depending on the tonal range.
As the plate begins to wear, the lightest, most delicate tones
disappear first because they represent the thinnest part of the
positive emulsion left on the plate.

One important consideration with positive plates is that the
image remains sensitive to light after development and must be
protected with lightproof paper from daylight, fluorescent light,
and other strong light sources. Even during printing, care must be
taken to avoid exposing an open plate to excess light; otherwise
the image will gradually deteriorate.

## MATERIALS AND EQUIPMENT

Access to a sink and good counter space are necessary; you will also need a good supply of sponges, clean wiping cloths, either paper or cotton, a plate squeegee, clamps, and clean newsprint or blotters. For Enco Positive plates (P-30 or P-150), described in the following step-by-step procedure, these supplies will also be needed:

Enco Positive Developer

Enco Positive Finisher

Enco FPC (Finisher, Developer, Cleaner)

Soft developing pad or roll of soft cotton

Enco P-30 or P-150 positive-working plates

## PROCESSING ENCO POSITIVE PLATES (P-30, P-150)

The same chemicals and procedures are used with either of these plates. P-150 plates, designed for longer runs, have a heavier coating. Although both plates can be used for hand printing, the greater resistance of the P-150 plate makes it considerably more durable for this purpose, especially for editions of 100 or more impressions. For offset printing, however, the P-30 plate with normal line or halftone images is good for 30,000 impressions and the P-150 for over 150,000—certainly a sufficient number for a limited edition.

The light sensitivity of these plates is greater than that of most negative plates; for this reason they should be protected from fluorescent light, daylight, and other bright light sources while being handled except for brief periods. The same guidelines for exposure apply as for other types of plates. A test series of exposures should be made with the Stouffer twenty-one-step sensitivity guide. A small (4-×-6) plate is provided with each box of twenty-five plates for this purpose. For normal halftone or line work, the manufacturer recommends that after development, step 2 should not be visible but step 3 should show. When you use these plates for continuous-tone work, especially with hand-drawn positives, you must make tests with whatever material is being used rather than with the sensitivity guide.

*Step 1.* After exposure, place the plate in the processing sink on a smooth, flat, heavy piece of plastic, Formica, or similar material. A little water underneath will create suction and keep the plate from sliding. Clamping the plate next to the sink on the countertop with some newsprint underneath is also good. Wearing rubber or plastic gloves, pour some Enco Positive Developer onto a clean plate swab or wad of cotton. This solution contains a weak mixture of ammonium hydroxide and water which produces no fumes or odor. Develop the plate by moving the swab back and forth over the surface until all nonimage areas are completely clear. Rinse with clean water. Repeat, adding more developer if necessary.

A light tone that remains visible on the plate in areas that

should be perfectly clear indicates that the plate was under-exposed. If a pin-registration system was used, which ensures accurate placement of the Mylar or film positive on the plate, the same plate can be rinsed, dried, then reexposed and redeveloped.

*Step 2.* Apply a quantity of Enco Plate Finisher on another clean swab or wad of cotton and rub it lightly over the entire surface. This contains a mild acid solution which neutralizes any alkali left from the developer. Rinse with clean water, then squeegee both sides of the plate of excess water.

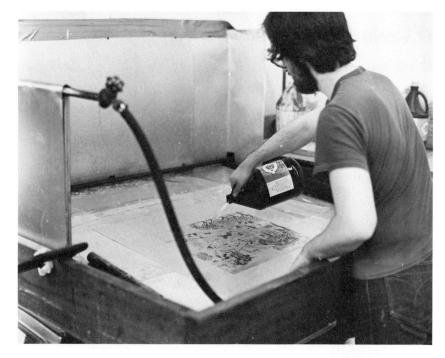

Step 1. After the positive image is developed, more developer can be used to further clean the nonprinting areas of the plate.

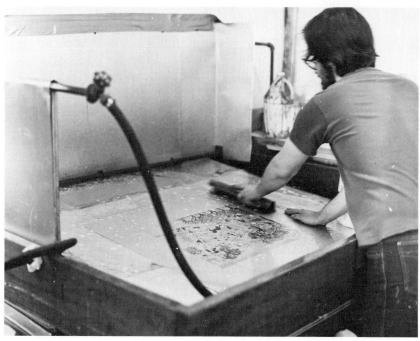

Step 2. The plate finisher is squeegeed from the plate after rinsing.

*Step 3.* Place the plate on a flat table or countertop on which you have placed several sheets of newsprint or other absorbent paper. Pour some Enco FPC (Finisher, Preserver, Cleaner) onto a clean, slightly damp cellulose sponge and rub with light but firm pressure over the entire surface of the plate.

*Step 4.* Immediately buff the FPC down thoroughly with a clean paper towel, Kimwipe, or cheesecloth while still wet. Any heavy deposits of FPC left on the plate will dissolve parts of the image underneath, so you must be careful to buff evenly. The plate can be printed immediately or stored for later use. It is important to keep the surface of all positive plates protected from light even after they have been developed. Cover each plate with a sheet of opaque paper and place it in a lightproof box after it has been processed and also after it has been printed if it is to be reused at a future date.

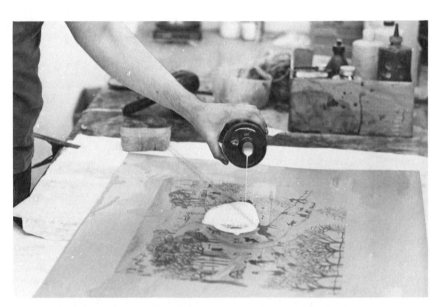

Step 3. Some Enco FPC is poured onto the plate or on a cellulose sponge and rubbed over the entire plate.

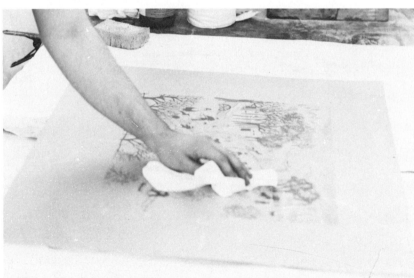

Step 4. The plate finisher is buffed down to a thin, even layer. The image must be protected from light until it is ready to be printed.

The most common type of wipe-on plate chemicals in use today are negative-working and use a diazo rosin compound for the light-sensitive coating. Many companies make chemicals for wipe-on platemaking, each having its own brand name. The procedure outlined for Western wipe-on chemicals, however, is basic and can be used as a guide for processing other wipe-on products.

The aluminum used for wipe-on platemaking has a coating of silicon phosphate or titanium phosphate on the grained surface. This subcoating is necessary to prevent a chemical reaction between the diazo sensitizer and the aluminum. If the aluminum plate does not have this subcoating, or if the coating has been removed by counter-etching, development will be irregular and incomplete.

After the sensitized plate is exposed, a pigmented lacquer-and-gum emulsion is used to develop the image. This dissolves the unexposed areas of the coating and deposits lacquer onto the light-hardened image areas. The surface is then treated with a gum-etch-asphaltum emulsion or gum-etch-lanolin emulsion, which desensitizes the nonimage areas of the plate and deposits an ink-receptive layer of asphaltum on the lacquer.

The chemicals for the positive wipe-on process described in this section are not packaged commercially as such, but the individual ingredients are readily available. The coating is a bichromatized gum arabic solution which is applied to a counter-etched plate and dried. After its exposure to the positive, the plate is developed with a saline solution which dissolves the unexposed image areas and leaves a gum stencil over the rest of the plate. After the plate has dried, a nonblinding lacquer is applied to the plate. (Non-blinding lacquer is one that remains ink-receptive and does not allow water to be held on its surface. When an image on the plate begins to hold water, it does not print and in printing terminology has "gone blind.") This attaches itself to the aluminum in the image areas where the gum has been removed but sits on top of the gum in all other areas. After a thin asphaltum layer is applied over the lacquer, the plate is washed with warm water and a cotton swab which removes the gum, leaving only the lacquered image area. Next, the plate is etched and is then ready for printing.

## MATERIALS AND EQUIPMENT

Ball-grained plate prepared for the wipe-on process (aluminum)

Western Diaz-a-Kote sensitizer (this is in two parts—a liquid and the diazo rosin powder—which should be mixed together at least an hour before use to allow any air bubbles to settle out. A Hi-Concentrate coating is available with extra diazo rosin for use with very coarsely grained plates.)

PN Red Developer (also available in black)

AGE (asphaltum-gum-etch)

Three clean fine-pore cellulose sponges

Paper towels, Kimwipes, or cheesecloth

## PROCESSING WESTERN NEGATIVE WIPE-ON PLATES

*Step 1.* First clamp the plate to the processing table. Next, pour some sensitizer solution onto the center of the plate, then spread it with a clean, damp, fine-pore cellulose sponge which has been wrung of all excess water. Spread the solution both horizontally and vertically in a thin, even layer. Fan-dry the plate. This step should be done only under very subdued lighting or under yellow safelight conditions. Expose the plate.

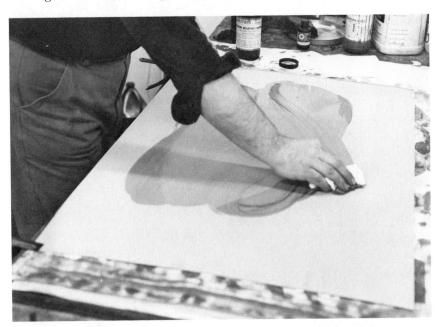

Step 1. Sensitizer solution is spread over the plate with a sponge.

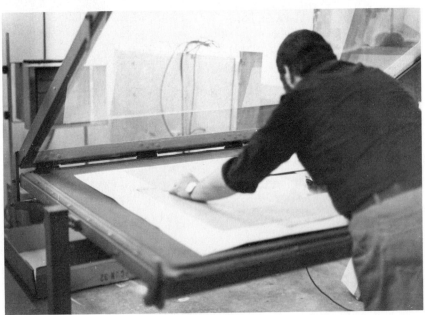

Step 1. The negative is placed in contact with the plate surface.

*Step 2.* To develop the plate immediately after exposure, place it
on the processing table and clamp it down to hold it firmly in
place. Pour some developer onto the center of the plate and with a
clean, slightly damp cellulose sponge spread the developer over
the image, using firm, even pressure, until all parts of the image
are clearly defined. (The developer is an emulsion made up of
pigment and lacquer, an organic solvent, gum arabic, and water.)
Next, rinse the developer from the plate in the sink with running
water. Squeegee the plate and let it dry.

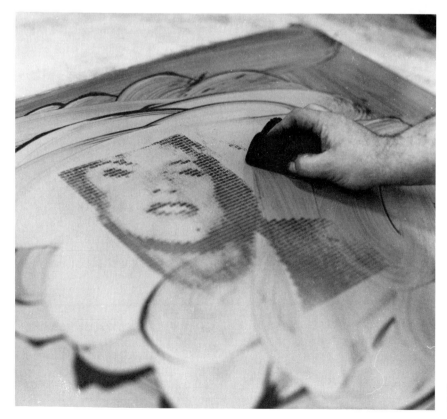

Step 2. The plate is developed with
lacquer developer.

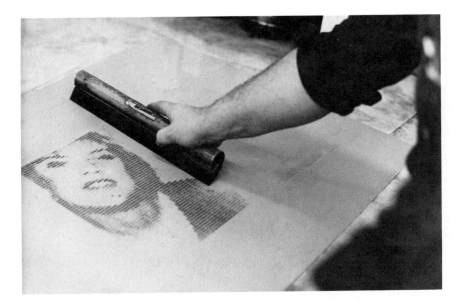

Step 2. The plate is squeegeed and allowed to dry.

*Step 3.* Place the plate back on the developing table and clamp it firmly in place. Pour some AGE (asphaltum-gum-etch) onto the plate and with another clean, slightly damp sponge, rub over the entire surface with firm pressure.

Step 3. Some AGE (asphaltum-gum-etch) is poured onto the plate.

Step 3. The AGE is rubbed over the entire plate with a damp sponge.

*Step 4.* While the AGE is still wet, buff it down with a cloth or paper wipe to a thin, even layer and fan-dry it. The plate may be printed immediately or stored in this state indefinitely.

Step 4. The AGE is buffed down.

*Notes on Printing.* For printing, dampen the plate with water and ink it immediately. Additions to the plate can be made with Enco plate tusche. For removing small areas from the plate, use a plate hone or some powdered pumice and a little water. Afterward, add a little FPC to the area and buff it down.

## HAND-DRAWN POSITIVE IMAGES

In recent years there has been a considerable increase in the use of positive-working platemaking techniques for printing limited editions. Because these procedures produce a positive printing plate from a positive image, the artist can make his or her own positive image by drawing directly on a translucent material, then exposing this onto a plate. This process does away with the need for photographic reproduction of the drawing. It not only saves time; it also preserves optimum image quality. This approach has proved to be extremely popular with artists and is employed in many workshops, often in combination with halftone or line photographic work, for the creation of limited editions of prints.

Working on a translucent material has proved for many artists to be both expedient and simpler than working directly on a stretched screen or grained lithographic plate, often allowing them greater control over their drawing. Drawings and color separations done by hand in this manner, when combined with a pin-registration system, provide the most accurate means of ensuring close registration. In lithography, for example, a special punch is used to punch holes into both the aluminum plate and each overlay sheet. Pins are inserted through the holes in the plate, and the holes in the overlay sheets are placed on the pins.

A multiple-hole punch makes register pin holes in both plates and overlay sheets.

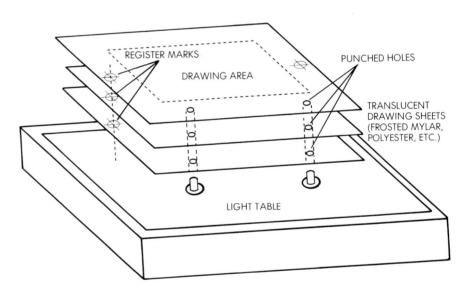

REGISTER MARKS

DRAWING AREA

PUNCHED HOLES

TRANSLUCENT DRAWING SHEETS (FROSTED MYLAR, POLYESTER, ETC.)

LIGHT TABLE

Negative or positive film or a drawing on translucent material is registered to the plate with the use of special pins.

With each overlay sheet held to the plate by the pins, the plate is placed in the vacuum frame and exposed. The placement of each registered sheet on each plate will be identical.

In judging the optimum exposure time when using Mylar or any other material, two considerations are important: the thickness of the material and the combined thickness if more than one sheet is used. If, for example, a sheet of 0.003-inch (0.08-mm) Mylar is used to make a test exposure, an increase in exposure time of approximately 15 to 20 percent will be needed with 0.004-inch (0.1-mm) Mylar.

In order to pick up most of the details from a drawing on Mylar or vellum, the drawing side should be placed next to the sensitized

plate or screen surface for exposure. If the drawing side is considered the "emulsion" side, the rule for obtaining maximum detail and sharpness applies to handmade positives as well as photographic film—that is, "emulsion to emulsion."

Because "emulsion to emulsion" exposures are not always possible (or necessary if the positive is made up of large solid areas), the type of light source used for making the exposure will also determine the degree of image clarity and sharpness. A point light source, such as single carbon arc, pulsed xenon, or mercury vapor light, produces sharper detail than a more diffused light source, such as a unit made with a series of fluorescent fixtures. A good vacuum frame is also essential.

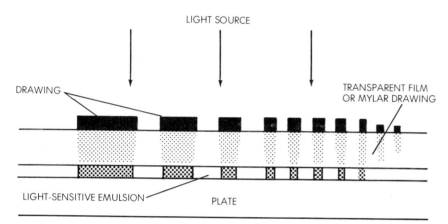

Light diffusion through the thickness of the film or translucent drawing sheet undercuts the image when it is not placed "emulsion to emulsion."

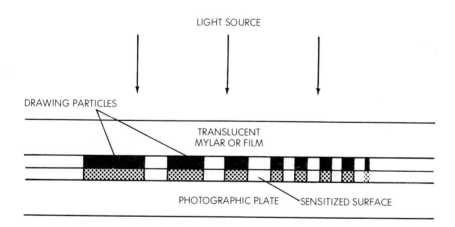

Greater fidelity and image clarity are possible when the drawing or emulsion side of the film is placed directly in contact with the sensitized plate surface.

## DRAWING SURFACES

*Mylar.* This polyester material is one of the best for all-around use. It is dimensionally stable, is unaffected by moisture and most solvents, and allows good transmission of ultraviolet light. Available in different thicknesses and surface grains, it can take a variety of drawing materials, including pencils, crayons, and India ink. The most common and practical thicknesses are 0.003 and 0.004 inch (0.08 and 0.12 mm). Because of the extreme toughness of Mylar, these weights can be used for large as well as small drawings. Although some types of Mylar are available with a

"tooth" on both sides of the sheet, those with the grained drawing surface on only one side provide less diffusion of light during exposure and result in sharper image transmission. Although Mylar with a finer tooth is more suitable for fine pen-and-ink work than coarser surfaces, two different-textured sheets can be laid one on top of the other and exposed together to obtain the combined merits of each.

*Acetate.* There are two main types of transparent acetate material suitable for making hand-drawn positive images: cellulose acetate and polyvinyl acetate. Cellulose acetate is commonly available in art supply stores in rolls and sheets and is usually referred to simply as acetate. The most common thicknesses are 0.003 and 0.005 inch (0.08 to 0.13 mm), either clear or frosted on one or both sides.

*Cellulose Acetate.* This plastic material is not as strong or as dimensionally stable as Mylar. It is affected by humidity, expanding slightly on humid days and contracting slightly on drier days. For large drawings that require several color overlay sheets, Mylar is recommended. Acetate, however, affords excellent light transmission and can be used for all single-color work. Special noncrawling India ink is available for solid brushwork or tusche effects. Matte acetate that is frosted on one side is the most practical to use. A thickness of 0.003 to 0.005 inch (0.08 to 0.13 mm) has sufficient body that it can be handled easily and will lie flat without wrinkling. Acetate that is completely clear is sometimes used for making line images in pen and ink because it allows excellent light transmission and requires slightly less exposure than a frosted sheet. Acetate in general has the advantage of being less expensive than Mylar.

*Polyvinyl Acetate.* This material (available from the Direct Reproduction Corporation, 835 Union Street, Brooklyn, New York) comes in a variety of sizes, weights, and surface finishes. It is similar to Dupont's Mylar in its dimensional stability, clarity, and strength and is excellent for use with any of the techniques outlined in this chapter. Dyrite Dry-Brush No. 111 material is an ideal all-purpose finish which has a slightly more granular "tooth" than Mylar or frosted acetate. As a result, it gives excellent rendition of crayon tones and good separation of values when used with wash techniques. Dyrite Dry-Brush Nos. XIX and XXII have a very coarse texture but also work well with both crayon and wash techniques.

*Translucent Vellum.* Some better grades of tracing paper are often referred to as vellum. Vellum has more transparency than other types of tracing papers and is available in different weights. Its main advantage, besides its lower cost, is that the texture of its surface is unlike that of either Mylar or acetate. Because vellum is a translucent paper rather than plastic, the drawing surface has a "tooth" which is ideal for both pencil and crayon renderings.

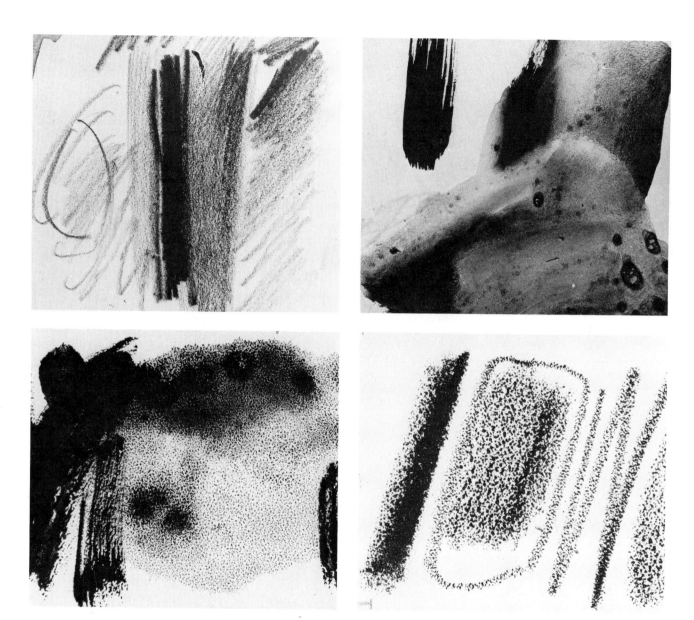

Effects of some drawing materials. Clockwise from left: Stabilo pencil drawing on Dyrite no. 111, a fine- to medium-textured plastic; wash and dry-brush textures on coarse-grained plastic (Dyrite Dry-Brush no. XIX); Stabilo pencil drawing on frosted acetate; wash and dry-brush effects on Dyrite no. 111; crayon drawing on coarse-grained Dyrite no. XIX.

When using a drawing on vellum for exposure, it is important always to place the drawing side in contact with the sensitized surface on which it is to be exposed. Otherwise, detail will be lost by the diffusion of light through the vellum. India ink or wash techniques should not be used on vellum in large areas because it wrinkles.

## DRAWING MATERIALS

For drawing on Mylar, acetate, or vellum, unlimited kinds of materials can be used; the only requirement is that they have a degree of opacity and prevent the transmission of light. Some of the best pencils for this use are Stabilo nos. 8046 and 8008, Prismacolor, china markers, lithographic crayons and pencils (harder grades, nos. 3, 4, and 5), and ordinary graphite pencils.

To produce wash effects or solid areas, either India ink or photo-opaquing solution may be used. If crawling occurs and the diluted solution does not adhere to the plastic surface, add a drop or two of liquid detergent or stroke the brush a few times on a piece of soap. A few drops of Kodak Photo-Flo solution (ethylene glycol) will also break the surface tension and prevent beading. Fingerprints often prevent good adhesion of the solution, but any of these remedies will correct this condition.

Airbrush techniques can be used effectively for graduated tonalities, overall tones, or special effects. Any liquid solution that works well in an airbrush and has a degree of opacity can be used on Mylar, acetate, or vellum. Keep in mind that red, brown, or orange solutions block ultraviolet light transmission and work as effectively as black.

Whatever material is used for drawing, a light table for making the drawing or for checking the tonalities is important. A

An artist making color separations by hand on overlay sheets. Note the pin at the top of the sheets which holds the multiple overlays in position.

completed drawing placed on a sheet of opaque white paper appears deceptively darker because of the shadowing effect of the image on the paper. If the drawing is placed on a light table or held up against the light, however, the tonalities are more indicative of how the drawing will translate upon exposure.

## NOTES ON PRINTING
## PHOTOLITHOGRAPHIC PLATES

One of the first considerations regarding photographic plates is whether printing is to be done by hand or on an offset press. For offset printing, the size of the plate and the exact placement of the image must be coordinated with the offset pressman. The type of paper must also be considered, so that the size of margins and the printing qualities of the paper relate to the image. The printing itself is left to the offset pressman, although the artist usually directs changes in color and corrections on the plate or registration when the work is first proofed.

All the photolithographic plates mentioned in this chapter can be printed by hand as well as on an offset press. For hand printing, however, smoother plates such as Enco P-30 plates present some difficulties in hand printing. Because they are so smooth and the fine grain on the surface holds so little water, it is essential to dampen the plate and immediately ink up the image before the water evaporates. If too much water is left on the plate, the smooth rubber roller will skid on the surface and the printing will be uneven. Plates that have a coarser grain such as ball-grained wipe-on plates or Enco P-150 plates, which have an anodized surface grain, retain more surface water and are easier to manipulate for printing by hand.

Artist Ivel Weihmüller making corrections on an Enco P-30 plate while proofing on the offset press at Siena Studios, New York.

# CHAPTER FOUR

# PHOTO-ETCHING

The process of photographically reproducing an image on a metal plate so that it can be etched and thus duplicated by printing has changed little over the past century. A line or halftone image on film is contacted to a plate covered with a light-sensitive coating, then exposed to an ultraviolet light source. Where light travels through the film, the coating hardens. A solvent appropriate to the coating used is then applied to dissolve the unexposed areas. The etch solution attacks the metal except where the coating remains on the surface.

In traditional photoengraving, the finished plate is printed in relief; that is, all the raised areas of the plate are inked, forming the positive image when printed. The areas etched by the acid are nonprinted areas.

In intaglio printing the opposite is true: everything etched below the surface of the plate is filled with ink, and the surface is then wiped clean so that it becomes the nonprinted area.

In photo-etching it is possible to print the etched plate using both relief and intaglio techniques; one of the resulting prints is the negative of the other.

The procedures outlined in this chapter deal with the production of an intaglio printing plate. These techniques allow the artist greater flexibility in reworking the plate, a richer, more tactile surface, and greater fidelity when working with images drawn directly onto Mylar or another translucent material in place of

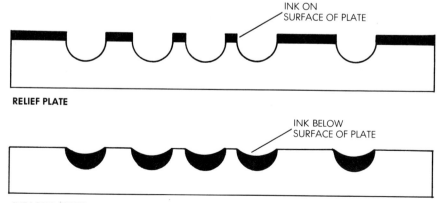

**RELIEF PLATE**

**INTAGLIO PLATE**

INK ON
SURFACE OF PLATE

INK BELOW
SURFACE OF PLATE

Comparison of relief and intaglio plates. Top: Etched photoengraving plate printed in relief. Bottom: Etched photoengraving plate printed as an intaglio plate.

photographic film. With all the light-sensitive coatings mentioned in this chapter, a positive image, either hand-drawn or on film, is needed for exposure to make a positive-printing intaglio plate.

Each of the following procedures has its own peculiarities. With the KPR resists and the cold top enamel methods, any mordant such as ferric chloride, Dutch mordant, or nitric acid may be used. The plates may be removed from the etching baths at any time to use stop-out varnish for controlling the depth of the bite of the etching in selected areas. With the carbon tissue process, only ferric chloride can be used for etching because acid would quickly erode the thin gelatin film. Stopping-out is also not possible in the carbon tissue method; the entire etching must be done in one stage.

The two most popular metals for photo-etching are copper and zinc. For fine tonal etching and especially for photogravure, copper is preferable. Linear work, however, can be successfully translated onto either metal. In addition, steel, magnesium, brass, and aluminum can be used with most of the processes described. One of the factors in limited production is the cost of the materials and the number of impressions to be made from the plate. Copper and brass are the most expensive metals, but for longer editions these metals can be readily steel-faced for extended printing. (The process of copper or steel facing is an electroplating procedure in which a microscopically thin layer of a harder metal is placed on top of the basic metal. See page 142.) Zinc, which is considerably softer than copper, yields far fewer good prints before wearing; however, the zinc can be first coated with copper, then steel-faced. The following processes can be used with all the commonly used metals, including copper, zinc, brass, magnesium, steel, stainless steel, and aluminum, with the exception of Kodak's KPR process, which is not recommended for use on aluminum or steel. For aluminum, Kodak's KMER and KTFR can be used; for steel and stainless steel, KTFR.

## KODAK PHOTO RESIST (KPR) AND KODAK PHOTO RESIST TYPE 3

These Kodak light-sensitive resists are composed of light-sensitive rosins dissolved in a volatile organic solvent. They may be applied to a plate by flowing, dipping, spraying, or with the aid of a plate whirler. Once the resist is applied in an even coating, the plate is prebaked over a controlled heat source to remove residual solvents, then exposed, developed, and dyed, after which it is etched. The main drawback to the use of these resists is that both the resists and their solvents are flammable and their vapors are potentially harmful. They should not be used near an open flame or where there is a danger of sparks being produced. Good

ventilation should be provided at all times.

Both KPR and KPR Type 3 can be used for all etching techniques; however, the manufacturer recommends Type 3 for dip or flow applications, and KPR for use in a whirler.

Because of their simplicity and predictability, the Kodak Photo Resists have replaced many of the older coatings once used in the photoengraving industry. But it must be noted in general that the letterpress industry is dying and is being replaced for the most part by offset lithography. For the artist, however, processes that are obsolete or rapidly becoming so in the commercial industry often have unlimited experimental and creative potential.

## MATERIALS AND EQUIPMENT

*Kodak Photo Resist (KPR) or KPR Type 3.* This is the light-sensitive emulsion which is coated onto the plate. It may be thinned with Photo Resist Thinner for flow or spray coating.

*Kodak Photo Resist Thinner.* This, as the name suggests, is used for thinning the photo resist. It is used with equal amounts of KPR for flow and spray coating.

*Kodak Photo Resist Developer.* After exposure, the plate is developed in this solution, which dissolves the unexposed resist.

*Kodak Photo Resist Dye (Blue or Black).* Because the resist is clear, it is difficult to see the image either before or after development. The dye solution adheres to the developed image and makes it stand out, so that minor corrections can be made, if necessary, before etching.

*Metal Tray.* This should be large enough to contain the plate if the dip-coating method is used, or wide enough to accommodate one side of the plate for the spray- or flow-coating technique. A stainless-steel tray is ideal, but other metals such as galvanized iron can also be used. The trays should not be used for etching because acid and ferric chloride will react with the metal.

*Hot Plate.* This is used for prebaking the KPR after it is coated onto the plate.

*Exposure Unit.* This may be any of the units previously described which has a high-ultraviolet output.

*Etching Trays.* These are preferably made of plastic such as polypropylene, nylon, or fiberglass. These substances are unaffected by acids, alkalies, or salts.

*Mordant.* KPR works well with any of the etching solutions in common use, such as Dutch mordant, nitric acid and water, and ferric chloride.

## PREPARATION OF THE PLATE

The following procedures should be followed for zinc, copper, or brass plates.

*Step 1.* First remove any heavy deposits of grease or oil on the plate by pouring a little benzine or lacquer thinner over the surface. Dry the plate with a paper towel.

*Step 2.* Next place the plate face up in the sink and rub it with a paste made from whiting and diluted ammonia (2 parts water to 1 part household ammonia). Rub thoroughly in all directions, paying careful attention to the edges. Fine pumice powder (FFF) may be used instead of whiting. Rubbing the surface of the plate with this solution helps provide a fine tooth to the surface and increases the adhesion of the resist. When water remains on the surface of the plate in an unbroken film without beading, the plate is adequately cleaned.

Step 2. The plate is dried after cleaning.

Step 2. Tooth is added to the surface of the plate with a whiting and ammonia paste. Above: The right side of the plate on which water beads needs further cleaning.

*Step 3.* Pour a weak solution of hydrochloric acid and water over the plate (10 percent HCl to 90 percent water). This brightens the plate and removes any surface oxidation. If you don't have HCl, another very effective mixture is 1 ounce (31 grams) of common salt dissolved in 1 quart (946 ml) of a 5 percent acetic acid solution. Rinse the plate thoroughly afterward with clean water, then dry quickly. Handle the plate carefully, and avoid touching the cleaned surface. The plate is now ready to receive the light-sensitive coating.

## APPLICATION OF RESIST

It is important to safeguard the work area from stray light, which could adversely affect the coating prior to development. Use only extremely subdued light or similar conditions that might exist in a normal photographic darkroom such as red or yellow safelights placed several feet away from the plate being coated. Yellow "anti-bug" incandescent bulbs or fluorescent bulbs carefully covered with orange "Kodagraph" sheeting or goldenrod paper allow good visibility yet prevent ultraviolet light from affecting the coating.

*Flow Coating and Dip Coating.* Both dip coating and flow coating require the same basic procedure except in the very first step. In dip coating, the plate is immersed in KPR, then lifted out and propped at an angle so that the excess coating flows down the plate. In the flow-coating method, the plate is first propped up and the KPR poured over the face of the plate so that the excess flows down into a tray. All other steps are identical.

*Step 1.* Place the cleaned plate so that the bottom edge rests in the metal tray. Pour a small quantity of KPR over the plate from the top edge. This should be done only in very subdued light or under red or yellow safelight conditions.

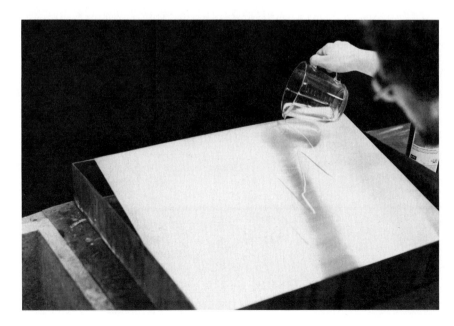

Step 1. KPR is poured over the plate.

For dip coating, place the plate face up in the tray and pour a small quantity of KPR onto the plate. Rock the tray until the whole plate is covered with the solution, then lift the plate and prop up one end so that the solution flows down into the tray.

*Step 2.* Leave the plate in this vertical position and allow it to dry. This should also be done under darkroom or subdued light conditions. For a single application, KPR can be used full-strength. Because of a wedging effect which makes the coating at the bottom of the plate heavier than at the top, two coats are sometimes preferable. Use a thinned resist (50 percent KPR and 50 percent Photo Resist Thinner), and change the position of the plate 180 degrees for the second coat.

*Step 3.* Still under subdued light, place the dried plate on a hotplate at a warm setting, approximately 248° F. (120° C.), for about 10 minutes. This removes any residual solvent and makes the coating more durable. Be sure to do this in a well-ventilated area to avoid breathing the vapors. This procedure is called postbaking. Afterward, allow the plate to cool. It is then ready for exposure.

EXPOSURE

The amount of exposure necessary depends on several factors: the strength of the light source and its ultraviolet output, the thickness of the coating, and the amount of residual solvent in the resist. A thinner coating requires less exposure time. Also, if the surface of the plate is shiny and not matte, the exposure time will be shortened because light will be reflected back from the surface. The light source should be any of the following: carbon arc lamp, mercury vapor lamp, pulsed xenon, or ultraviolet fluorescent tubes, type BL. The use of a vacuum frame for close contact between film and plate is preferable (see page 51).

The positive halftone film is exposed to the sensitized plate.

## DEVELOPMENT

*Step 1.* Immediately after exposure, place the plate in the stainless-steel tray containing the developer. Pour additional developer over the plate and develop for 1 to 2½ minutes. The developer will dissolve the unexposed KPR.

*Step 2.* Discard the developer in the tray; it contains dissolved resist which could redeposit on the surface of the plate. Pour fresh developer over the surface. This second step is important to ensure complete removal of the unexposed areas.

*Step 3.* Prop the plate in a vertical position and spray fresh developer over the surface. This provides a continual rinsing and is ideal as a last step in development. It should be done in a well-ventilated area.

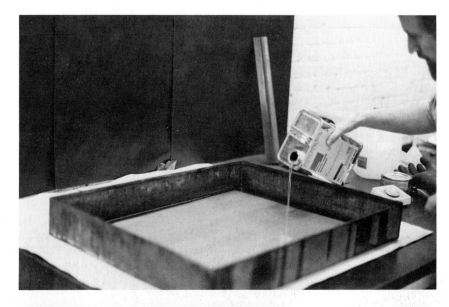

Step 1. Developer is poured over the plate.

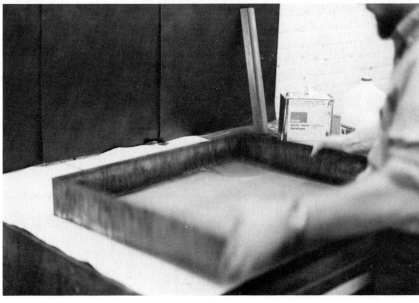

Step 1. The tray is rocked to distribute the developer over the surface.

## DYEING THE IMAGE

Because the resist is clear and almost impossible to see on the surface of the plate after development, the dye is necessary for visual inspection. Dyeing should be done immediately after developing the plate and while it is still wet because the resist is then more receptive to complete absorption of the dye. Make sure to wear plastic gloves to prevent the dye from staining your hands.

*Step 1.* Place the plate in the metal tray and pour some dye onto the middle of the plate.

*Step 2.* Rock the plate until the entire surface is covered.

*Step 3.* Remove the plate from the tray, draining excess dye briefly into the tray. Spray the plate with water to remove any remaining dye from the surface. Dry the plate by blotting with clean newsprint, or with a fan. The dye, unlike the developer, may be reclaimed from the tray and reused. Cover the solid areas, margins, and edges of the plate with asphaltum to prevent false biting in these areas. The plate is then ready for etching.

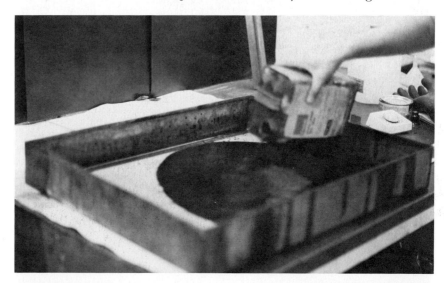

Step 1. KPR dye is poured over the plate immediately after development.

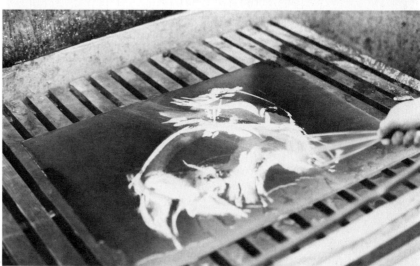

Step 3. Dye is removed from the plate with a spray of water.

Step 3. Excess water is blotted carefully from the plate.

Step 3. Before the plate is etched, asphaltum is brushed over nonetching areas of the plate to protect them from false biting.

*Note.* As an alternative method of dyeing, use an atomizer to spray the dye onto the plate while it is in a vertical position, with the bottom resting in the tray. Do not use plastic trays for developing or dyeing because the solvents in both will dissolve the plastic. The gloves you use should also be solvent-resistant. To remove the dye stain from your hands, use a lanolin-type "waterless" hand cleaner.

## COLD TOP ENAMEL

This light-sensitive coating for zinc and copper is an emulsion of water, ammonium carbonate, shellac, and ammonium dichromate (see formulary, page 187). It is still available commercially, although it is becoming increasingly more difficult to find sources because of the waning photoengraving industry. Cold top enamel, as opposed to "hot top" enamel, does not require heating and is

simple to use. Because a dichromate is used as the sensitizer, the coating is susceptible to "dark reaction" after several hours. (Dark reaction is the gradual hardening of a coating even when it is completely protected from any light source.) It must therefore be exposed and developed as soon as possible after it has been applied.

Cold top developer consists of alcohol and a dye. This dissolves the unexposed coating and dyes the hardened coating for greater visibility.

## MATERIALS AND EQUIPMENT

Cold top enamel

Cold top developer

Plastic or metal trays

Copper or zinc plate

Vacuum frame and ultraviolet light source

## APPLICATION

One of the best ways to coat the plate is with a whirler. This device holds the plate and spins it so that the centrifugal force spreads the coating from the center of the plate outward in a very thin, even film. A rotation speed of about 90 rpm is normal for most coating solutions. A faster speed will produce a thinner coating, and a slower speed a thicker one. A whirler may be bought commercially, or one can be constructed with either a mechanical or a motor drive. A simple whirler can be made using an old 78 rpm phonograph turntable.

The following procedure for flow-coating the enamel onto the plate may be followed with good results if a whirler is not available. The procedure is the same for KPR; and as for that process, yellow safelight conditions must be observed and the plate must be thoroughly cleaned beforehand.

## FLOW-COATING

*Step 1.* Place the clean plate in a plastic or metal tray, being careful not to get fingerprints on the surface of the metal. Pour enough cold top enamel on the surface to cover about one-third of the plate. Rock the plate until the enamel covers the entire surface.

*Step 2.* Lift the plate and prop it up vertically, and allow the coating to flow down the plate into the tray. After about 30 seconds, place the plate face upward on a flat surface and dry it using a hair dryer set for warm air, or place it on a hot plate with a warm setting. The temperature must be no hotter than the hand can stand.

*Step 3.* Place the plate in a vacuum frame with the positive facing the coated surface so that it is a mirror image of the way it should print. Expose to a light source high in ultraviolet, such as an arc

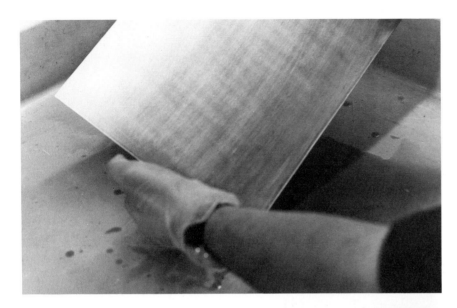

Step 1. The plate is rocked until all parts of the surface are covered with cold top enamel.

Step 2. The plate is propped vertically to allow the excess coating to flow down.

Step 3. Exposure.

lamp, mercury vapor, pulsed xenon, or ultraviolet fluorescent tubes, type BL.

*Step 4.* Develop the plate by immersing it in a tray containing some cold top alcohol developer or by pouring or spraying some of the developer over the plate. The developer is composed of an alcohol solution and a dye. The alcohol dissolves the unexposed resist, and the dye stains the light-hardened coating. Complete development takes about 4 minutes. The image area can be swabbed lightly with cotton.

*Step 5.* Immediately after development, and while the plate is still wet, wash the plate with a spray of clean tap water and fan-dry it. Discard the used developer. Check the plate for defects and touch it up with stop-out varnish or asphaltum. Make sure the back and edges of the plate where you don't want it to etch are covered as well. The plate is now ready for etching. The coating is resistant to all acids, alkalies, and salts.

Step 4. Development.

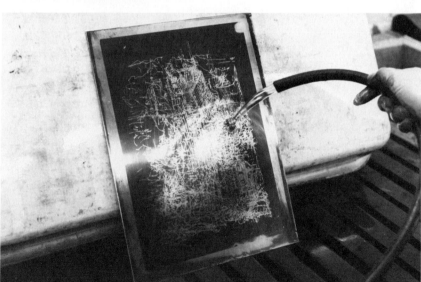

Step 5. A spray of lukewarm water removes the unexposed parts of the image.

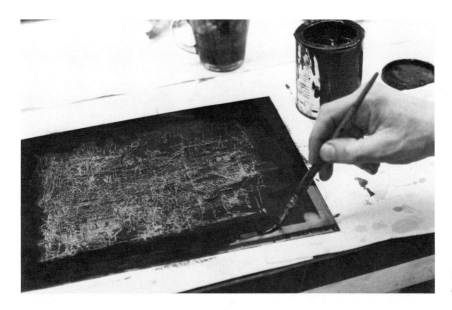

Step 5. The edges of the plate are covered with asphaltum before etching.

## SAFETY PRECAUTIONS

Cold top enamel presents few health hazards. There is a minor evaporation of ammonia from the enamel and some alcohol evaporation from the developer. Because of the low levels of each of these substances in normal use, they do not present serious hazards. Because of the alcohol in the developer, however, care must be taken to avoid open flames or sparks. With limited use, a fan to disperse alcohol evaporation is usually sufficient.

## PHOTOENGRAVER'S ENAMEL
## (SENSITIZED GLUE PROCESS)

This process was once widely used in the photoengraving industry but has been replaced almost entirely by presensitized plates or by other procedures such as Kodak's KPR method. The basis of this light-sensitive coating is fish glue, often referred to as photoengraver's glue, and ammonium bichromate. Its simplicity and ease of use make it ideal for artists. Small quantities can be mixed and used on a limited basis, and the stock solutions of both glue and sensitizer can be kept almost indefinitely. Here is the basic formula:

| | |
|---|---|
| Fish glue (photoengraver's glue) | 3 ounces (90 ml) |
| Water | 8 ounces (240 ml) |
| Ammonium bichromate | ¼ ounce (7 grams) |

Mix the glue and water, then add the ammonium bichromate and shake the solution in an enclosed glass or plastic bottle. Allow it to sit for several hours before applying it to the plate so that air bubbles in the solution have a chance to disappear. It is also a good idea to filter the solution through a piece of cotton or some filter paper placed in the neck of a funnel. A coffee filter works fine.

This coating adheres well to almost any metal, provided it is well degreased and properly prepared. To clean the plate, scrub it thoroughly with whiting and ammonia or a weak lye solution (see page 115).

Once the bichromate is mixed with the glue, the mixture will be good for up to two weeks if kept in a refrigerator, or for about three or four days at room temperature.

The plate is first cleaned and degreased.

## COATING THE PLATE

The coating is best applied to the plate with the aid of a whirler. The plate is first cleaned, then placed in the whirler while still wet. When the plate is in motion, the glue-bichromate solution is poured onto the center of the plate. This drives the water from the plate and should be free of specks or bubbles. If imperfections exist, a second application of the coating will often draw out the bubbles. When the coating is even overall, infrared heat lamps

The plate is placed in the whirler.

The sensitizing solution is poured slowly onto the plate while it is motion.

may be turned on while the whirler is still in motion until the coating is completely dry—about 5 minutes. This procedure may be done under subdued room light. The speed of the whirler should be between 70 and 90 rpm. A faster speed produces a slightly thinner coating and a slower speed a slightly heavier one. When dry, the coating should appear glossy and transparent so that the metal can be seen clearly through it. If there are too many defects in the surface, wash with water and repeat the coating procedure.

## EXPOSURE

Exposure times are influenced by the coating thickness and the strength of the light source. A vacuum frame for close contact with the positive or negative is important. Trial exposures can be made to determine the optimum times and distance to the light source.

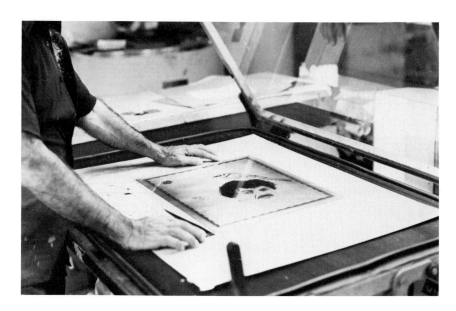

The positive is placed in position on the plate in the vacuum frame.

Exposure is made to a high-intensity UV light source.

## DEVELOPMENT AND DYEING

Although water alone is sufficient to develop the image by dissolving the unexposed areas of the coating, the addition of a water-soluble dye to the water will show up the image clearly. A water-dye solution composed of the following ingredients will serve the purpose:

Methyl violet     1 ounce (30 ml)

Water              25 ounces (750 ml)

Place the exposed plate in a tray with this dye solution for about 2 minutes, then lift the plate out of the dye and hold it under running water at room temperature to develop the image. You can assist development with a piece of cotton swabbed gently over the surface during washing. Take care not to scratch the coating at this stage, as it is quite tender.

When the image is clearly defined, air-dry the plate or immerse it in a solution of alcohol, which will absorb water from the surface and speed drying.

## BURNING-IN

To fix the glue coating firmly, after development heat the plate on a hotplate or over a gas flame until the remaining coating changes to yellow and finally dark brown. Allow it to cool, and touch it up with asphaltum at the edges and back. When it is dry, it is ready for etching and can be used with any of the common etching solutions, acids or salts.

The plate is burned in over a direct gas flame and rotated until the entire surface has turned an even deep brown color. A hotplate can also be used for this purpose.

## CARBON TISSUE METHOD

The same type of carbon tissue that is used for photogravure can also be used for line and halftone images made on film. First the line or screened halftone positive is made on film, then exposed to the sensitized carbon tissue in a vacuum frame. The carbon tissue is adhered to the metal (zinc, copper, or brass), washed out with hot water in the development stage, and dried. Because the carbon tissue emulsion is composed of gelatin and pigment, acids cannot be used to etch the plate; only ferric chloride (a salt) is practical.

### SENSITIZATION OF THE CARBON TISSUE
This step is identical to that used in the photogravure process (see page 112). Immerse the carbon tissue in a 3 percent solution of

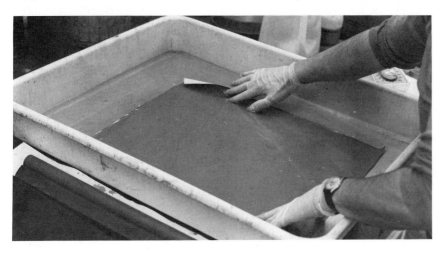

Carbon tissue is sensitized in a potassium bichromate solution.

potassium bichromate and water at a solution temperature of approximately 65° F. (18° C.) for 3 to 3½ minutes. Remove it and squeegee it, face down, onto a clean Plexiglas sheet. Dry it in a darkened room. In about 4 to 6 hours, you can peel it from the plastic, or it will have lifted from the plastic of its own accord. It can then be exposed immediately, or stored in a plastic bag in a refrigerator for three to four days, or completely frozen for an indefinite period before exposure.

## EXPOSURE

Exposure of the carbon tissue should be made so that the image reads correctly when placed against the carbon tissue. After exposure, the tissue will be placed face down on the metal so that it will be etched as a mirror image and in printing will read correctly.

If the positive is on clear film and consists of an image with a multitude of fine lines only, it can be exposed directly onto the carbon tissue in one exposure. The exposure time would be considerably less than that for exposure to a continuous-tone image in photogravure. The exposure should be approximately 2 to 4 minutes with a carbon arc light source at a distance of 4 feet (1.2 m). If some of the lines in the line shot are wider than about 3/16 inch (5 mm), a screen exposure to the carbon tissue of approximately half the time of the positive exposure will provide a grain. In this way the wide linear areas will be etched similarly to an aquatint and the area will be better able to hold a quantity of ink during printing.

## ADHERING THE CARBON TISSUE

Adhere the carbon tissue face down onto the cleaned copper plate exactly as you would for photogravure—that is, either tape one edge to the metal, then pour a small amount of distilled water onto the plate and squeegee the tissue immediately down onto the metal starting at the taped edge; or immerse the tissue in a tray containing 50 percent distilled water and 50 percent alcohol until the tissue becomes limp, then remove it and place it face down on the metal, and squeegee it to remove excess liquid. Allow the adhered tissue to set for approximately 15 minutes, then swab alcohol on the back with a piece of cotton and develop the tissue in hot water.

## DEVELOPMENT

After 3 to 4 minutes in the hot water, 110° F. (43° C.), grab an edge of the backing paper and lift it gently until it is removed entirely. Swab the gelatin adhered to the metal lightly with a soft piece of cotton and change the water as it becomes murky with dissolved pigment and gelatin from the tissue. After about 10 minutes in several changes of hot water, the image should appear clearly defined with little pigment showing on the cotton swab. Rinse the surface with cold water, then immerse it in an alcohol-and-water

solution (75 percent alcohol, 25 percent water) for about 3 minutes. This will absorb water from the gelatin and promote quick and even drying of the tissue on the metal. For the final drying, take the plate out of the alcohol solution and prop it up at an angle so that the excess alcohol and water drain to the bottom of the plate and it dries from the top down.

## ETCHING
Before etching, examine the tissue for defects and spot them out with asphaltum or stop-out varnish. Protect the edges and back with asphaltum. When this is dry, immerse the plate in the etching solution.

Ferric chloride is the only practical mordant to use with carbon tissue. Etching should begin with a solution of about 40° to 42° Baumé ferric chloride so that the process works quickly and evenly. When the etching has begun over the entire image area, continue the etching in a higher-Baumé solution (approximately 44° to 45° Baumé) until the desired depth has been reached. A total etching time for fine and medium linear work is in the neighborhood of 30 to 45 minutes after overall etching has begun. For further information regarding the characteristics of carbon tissue and the etching procedure, see the chapter on photogravure.

# CHAPTER FIVE

# PHOTOGRAVURE

Photogravure is one of the most complex techniques, yet when successfully done it is also one of the most rewarding. The range of tonalities possible with this process approaches that of photographic paper itself, with the added advantage that the results are archivally more permanent than the best results obtained using one of the silver processes. The final printed photogravure image consists solely of ink on paper—two elements that are as permanent as a Rembrandt etching, provided a good-quality paper has been used.

With the increasing use of photographic imagery by printmakers and the emergence of a whole new generation of photographic artists, the process has unlimited potential. The expense of the materials needed is not great; in fact, it is considerably less than that of many other processes. What is needed, however, is patience in discovering some of its idiosyncrasies, and an understanding of some of the considerable number of variables that could have a direct bearing on the final results.

## MATERIALS AND EQUIPMENT

Carbon tissue

Potassium bichromate

Measuring beakers

Thermometer

Humidity scale

Photographic trays

Piece of ⅛-inch (3-mm) Plexiglas

Rubber brayer or soft rubber squeegee

Ferric chloride in the following dilutions: 45°, 42°, 40°, 39°, and 37° Baumé

Hydrometer for heavy liquids, 35° to 45° Baumé

Vacuum frame with light source high in ultraviolet output

Supply of hot water at 110° to 120° F. (43° to 49°C.)

Photographic enlarger

Photographic film for making positives

Developing and fixing chemicals
Stouffer sensitivity guide

## DARKROOM ARRANGEMENT

Although most of the procedures for making a photogravure may be done in ordinary room light, it is essential that some steps be carried out either in darkness or under yellow or red safelight conditions. This is particularly important for making photographic positives in the enlarger with either panchromatic or orthochromatic film (see pages 50–51). All photographic chemicals should be kept in the darkroom and stored in amber-colored glass or plastic containers for longer shelf life.

Carbon tissue as it comes in the roll will keep indefinitely, but after it is sensitized in potassium bichromate, it must be dried, exposed, and adhered to the copper as soon as possible. When carbon tissue is still wet with sensitizing solution, it is relatively insensitive to light. As it dries, however, it becomes increasingly light-sensitive. For this reason, the tissue should be dried in a darkened room or in a light-tight box with good air circulation to promote drying. When it is dry, the sensitized tissue should be handled under yellow safelight and protected completely from other kinds of light until it is ready to be exposed to the positive.

When the tissue is placed in the vacuum frame just prior to exposure, the brief exposure to subdued room light will not affect it. Ultraviolet light has the greatest effect on sensitized tissue, so avoid stray daylight or direct fluorescent light.

If considerable work is to be done with either photographs or handmade positives, a light table is indispensable. Tonal values can be carefully controlled through all phases of creation. The table, in addition, can be used for retouching photographs, making overlay drawings for separate color plates (with registration marks), and combining multiple images.

A light table can be made simply and inexpensively by using one or two fluorescent fixtures, a sheet of glass or Plexiglas, a suitable base, and a frame.

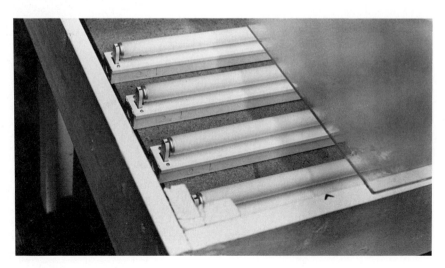

Fluorescent light arrangement on a light table. The glass top has been shifted to show the inside. The underside of the glass has been sprayed with Krylon dulling spray to help diffuse the light.

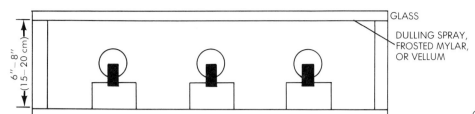

GLASS

DULLING SPRAY,
FROSTED MYLAR,
OR VELLUM

6″ – 8″
(15 – 20 cm)

Cross section of the light table.

## THE EXPOSURE UNIT

Several arrangements can be made for exposing sensitized carbon tissue. Almost any light source high in ultraviolet output will do. This includes arc lamps, pulsed xenon, mercury vapor, sunlamps, and cool white- and black-light fluorescents. For best results there should be close contact between the positive and the sensitized tissue. The use of a vacuum frame and a single-point light source such as carbon arc, mercury vapor, or pulsed xenon is ideal and will produce the sharpest results. Fluorescents that diffuse the light somewhat work well, however, if good contact is made between the positive and the tissue.

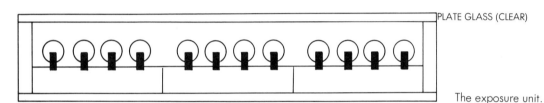

PLATE GLASS (CLEAR)

The exposure unit.

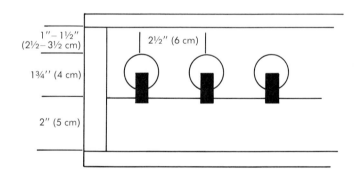

1″ – 1½″
(2½ – 3½ cm)

2½″ (6 cm)

1¾″ (4 cm)

2″ (5 cm)

Cross section of the exposure unit.

Wiring diagram for the light table. The same arrangement can be used to make an exposure unit.

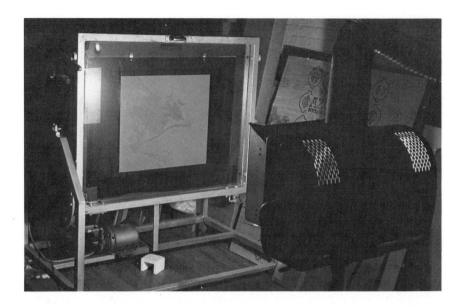

Carbon arc exposure unit and vacuum frame.

## THE PHOTOGRAPHIC POSITIVE

A photographic positive can be made from any camera-produced negative. The completed positive should be the exact size of the final photogravure. For example, if a 35mm negative is used to make an 8-×-10 photogravure plate, the positive must also be 8 × 10.

The ideal photographic positive for photogravure has a carefully graduated range of tonalities with good shadow detail. The middle and dark tones should be well defined and not too dense or a single continuous tone will result in these areas.

When it is held up to the light, the positive should appear slightly thin, yet have subtlety and detail in the middle tones and highlight areas. A useful guide for checking the density of the positive is comparison with the Stouffer twenty-one-step sensitivity guide on transparent film, available from all graphic arts distributors. If the positive exhibits gradations from highlights to dark tones similar to steps 3 through 12 or 13, the range of tonalities is ideal. Later, as you gain experience in the etching procedure, you may increase or decrease contrast by varying the times in the different ferric chloride baths, thereby compensating for positives that may be too flat or have too much contrast.

Several types of photographic film may be used to make continuous-tone positives, including panchromatic and orthochromatic (see page 45). The film is placed in the enlarging easel and exposure is made through a 35mm, 2¼, or larger-format negative directly onto the film. See page 58, "Continuous-Tone Film Enlargements," for more information.

## THE HANDMADE POSITIVE

There are an infinite number of ways to make a handmade positive on transparent or translucent stock. Graphite pencils, markers, crayons, tusche, and India ink may all be used for a

variety of direct drawing techniques to produce solids, fine lines, or wash effects. Three of the best surfaces to draw on are frosted Mylar, a highly stable and strong plastic; frosted acetate, which tears easily and is affected by moisture but like Mylar allows good light transmission; and translucent vellum, which has greater "tooth" than the other two materials. The "tooth" is the surface texture which grips the drawing materials, producing a more pronounced textural effect. Because vellum is slightly less transparent than the other two materials, exposure times must be increased slightly.

When you work directly on any of these materials, judge tonalities and image quality by holding the drawing up to the light or putting it on a light table. This shows the values of all the tonalities more accurately. On white paper, the shadows cast by the drawing make the tones appear much darker than they actually are and therefore give a false reading.

These materials are the same as are used for photolithography; see pages 77–83.

## CARBON TISSUE

Carbon tissue is composed of an emulsion of finely ground pigment and gelatin adhered to a paper backing sheet. The pigment, usually burnt sienna or iron oxide, gives the tissue its characteristic color and allows good visibility of the developed image and visual control during the etching procedure.

The gelatin layer is hygroscopic, which means that it absorbs moisture from the air. It is therefore readily affected by changes in atmospheric humidity. On dry days it curls inward tightly, whereas on more humid days it becomes more flexible as the gelatin absorbs moisture from the atmosphere. With the aid of a wet- and dry-bulb relative humidity scale placed in the working area, you can compare conditions from one day to the next and compensate.

Two manufacturers currently make carbon tissue: Autotype USA Ltd., which makes Rotogravure Pigment Paper No. G25; and McGraw Colorgraph Company, which makes Carbon Tissue Type 37. Both are excellent and have similar working characteristics. Rolls are available in approximately 40-inch (102-cm) widths and in lengths of 12 feet (3.7 m) from McGraw Colorgraph and 15 and 30 feet (4.6 and 9.1 m) from Autotype USA Ltd.

LAYER OF GELATIN AND PIGMENT

PAPER BACKING

Cross section of carbon tissue.

## FERRIC CHLORIDE (IRON PERCHLORIDE)

Ferric chloride, a salt of iron, is used to etch the copper photogravure plate. Although several acids will etch copper, the advantages of ferric chloride are that (1) no bubbles are formed in the mordant action; (2) it breaks through the layers of carbon tissue in controlled stages; and (3) it etches the copper quickly with a straight, clean bite and little tendency toward "crevé" or undercutting of either linear or tonal work.

Commercial ferric chloride is made by dissolving scrap iron in hydrochloric acid and oxidizing the solution with nitric acid. The reaction of the iron and concentrated acids forms solid lumps of hydrated ferric chloride. Dissolved in water, this highly concentrated salt reacts strongly with many metals and alloys such as copper, zinc, brass, bronze, iron, and steel as well as stainless steel.

In etching the copper plate, ferric chloride dissolves the copper in two stages. Cuprous chloride is formed in the first stage:

$$FeCl_3 + Cu = CuCl + FeCl_2$$

and cupric and ferrous chloride are formed in the second stage:

$$CuCl + FeCl_3 = CuCl_2 + FeCl_2$$

As a result of considerable etching of copper, the ferric chloride solution gradually changes from a warm brownish color to a greenish brown, indicating exhaustion of the solution.

Several forms of ferric chloride are available, already mixed in liquid form or in dry lumps or granules. The color of lump ferric chloride varies from a bright yellow to an orange brown. The more yellowish the color, the more acid the substance contains. For photogravure, the acid must be neutralized before the solution can be used. When ordering ferric chloride, in either the liquid or the dry form, specify acid-free, because any acid in the final solution will cause irregular etching results.

To prepare a stock solution from lump ferric chloride, use a plastic or glass container and add water until the lumps are almost covered. Stir frequently until the lumps are completely dissolved. A solution of 120 pounds (54.4 kg) of ferric chloride lumps dissolved in 3.8 gallons (14.4 liters) of water has a density of approximately 48° Baumé. Stir as continuously as possible; otherwise the lumps will cake together and form a solid mass that is difficult to dissolve.

If you suspect from the color of the ferric chloride lumps that the mixture is acidic, add some ferric hydroxide to the solution to neutralize any free acid. Some ferric hydroxide can be made by the following procedure: Add 8 ounces (240 ml) of water to 2 ounces (60 ml) of liquid ammonia (for each gallon of solution). Pour this ammonia solution slowly into 10 ounces (300 ml) of ferric chloride solution diluted in the same manner. Let the mixture stand for 30 minutes; a sludge of ferric hydroxide will settle on the bottom. Decant the liquid and add the ferric hydroxide sludge to the stock ferric chloride solution.

The most convenient form in which to purchase ferric chloride is in the liquid state, acid-free and in a standard Baumé of 48°. It is

Ferric chloride stored in plastic containers and labeled according to the Baumé of each solution.

available in this state for the rotogravure printing industry, which uses copper and carbon tissue. One of the most common suppliers is Philip A. Hunt Chemical Corporation, which manufactures Rotogravure Iron Chloride Solution, 48° Baumé (catalog no. 839589). This may be diluted with water to produce working solutions with Baumés 45°, 42°, 40°, 39°, and 38°, according to the following tables.

### DILUTION USING 48° BAUMÉ FERRIC CHLORIDE ("IRON")

| | English | | Metric | |
|---|---|---|---|---|
| Baumé required | Water added to each quart (fluid ounces) | Final volume (fluid ounces) | Water added to each liter (cc) | Final volume (cc) |
| 45° | 3⅜ | 34½ | 108 | 1103 |
| 44 | 4⅝ | 35¾ | 148 | 1140 |
| 43 | 6 | 37 | 193 | 1185 |
| 42 | 7½ | 38½ | 238 | 1230 |
| 41 | 8⅞ | 39⅞ | 283 | 1272 |
| 40 | 10½ | 41⅜ | 333 | 1322 |
| 39 | 12 | 42⅞ | 380 | 1368 |

### INCREASING IRON STRENGTH

| | English (fluid ounces) | | | | | | Metric (cc) | | | | | |
|---|---|---|---|---|---|---|---|---|---|---|---|---|
| Baumé to start | 48° Iron to be added to each quart | | | | | | 48° Iron to be added to each liter | | | | | |
| | 39° | 40° | 41° | 42° | 43° | 44° | 39° | 40° | 41° | 42° | 43° | 44° |
| Baumé required: | | | | | | | | | | | | |
| 45° | 57½ | 49⅜ | 39¾ | 30½ | 20¾ | 10½ | 1840 | 1578 | 1270 | 978 | 664 | 325 |
| 44 | 35⅞ | 29½ | 22⅛ | 15½ | 8 | | 1147 | 945 | 715 | 495 | 256 | |
| 43 | 22¾ | 17 | 11 | 5⅞ | | | 710 | 548 | 356 | 190 | | |
| 42 | 13½ | 9½ | 4⅝ | | | | 436 | 302 | 149 | | | |
| 41 | 7⅞ | 4¼ | | | | | 251 | 134 | | | | |
| 40 | 3¼ | | | | | | 103 | | | | | |

## THE COPPER PLATE

One of the most convenient types of copper to use, as well as the most expensive, is known as photoengraver's copper. It comes with an acid-proof backing and has an immaculate, smoothly polished surface. The thin film of oil that usually covers the copper to prevent tarnishing must be removed completely before adhesion of the carbon tissue resist.

Copper of the type available from metal dealers does not have an acid resist coating on the back, and the surfaces are often scratched, necessitating some burnishing, scraping, and polishing prior to use. Before etching, this copper must be protected on the back with liquid asphaltum to prevent etching. Whichever type of copper you use, the surface to which the carbon tissue is to be transferred must be completely free of oil, grease, and tarnish. Cleaning is best done just before the adhesion of the resist (see page 89).

Copper is available from several sources: graphic arts supply houses that specialize in photoengraving supplies; and art and printmaking suppliers and metal dealers, which generally handle both copper and brass products.

## MAKING THE PHOTOGRAVURE

There are several preparatory steps that must be followed before the photogravure is made. Arrange the necessary materials close at hand to facilitate the work. As with most procedures, a well-organized and well-thought-out arrangement will make the work proceed more smoothly, and be more consistent.

The basic steps in making the photogravure are (1) sensitizing the carbon tissue, (2) preparing and cleaning the copper plate, (3) exposing the tissue to the positive, (4) transferring the tissue to the copper, (5) etching the plate, and (6) printing.

## SENSITIZING THE CARBON TISSUE

The carbon tissue may be tightly rolled, particularly if the weather has been dry. Unroll it and tape one edge to a flat surface, measure, then cut one or two pieces the same size as the plate to be used. It is a good idea to sensitize two pieces and have one as a spare in case anything should happen to the first along the way. To avoid greasy finger marks on the tissue, which would prevent good adhesion, wear cotton gloves or handle the tissue carefully at the edges only.

### MATERIALS AND EQUIPMENT

Potassium bichromate (dichromate) crystals

Photographic trays

Large measuring beaker

Scale

Plexiglas sheet or ferrotype plate
Carbon tissue cut to size
Timer

Sheets of carbon tissue are cut from the roll.

## THE SENSITIZING SOLUTION

The sensitizing solution is made from potassium bichromate. Solutions of from 2 percent to 3½ percent can be made. A 2 percent solution results in greater contrast than a 3 or 3½ percent solution. It also requires increased exposure time as compensation.

All sensitizing operations should be carried out in subdued light, and the drying in complete darkness or under red or yellow safelight conditions. Care should be taken with higher concentrations of potassium bichromate sensitizer because it is particularly vulnerable to stray light. Prepared sensitizer may be stored in an amber or other lightproof container. It will remain in good condition for several months at room temperature or considerably longer if refrigerated. Once it has been used to sensitize tissue, it may be kept for a few days for reuse or discarded. To make a sensitizing solution of 3 percent (for an average-contrast positive),

The potassium bichromate is weighed.

The bichromate is mixed with water, then poured into a plastic container and refrigerated.

mix 3 grams (0.11 ounce) of bichromate solution with 1 liter (1 quart) of cold water, not above 70° F. (21° C.).

*Step 1.* Pour the sensitizing solution into one of the photographic trays under subdued light. Using rubber or plastic gloves, place the sheet of carbon tissue face up in the solution, uncurling it as necessary so that the entire emulsion side is evenly covered. Set the timer for 3 minutes.

*Step 2.* As the tissue begins to uncurl and lie flat, rock the tray to maintain even coverage.

*Step 3.* When 3 minutes have elapsed, lift the tissue by two corners and lay it gently on the Plexiglas or ferrotype plate.

*Step 4.* Using a squeegee or brayer, roll out the tissue on the paper backing side while holding the tissue at one edge. This removes air pockets under the tissue. Do not use too much pressure.

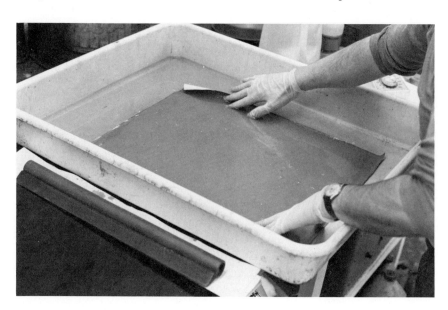

Step 1. After about 1 minute in the sensitizing solution the carbon tissue begins to lie flat.

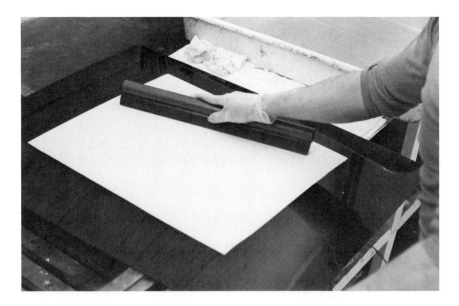

Step 4. The tissue is squeegeed face down onto a Plexiglas sheet and dried in a dark room.

*Step 5.* Place the tissue in a dark area to dry. A cool fan may be used in the darkroom for faster drying. Depending on humidity, the tissue will dry in 3 or 4 hours. It will peel off the surface by itself or can be peeled easily from the surface when it is ready.

*Step 6.* Place the tissue in a lightproof plastic bag, close the bag tightly, and allow the tissue to remain enclosed for at least 2 hours. In warm weather, place the bag in a refrigerator. (Because the tissue dries at the edges first, the center will retain slightly more moisture although it may appear to be equally dry. This procedure ensures equalization of the moisture content throughout the sheet.)

Once prepared in this fashion, the tissue should be exposed as soon as possible. If kept refrigerated, the tissue can be kept up to one week before exposure; otherwise it should be exposed the same day. If carefully sealed in plastic and frozen, it can be stored indefinitely before use.

## CLEANING THE COPPER PLATE

The copper plate to be used for photogravure is cleaned in the same way as for other photo-etching techniques. There are several important points, however, that are especially pertinent to good adhesion of carbon tissue. Although other types of copper can be used, photoengraving copper has a flawless surface which, unless scratched, needs a minimum of preparation. First, remove the light oil covering from both the surface and the back of the plate with a liberal application of whiting mixed with a little water and ammonia (50 percent water, 50 percent household ammonia). Make a paste of this mixture and rub both sides of the plate thoroughly, using clean paper towels. Rinse with tap water. If the surface shows discoloration due to oxidation, use a mixture of common salt, acetic acid, and water to brighten the copper. A

common mixture is 1 part table salt, 1 part glacial acetic acid (3½ parts acetic acid 28 percent), and 8 parts water. The commercial copper cleaner Twinkle is also excellent for this purpose. Use the whiting-ammonia paste again after treating the plate to remove oxidation if water beads on the surface. Water must remain on the plate in an unbroken film. A dilute solution of lye and water—1 teaspoon (5 ml) to 8 ounces (240 ml) of water—can be used in place of the ammonia for this procedure.

Once the plate is completely degreased, pour some of the salt–acetic acid–water solution over it and rinse immediately with clean water. Dry with clean paper towels. Avoid touching the surface with your fingers. The exposed carbon tissue should be adhered to the cleaned copper as soon as possible after cleaning.

## EXPOSING THE SENSITIZED TISSUE

There are two methods for exposing the continuous-tone positive: the halftone screen method and the aquatint ground method. The second process produces excellent results, but it requires several extra procedures and an aquatint box for consistent and even tonalities.

### THE SCREEN METHOD

Special screens of the type used by rotogravure printers are available for photogravure. They consist of finely ruled clear lines on an opaque background. These screens, unlike those used in lithography, have a hard dot pattern. Conventional gravure screens have a ratio of opaque space to clear line of 2½ or 3 to 1. The screen is contacted to the carbon tissue first and then exposed to a nondiffusing light source so that the screen pattern is as sharp as possible. Then the screen is removed and the continuous-tone positive is exposed to the tissue.

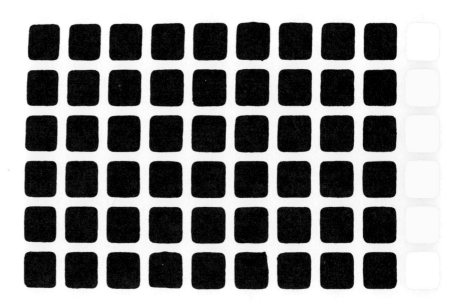

A greatly enlarged pattern of a conventional gravure screen.

For good contact between the screen and the positive to the carbon tissue, a vacuum frame is essential. To ensure optimum overall contact and even illumination, allow the vacuum-frame suction motor to run at least 5 minutes before exposure.

As exposure is made through the screen onto the sensitized carbon tissue, a grid of hardened gelatin is produced. The ferric chloride does not completely break through, which allows the etching to be contained within the grid. This forms a series of minute etched wells of varying depth and almost uniform width.

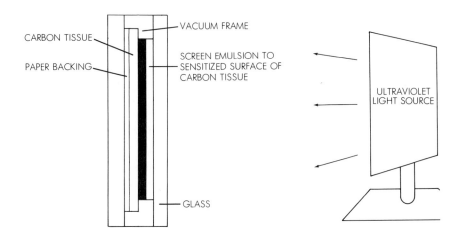

The contact arrangement between sensitized carbon tissue and contact screen.

The gravure screen is expensive, but if handled carefully it will last indefinitely. The most practical ruling is 150 lines to the inch, although finer screens are available.

Another type of screen that can be used for this procedure is the mezzotint screen. It is used in exactly the same way as the gravure screen, but instead of producing a grid of equally spaced intervals, it has a random dot pattern. This gives results closer to those of the aquatint method but with much greater predictability. Also, by making a double screen exposure, with the screen position changed for the second exposure, you can set up an extremely fine mezzotint grid on the carbon tissue which will produce finely graduated tonalities.

The mezzotint screen I use for photogravure was made by contacting a normal 150-line (equivalent) mezzotint screen that is used for lithographic work directly onto a sheet of orthochromatic lithographic film. This makes a fine, sharp, random pattern which I have found to be ideally suited to photogravure.

A greatly enlarged pattern of a mezzotint screen.

## THE AQUATINT METHOD

In this method, instead of a screen to help break up the tonalities so that the etching will produce a series of wells to hold the ink, a fine rosin or asphaltum powder is dusted onto the plate and heated so that each particle melts and adheres to the plate. Each particle forms a minute resist so that as the etching proceeds, the spaces between the particles form etched wells that hold the ink. The rosin or asphaltum may be dusted onto the plate by either the hand method or the aquatint box method.

In the hand method, the powder is placed on several thicknesses of muslin or silk. The edges of the cloth are then lifted and tied at the top to form a bag. As the bag is shaken over the plate, the particles of rosin or asphaltum sift through the material and settle onto the plate's surface. To guarantee an even layer of rosin or asphaltum, the bag must be shaken in a place where there are no drafts. The plate is then heated over a hotplate or alcohol lamp until the particles melt and adhere to the metal. Rosin melts at a temperature of approximately 225° to 250° F. (107° to 121° C.), asphaltum at considerably higher temperatures, between 450° and 500° F. (232° to 260° C.). The grained plate should have a fine and equal dispersion of particles; the spaces between the fused particles should constitute approximately one-third of the total surface area.

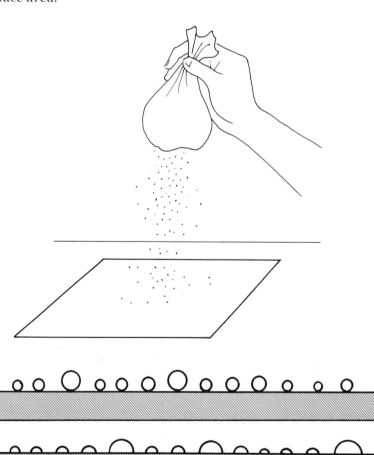

A plate is dusted with rosin by the hand method.

Rosin particles on the surface of the plate (top) are heated and melt (bottom) to adhere to the metal.

A box can be constructed especially for graining the plate. Make an opening in the bottom third of a box, attach a door, and fix a wire rack inside to hold the copper plate. Place rosin or asphaltum powder in the bottom of the box and then stir it with a fan, bellows, or other device until the box fills with dust. After waiting a minute or so while the coarsest particles fall to the bottom, open the door, place the plate inside, and leave it for 2 or 3 minutes. Lift the plate carefully from the box, and heat it until the particles fuse onto the surface, as in the hand method. Check the distribution of the particles on the surface with a magnifying glass. If they are too sparsely distributed, repeat the operation. It is best to place the plate in the box on a piece of cardboard or plywood about 1 inch (25 mm) wider than the plate all around. This prevents disruption of the particles at the edges of the plate due to convection within the box.

A large aquatint box at Aero Press, New York. Rosin powder is first stirred up in the bottom area; then the plate is placed inside as shown.

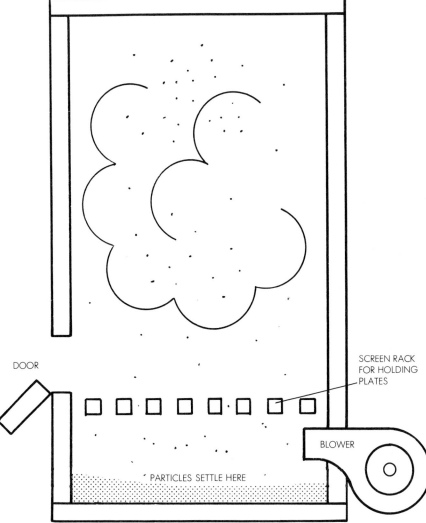

DOOR

SCREEN RACK
FOR HOLDING
PLATES

BLOWER

PARTICLES SETTLE HERE

Cross section of an aquatint box (dust box).

## EXPOSURE TIMES

Because there are so many variables affecting exposure, the times given in the exposure chart below should be used as a starting guide only. Make tests with the equipment you have at hand, using step exposures.

The Gravure Technical Association recommends that at a distance of 6 to 8 feet (1.8 to 2.4 m) between light source and vacuum frame, a Weston light meter registering candlepower should read approximately 800. Exposure time at this reading would be from 10 to 15 minutes. At closer distances the time would be cut considerably. At 3 to 4 feet (0.9 to 1.2 m) the exposure would be approximately 4 minutes. In the screen method, absolute contact between the halftone screen and the tissue is important and a vacuum frame is recommended. For other procedures, a less sophisticated arrangement will give good results (see page 107).

The basic ratio between screen exposure time and exposure to the positive is about 50/50, although this may be changed to alter image contrast or gradation. The screen exposure should be long enough that the cell walls will not break down during etching. Because the clear parts of the gravure screen are more transparent than the lightest tones on the continuous-tone positive, the cell wall created by the screen in a 50/50 exposure affects the tissue to a greater depth than the highlights on the continuous tone and is therefore adequate for the entire etching procedure.

### CARBON TISSUE EXPOSURE TIMES

| Light source | Exposure | Exposure time |
|---|---|---|
| Carbon arc lamp (30 amps) to be held 30 inches (76 cm) from vacuum | Screen | 2—3 minutes |
| | Positive | 3—4 minutes |
| Carbon arc lamp (15 amps) (enclosed unit such as Nu Arc Flip Top Arc) | Screen | 4—5 minutes |
| | Positive | 6—8 minutes |
| Sunlamp (175 watts) 24 inches (61 cm) from vacuum with cooling fan directed at glass | Screen | 10—12 minutes |
| | Positive | 12—15 minutes |
| Pulsed xenon (1,000 watts) 30 inches (76 cm) from vacuum, enclosed unit | Screen | 1½—2 minutes |
| | Positive | 3—4 minutes |
| Mercury vapor lamp (400 watts) 30 inches (76 cm) from vacuum | Screen | 8—12 minutes |
| | Positive | 12—14 minutes |

Be careful to avoid both overexposure and underexposure. Overexposure to the screen thickens the screen lines so that the surface hardens to a degree that it cannot adhere properly to the copper. Too short a screen exposure causes excessive lateral etching and breaks down the cell walls before the highlight

etching is completed. Overexposure of the continuous-tone positive increases the contrast of the image and produces weak or underetched highlights. Underexposure causes the etching to proceed too rapidly and produces an overall flatness in the print, greatly reducing definition and separation of tonalities.

Keep in mind that if the rosin or asphaltum method is used, the screen exposure is eliminated and the tissue is exposed only to the positive.

## TRANSFER: CARBON-TISSUE LAY-DOWN

The exposed tissue must be transferred to the copper and developed before etching can take place. Once the tissue is exposed, it can be adhered to the copper by either of two methods: the "dry-lay" technique or the "wet" method. The adhered carbon tissue is then developed in hot water to dissolve all the unexposed gelatin and allow removal of the paper backing. Finally, the tissue on the copper is dried, staged out with asphaltum, and etched.

In the dry-lay procedure, the exposed tissue is moistened and contacted to the copper almost simultaneously in a single motion with a squeegee or by rolling the tissue down onto the copper with a rubber brayer. Upon contact with the copper, a strong molecular attraction is set up as the gelatin absorbs residual moisture, and the two surfaces adhere. With this procedure, the tissue absorbs only a minimum of water, and at the point of adhesion, no distortion of the image occurs, making this method ideal for color work and for accurate placement of images on copper. This procedure is the fastest and the most dependable. The tissue, however, must be reasonably flexible and not too dry. Ideal humidity of about 60 percent helps maintain the tissue, both before and after exposure, in an easily manageable state. If the tissue becomes too dry, it curls up tightly and is hard to handle, making smooth lay-down on the copper all but impossible.

When the "dry" technique is used, development can proceed immediately after lay-down.

For the wet lay-down technique, immerse the tissue in a tray filled with cool distilled water, 58° to 65° F. (14° to 18° C.), or a 50/50 mixture of alcohol and water until it becomes limp. Place it face down, in position, on a wet copper plate and squeegee to remove excess water. Another method is to immerse both the copper plate and the tissue in water. Lift them together from the tray, with the tissue in position, place on a flat surface, and squeegee. Avoid trapping air bubbles between the tissue and the copper. Squeegee the back of the tissue starting from the center and working outward in overlapping strokes from several directions. Immediately dry the back of the tissue with a soft absorbent cloth or paper towels.

A certain amount of manual dexterity is required for the wet lay-down procedure. You must be careful not to oversoak the

tissue and to position the tissue without trapping air underneath. If this operation is done quickly and the tissue has absorbed a minimum of moisture, it can be set aside for about 10 to 15 minutes before development. If the tissue has absorbed considerable water, however, you must wait from 30 minutes to 1 hour to allow some of the water to evaporate before proceeding with development.

If a mixture of 50 percent alcohol and 50 percent distilled water is used for this process, the amount of water absorbed by the gelatin is considerably less and the tissue remains suitable for transferring for a longer time. Positioning is also easier, because the tissue does not at first adhere tightly to the surface. Only after most of the alcohol has evaporated, leaving some of the water, does firm adhesion take place. A waiting period of approximately 20 to 30 minutes is usually sufficient before development.

With both the "wet" and "dry-lay" methods, take care to ensure equalization of the moisture content over the entire tissue surface. Avoid splashing the water, and do not allow excess water to remain at the edges of the tissue. If the tissue has been oversoaked and excess moisture remains, it will lift off during development.

## TRANSFER: "DRY-LAY"

### MATERIALS AND EQUIPMENT

Alcohol—denatured hardware-store variety (70 percent) or anhydrous (isopropyl water-free)

Rubber squeegee or soft rubber brayer

Soft cotton cloth or paper towels

Water trays large enough to accommodate the copper plate

Thermometer

Supply of hot water

Distilled water, room temperature

Soft absorbent cotton roll or pads

Masking tape

### PROCEDURE

*Step 1.* Place the clean, degreased copper plate on a pad of blotters or clean newsprint. Position the exposed carbon tissue face down on the copper surface and tape the farthest edge to the copper. (Exposure is normally made shortly before this step is carried out. It is possible, however, to store exposed tissue indefinitely if it is carefully sealed in plastic and placed in a freezer. Until the tissue is actually adhered to the copper, it should be handled only briefly in subdued room light or under yellow safelights.)

*Step 2.* Hold up the free end of the tissue with one hand, then pour a bead of distilled water along the taped edge and onto the plate. Immediately squeegee or roll the tissue onto the plate with a firm and not too slow motion, starting at the taped edge.

*Step 3.* Blot excess water from the edges of the adhered tissue. Remove the strip of tape and blot that edge.

*Step 4.* Swab the back of the tissue with a piece of cotton saturated with alcohol. This penetrates the backing tissue. When the darker transparent tone created by the alcohol is even over the entire surface, the plate is ready for development.

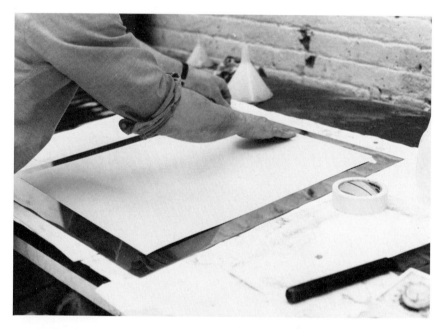

Step 1. The carbon tissue is positioned on the copper plate.

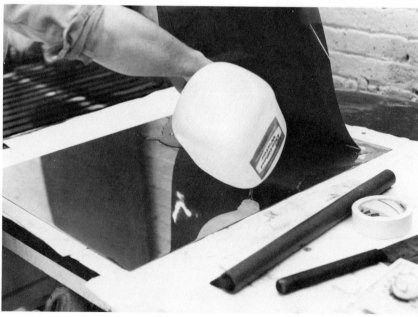

Step 2. Distilled water is poured onto the plate at the taped edge while the tissue is held up out of the way.

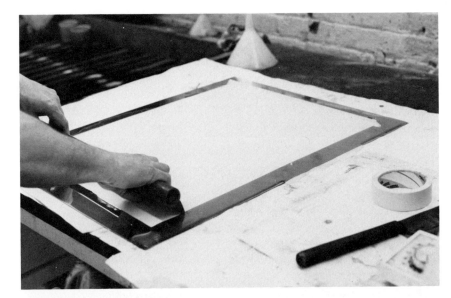

Step 2. The tissue is squeegeed to the plate carefully with a smooth, even motion.

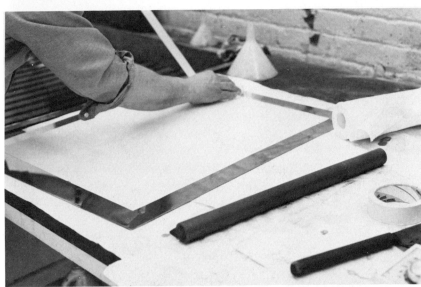

Step 3. Excess water is blotted up.

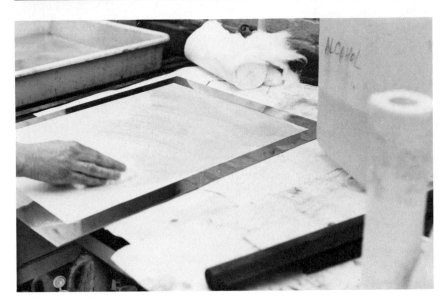

Step 4. The back of the tissue is swabbed with cotton saturated with alcohol.

## DEVELOPMENT

*Step 1.* Immediately following the treatment with alcohol, immerse the plate in a tray of hot water at 110° to 120° F. (43° to 49° C.). After 2 or 3 minutes, lift a corner of the tissue and peel it back. It should lift easily and with little resistance. If it separates with difficulty, let it sit in the hot water for a longer time. Check the temperature of the water. If it has cooled considerably, add more hot water.

*Step 2.* Next, using a wad of soft absorbent cotton, swab the surface gently to disperse the dissolved gelatin. Complete development takes approximately 10 to 15 minutes with intermittent swabbing. Change the water as it becomes murky with dissolved tissue, and be sure to maintain the same temperature. Do not apply pressure on the cotton; only the slightest contact is necessary to remove the unexposed parts of the gelatin. Also, take care not to touch the surface with a fingernail, as this will scratch the tissue irreparably.

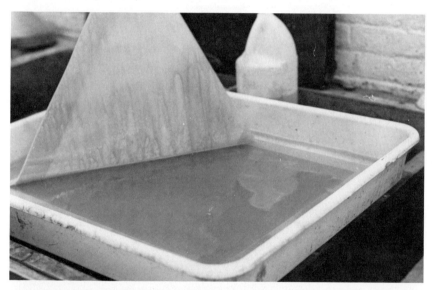

Step 1. The backing is separated from the tissue.

Step 2. Swabbing disperses the dissolved gelatin.

*Step 3.* When the image appears clearly defined and the cotton does not show pigmentation from the tissue, remove the plate from the tray and spray it gently with some cool water to firm up the remaining tissue. Next, place the plate in an alcohol-water bath (75 percent alcohol, 25 percent water) for 2 to 3 minutes. Rock the tray for this period. In this operation the alcohol draws moisture from the gelatin and promotes speedy and even drying.

*Step 4.* Remove the plate from the tray and prop it up vertically to dry. Do not attempt to speed up the drying with a fan. Drying will take place from the top down. Allow at least 1 hour and preferably 2 or more hours for even drying and for the tissue to reach equilibrium with the surrounding atmosphere. The edges of the tissue and the plate can then be protected (staged out) with asphaltum or stop-out varnish.

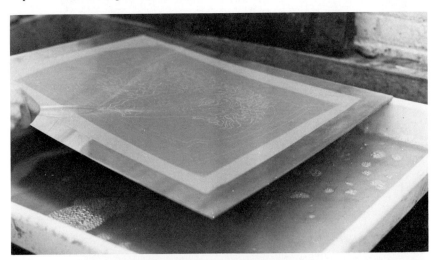

Step 3. A spray of cold water firms up the tissue before the plate is immersed in alcohol.

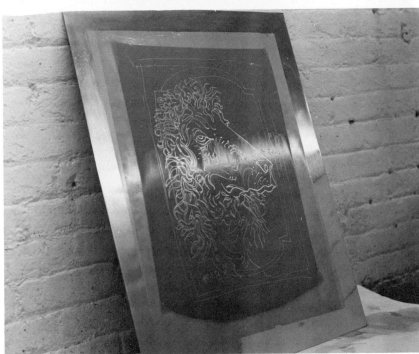

Step 4. After immersion in alcohol the plate is propped up and allowed to dry.

*Step 5.* For margins outside the image areas, the asphaltum can be thinned with paint thinner and used in a ruling pen for making lines directly on the tissue.

*Step 6.* The areas outside the ruled lines can be covered with additional asphaltum using a brush. If unbacked copper is used, the back must also be covered with asphaltum or stop-out varnish. When the asphaltum is dry, the plate is ready for etching.

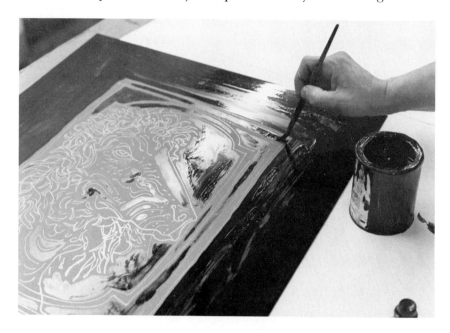

Step 6. Asphaltum is brushed outside the image areas.

## THE NATURE OF THE
## ETCHING PROCESS IN PHOTOGRAVURE

Although copper can be etched satisfactorily with different acids in conventional etching and photoengraving techniques, photogravure requires the use of a concentrated salt. Ferric chloride, which replaced platinic chloride early in the history of photogravure, is still the best and the most economical substance to use for the process. This salt of iron has a strong mordant effect on the copper, does not produce gas bubbles, and has a controlled breakthrough rate through the gelatin resist (carbon tissue).

Once the carbon tissue of a continuous-tone subject has been transferred to the copper and washed out, it represents a gelatin resist that ranges in thickness from about zero in the deepest shadow areas to about 15 microns (0.015 mm) in the highlight areas. When a concentrated salt such as ferric chloride is applied to the dry gelatin resist, the gelatin slowly absorbs the solution and swells to a maximum. The solution then diffuses through the gelatin, first in the thinnest parts of the resist, and begins to etch the underlying copper. In the thinnest areas of the gelatin, the ferric chloride rapidly breaks through the tissue. As the thickness of the gelatin increases, swelling and diffusion occur at increasingly longer intervals.

When a solution of ferric chloride is made more dilute by the addition of water, the gelatin absorbs the solution more rapidly, decreasing the diffusion time and allowing the solution to attack the copper. The most concentrated solution of ferric chloride (usually 43° to 45° Baumé) is used first. This solution penetrates the thinnest layers of the gelatin (shadow tones), but the rate of penetration decreases as thicker layers of gelatin are reached until it becomes too slow for graduated etching. If the etching is continued in this solution, the contrast would be increased and thicker parts of the gelatin would not be penetrated. Therefore, to begin the etching in the middle-tone and highlight areas, progressively diluted solutions of ferric chloride are used at appropriate time intervals.

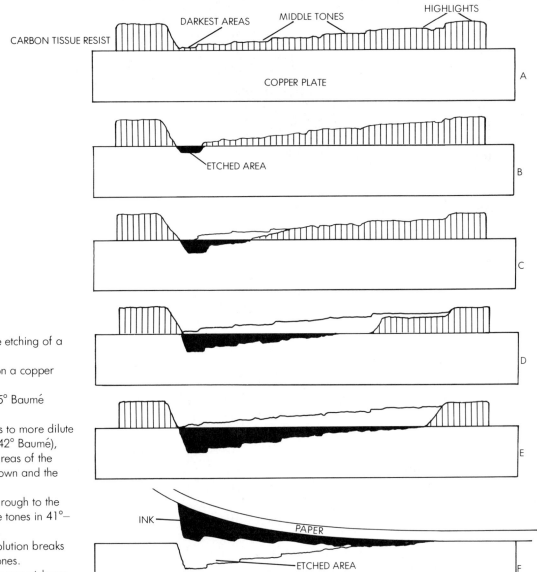

Stages in the progressive etching of a photogravure plate:
A. Carbon tissue resist on a copper plate.
B. Etching begins in a 45° Baumé solution.
C. As etching progresses to more dilute FeCl solutions (43°– 42° Baumé), increasingly thicker areas of the gelatin are broken down and the copper etched.
D. The etching breaks through to the copper on the middle tones in 41°– 40° Baumé solutions.
E. A 39°– 38° Baumé solution breaks through to the final tones.
F. During printing, the paper picks up ink from the plate.

You can control the progressive etching by adding water to the concentrated solution as the etching proceeds or by premixing four or five baths of different dilutions. It is common to have three or four different baths for etching. The best and most controllable method is to premix the solutions so that the diluted etching solutions have a chance to mature. This is a gradual process that takes place when water is added to ferric chloride as partial hydrolysis of the solution occurs. The usual progressions are 45°, 43°, 41°, 39°, and 37° Baumé. Even though etching seldom takes place in the 45° Baumé ferric chloride, it is a good idea to begin with this concentration as it acts as a preconditioning bath for the tissue and helps equalize the moisture content in the tissue. In addition, if the relative humidity in the etching room is abnormally high (75 percent or above), the tissue will already have absorbed considerable moisture from the atmosphere, and diffusion of the ferric chloride will take place at a more rapid rate. Under these conditions, etching of the copper will likely begin at 44° or 45° Baumé. In normal humidity (50 percent to 60 percent), the thinnest parts of the tissue may not be affected by either the 45° or the 44° Baumé solutions, and actual etching will begin only after the plate is immersed in the 43° Baumé solution.

It is also assumed that the temperature of the solutions is within the room-temperature range of 64° to 72° F. (18° to 22° C.). If the temperature is lower, the etching through the resist and its attack on the copper will be markedly slowed. The opposite is true when the temperature rises above this range—the penetration time is then shortened.

Because of the number of variable factors in the etching process, it is best to maintain as many constant elements as possible. Total control over humidity and temperature would be ideal; however, these conditions are seldom achieved in the small workshop, and so it is important to be aware of their effects and compensate for them.

The charts on the next page will help give an overall view of the etching procedure and the main variable factors—thickness of the resist, Baumé of the solution, etching time, and depth of etching.

The second chart shows that the depth of etching is relatively uniform and progresses at a rate of approximately 1 micron (0.001 mm) per minute. For commercial rotogravure printing the maximum plate depth for the darkest shadow tones is seldom more than 35 microns (0.03 mm or 0.001 inch). For making plates for hand printing, however, the requirements of high-speed printing machinery are not a consideration, and depths of over 80 microns (0.08 mm or 0.003 inch) are both possible and practical. At the etching rate of approximately 1 micron per minute, a total etching time of about 1½ hours would be necessary to reach this depth. This would provide a substantial depth suitable for strong linear or high-contrast images. Most of the etching would be done with highly concentrated ferric chloride in the 45° to 42° Baumé range. For the etching of full tonal subjects for printing by hand,

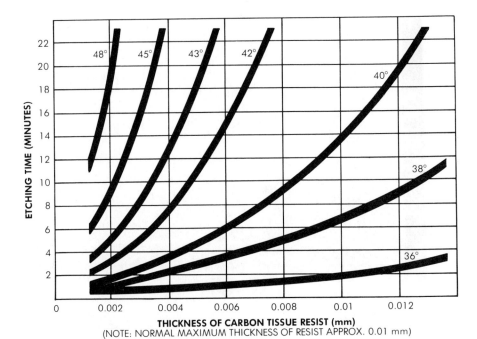

Rate of etching in ferric chloride.

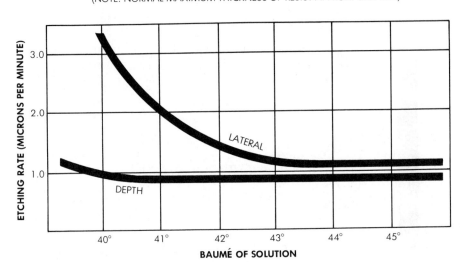

Depth of etching.

the most practical total etching time is between 30 minutes and 1 hour. Within this time frame it is possible to exert control over the entire tonal range yet achieve results that have a richness and quality that are difficult to get in high-speed gravure printing.

Crevé is a factor that you must watch for in the course of etching. It can be a clue to etching factors that could affect timing in the various solutions. Crevé occurs when the lateral etch breaks through to the next etched well, eliminating the intermediate pinnacle of copper which holds the ink during printing. The finer the screen or aquatint used in a deeply etched plate, the more danger there is of crevé.

It is possible to obtain a plate with a complete range of tonalities with a total etching time of from 15 minutes to 1 hour. So not only the etching time, but also the grain or screen size, exposure time, thickness of the carbon tissue image on the copper, and the type of paper to be used for printing have to be taken into account.

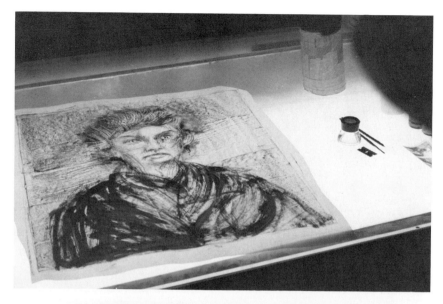

Drawing by artist Jim Dine made on translucent vellum with crayon and India ink. Some areas in the hair have been scratched with a razor blade.

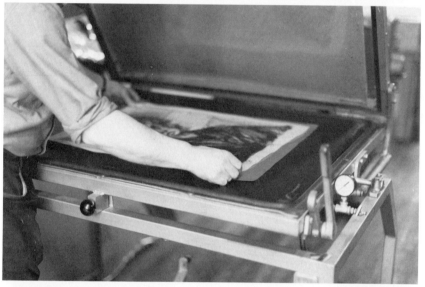

The drawing is placed in contact with the sensitized carbon tissue in the vacuum frame.

Exposure is made to an arc lamp.

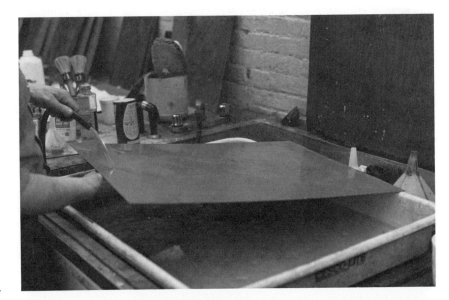

The adhered and developed image on the copper is firmed up with cold water.

After the plate has been in the alcohol bath, drying is speeded up with the use of a fan.

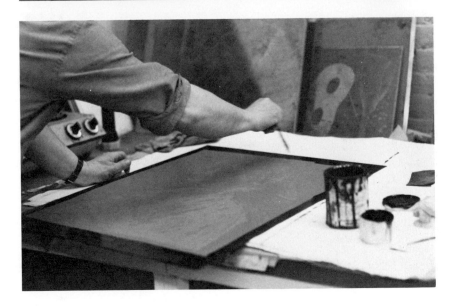

The plate is staged out with asphaltum.

During etching, the tray is tilted for inspection of the image.

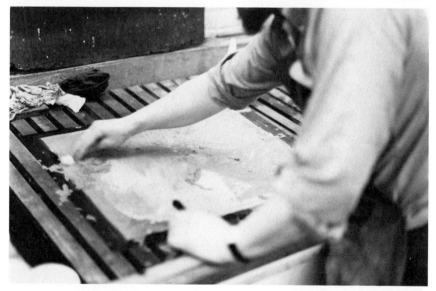

When the etching is completed, the plate is washed in the sink and the remaining carbon tissue removed from the surface. Asphaltum used for staging is removed with mineral spirits, paint thinner, or kerosene.

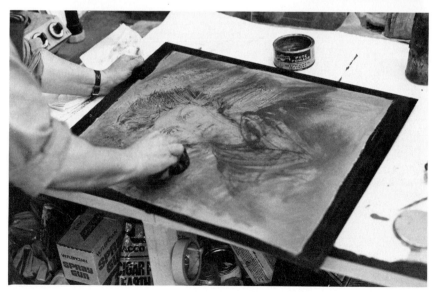

The plate is polished with Putz Pomade or another metal cleaner-polisher to remove discoloration and to allow inspection of the plate. Before proofing on the press, the plate edges must be filed so that the paper and blankets will not be damaged in printing.

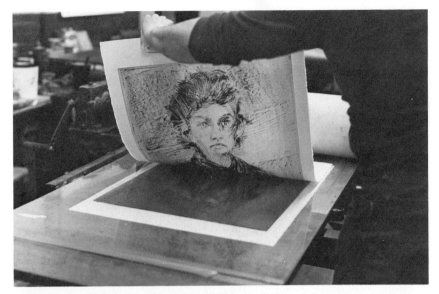

A proof being taken from the plate.

A detail of a section of the printed image.

Jim Dine, *Nancy Outside in July*, number 16 from a series of twenty-five prints. Published by Atelier Crommelynk, Paris. Courtesy of Pace Editions, Inc., New York.

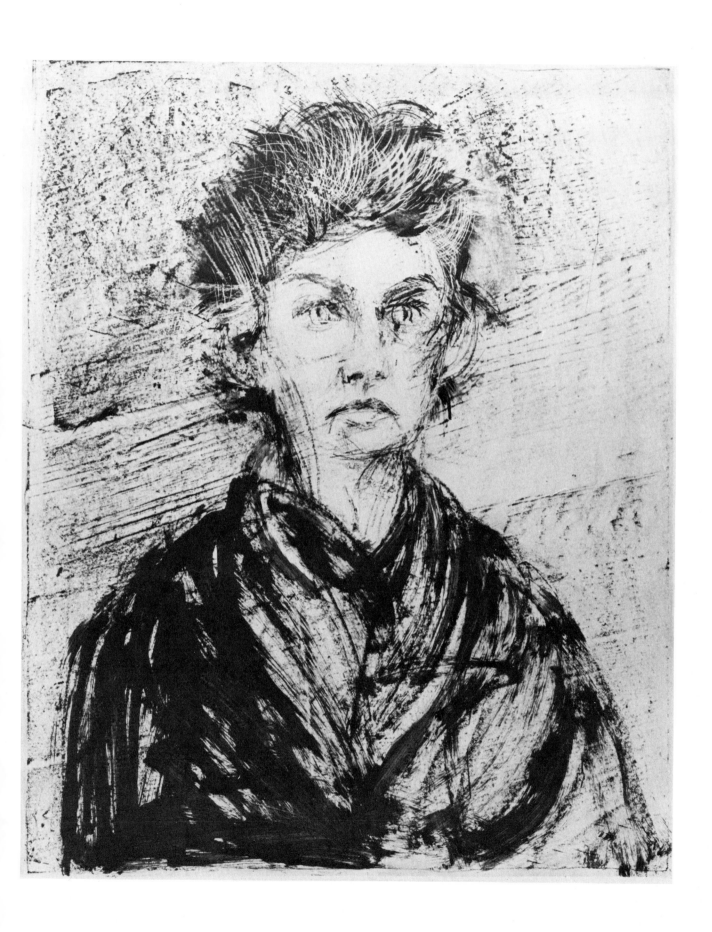

In commercial rotogravure etching, several different etching systems are used in addition to the multiple-solution technique. One system employs a carefully monitored continuous-dilution technique in which a machine electronically controls the dilution, agitation, and temperature of the ferric chloride throughout the process. Other systems employ a single-bath or double-bath method. These techniques rely on specific thicknessess of the carbon tissue on the copper so that the ferric chloride breaks through them at a controlled rate with a single solution. The Baumé of the single-bath technique is approximately 40°. A concentration slightly under this figure speeds up the progressive action; one slightly higher slows the action of the etch.

For etching flat plates for hand printing, the most reliable method is the multiple-bath technique. In this system, four or five different solutions are mixed and stored in separate plastic or glass containers. A normal range of concentrations is 45°–44°, 43°–42°, 41°–40°, 39°–38°, and 37° Baumé. These solutions should be mixed several hours in advance and a reading taken with a hydrometer. When water is first added to ferric chloride, partial hydrolysis of the solution takes place; only after a period of time does the solution become stable. Because of this, the method of adding water to lower the Baumé while etching is in progress is less dependable.

Each container should be labeled according to its Baumé. The solutions can be used over and over again; only when a solution has become greenish in color, as opposed to the warm brownish color of a fresh solution, should it be discarded.

## MULTIPLE-BATH METHOD: MATERIALS AND EQUIPMENT

Two etching trays large enough to accommodate the copper plate (trays must be glass or plastic; stainless steel will be affected by the ferric chloride)

Separate containers of premixed ferric chloride in the following solutions: 45°, 43°, 41°, 39°, and 38° Baumé; or 44°, 42°, 40°, 38°, and 37° Baumé

Hydrometer for heavy liquids with a range of 37° to 50° Baumé

Solvent for removing asphaltum (paint thinner, kerosene)

Copper cleaner (Twinkle, acetic acid–salt–water solution)

Putz Pomade for final polishing of the copper

## MULTIPLE-BATH METHOD: PROCEDURE

*Step 1.* Pour some of the 45° Baumé solution into one of the trays and slowly lower the plate, face up, into the solution. The ferric chloride should cover the plate by at least ¼ inch (25 mm). Set the timer. Prepare the second tray and pour the second solution (44° or 43° Baumé) into it.

*Step 2.* Tilt the tray slowly so that you can see the surface. Watch the plate closely. The darkest parts of the image will begin to etch first. (These are the lightest, thinnest parts of the carbon tissue.) When etching begins, the plate will change color from a faint sienna tone to a dark brown-black as the ferric chloride begins to attack the copper. If the first bath used is 45° Baumé, the first signs of the copper being etched should begin to show within 5 minutes if the relative humidity is 60 percent or over. This is because of the hygroscopic nature of the gelatin which absorbs moisture from the atmosphere and speeds up the etching process. If the tissue is very dry, etching may not begin even after 10 minutes. In that case, transfer the plate to the next solution; it should begin to etch within 2 to 3 minutes. Begin timing the etch from the moment the ferric chloride begins to attack the copper.

After shifting the plate to the second tray with the lower Baumé, pour the solution from the first tray back into its original container. Throughout the etching procedure, change the solution in one tray while the plate is in the other. If the etching appears to progress too quickly when you move the plate to a lower-Baumé solution, put the plate back into the previous bath.

The following etching table can be used as a general guide to timing in the various ferric chloride solutions:

| Bath | Solution | Time after etching begins |
|------|----------|---------------------------|
| First | FeCl 45° Baumé | 5—8 minutes |
| Second | FeCl 43° Baumé | 12—14 minutes |
| Third | FeCl 41° Baumé | 8—10 minutes |
| Fourth | FeCl 39° Baumé | 4—5 minutes |
| Fifth (if necessary) | FeCl 37° Baumé | 2—3 minutes |

Stages in photogravure etching using the multiple-bath technique.

The total etching time can vary from about 20 minutes when an extremely fine screen or aquatint is used to about 1 hour when a high-contrast image with deeply bitten darks is desired. Prolonged etching times require that the plate remain in more concentrated ferric chloride solutions. Also, if the resist on the

plate is thicker than normal because of overexposure, the etching times must be extended.

*Step 3.* After the highlights have been etched in the last bath, transfer the plate to the sink and rinse the back and the face with running water. The tissue will come off easily when scrubbed with a nylon brush and water or with an application of copper cleaner such as Twinkle. Remove the asphaltum with some paint thinner or kerosene. At this point the entire plate will appear discolored. Only when it is polished with some Putz Pomade, a compound containing jeweler's rouge, will the image become clearly visible.

*Step 4.* File and smooth the edges of the plate with snakestone, no. 600 emery cloth, or steel wool in preparation for printing. Any sharp edges left on the copper can cut through the printing paper and the felt blankets under pressure.

## ETCHING LINE WORK

For etching deeply bitten linear work, it is important that good contact be made between the positive and the carbon tissue during exposure. Leave the vacuum frame on for at least 5 minutes before exposure to ensure total contact between the tissue and positive. This will give the sharpest possible results.

Start the etching in a 43° Baumé or 42° Baumé bath. As soon as the majority of lines have begun to etch, shift the plate into a bath of higher concentration, either 45° or 46° Baumé, for the duration of the etching.

If the line width exceeds 3/16 inch (5 mm) in any area, provide a screen exposure in addition to the main exposure, or use an aquatint grain on the surface of the plate.

Left: Crevé occurring as the lateral etch breaks through the pinnacle of copper in the darkest tones. Right: A deeply bitten plate that does not crevé because of greater coverage of the aquatint grain or screen.

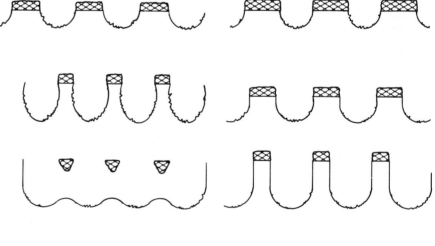

Left: A wide line etched without screen or aquatint. Ink is held only at the edges while the center area is wiped clean. Right: Ink is held by the smaller wells, printing a solid mass of ink over the line width.

# NOTES ON PRINTING
# PHOTOGRAVURE PLATES

The basic procedure for printing photogravure plates follows that of normal etchings or engravings. The paper is dampened either the night before and wrapped in plastic, or several hours in advance of printing.

One common fault in printing photogravure plates is to use too little pressure. Because the etching in a photogravure plate is shallow compared to that in normal etching, the assumption is made that only light pressure is necessary. Just the opposite is true, however. It is common to have a margin between the image and the filed edges, so I have found that a piece of paper (approximately 100# stock) cut to the size of the image and adhered to the back of the plate with spray adhesive directly behind the image area helps provide extra pressure on the printing parts of the image and helps keep the margin areas clean. This is effective even with heavy 16-gauge copper.

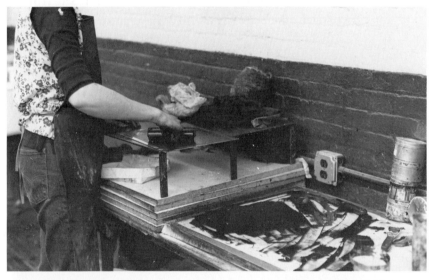

Ink is applied to the plate with a brayer.

The plate is wiped with tarlatan.

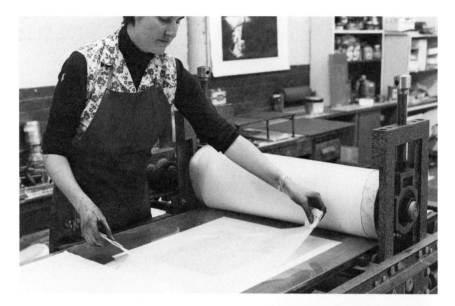

The dampened paper is placed over the inked plate on the press bed.

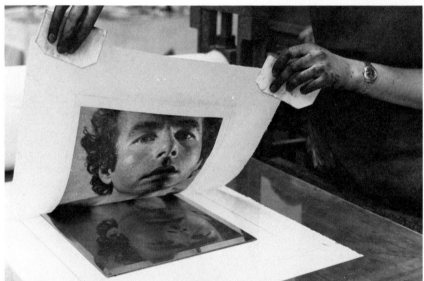

The printed sheet is removed from the plate.

The print is then placed between blotters and weighted.

Wipe the plate both with a rag as a final wipe and with the palm of your hand so that you can compare the results. The first leaves a slight plate tone; the *a palma* method gives a cleaner overall wipe. In both cases, any margin around the image should be cleaned thoroughly by hand with some calcium carbonate (whiting) powder. Use it sparingly and carefully so that none of the powder gets into the actual image areas.

## ETCHING PROBLEMS

| Problem | Cause | Remedy |
|---|---|---|
| Tissue does not lie perfectly flat in vacuum frame; cracks along edges. | Tissue too dry | Tissue should be handled in an area that is humidified, ideally to 60 percent |
| Tissue curls up tightly, is difficult to lay down evenly on copper | Tissue too dry | Same as above; however, "wet" method for adhering tissue to copper can be used |
| Tissue lifts from copper during development, either at the edges or over larger areas | Excess water absorbed by tissue | Blot excess moisture from back of tissue immediately after lay-down |
| | | Let excess moisture evaporate from backing tissue for a longer period |
| | | Avoid splashes of water on back of tissue at any time before development |
| | Copper insufficiently cleaned | Clean copper surface thoroughly to remove any grease or oil |
| | | Remove oxidation from surface |
| Small blisters appear in adhered tissue during development | Air trapped between tissue and copper | Take more care during lay-down |
| | | Use distilled water |
| | | Apply more pressure on squeegee or brayer during lay-down |
| Plate etches unevenly, or streaks appear which fail to etch | Incomplete development in hot water, leaving traces of dissolved gelatin | Develop longer and change hot water more frequently |
| | | Check temperature of water; it may not be hot enough |
| | | Swab more carefully with cotton during development |
| Mottled etching | Incomplete contact of tissue and positive in vacuum frame caused by textured base surface in vacuum frame or insufficient contact | Place a smooth, heavy-weight paper in vacuum frame base |
| | | Leave vacuum on for longer period before exposure |
| Copper pits due to pinholes in resist; etch breaks through; can begin to spread underneath tissue ("etching devils") | Specks of dust embedded in tissue during sensitization or during lay-down; or too much free acid in ferric chloride (cause is often difficult to isolate) | Scrupulous attention to every phase is important; watch for contamination of water with particles of whiting or dust |
| | | Use only acid-free ferric chloride such as Hunt Chemical Roto Iron Blue Label 48° Baumé (catalog no. 839589) |
| Dark areas begin to etch totally, causing crevé before etching of lighter tones is complete | Screen exposure breaks down or aquatint too fine for depth of bite | Lengthen screen exposure |
| | | Apply coarser aquatint screen to plate |
| Round spots that suddenly turn dark and begin to etch | Water inadvertently splashed on plate either before or after etching has started (tissue will retain moisture in spots even when superficially dry) | No solution except to redo plate or make corrections if areas affected are away from image |

# STEEL FACING

When the principles of electrodeposition were discovered in the mid-nineteenth century, innumerable practical uses for the process appeared almost instantly. One such application was electroplating a harder metal such as iron onto etched or engraved copper plates which allowed a greater number of good impressions to be made. This proved to be extremely helpful, not only for the extended printing of photogravure plates, which were becoming increasingly important as a method of reproductive etching, but also for strengthening work made by more traditional techniques such as mezzotint and drypoint.

Over the years, nickel and chromium were used in addition to iron for electroplating onto etched or engraved copper. These metals provided an even harder and more durable surface than iron. Nickel and chromium, however, became more useful to the letterpress industry, where the number of impressions printed from type-high metal often ran into the hundreds of thousands.

The plating of iron onto copper etching and engraving plates—a process that became known as steel-facing—became the preferred method for treating these plates, not only because of the simplicity and availability of the basic materials, but also because iron is extremely sensitive to fine detail and seldom interferes with the integrity of the image. It can also be removed from the copper quickly and easily when the plate shows the slightest signs of wear or when the plate is to be reworked.

In the steel-facing process, a copper plate is immersed in a vat containing a electrolyte solution and suspended from one side. Iron is suspended from the opposite side of the vat and a direct electrical current, supplied by a battery or rectifier, is hooked up

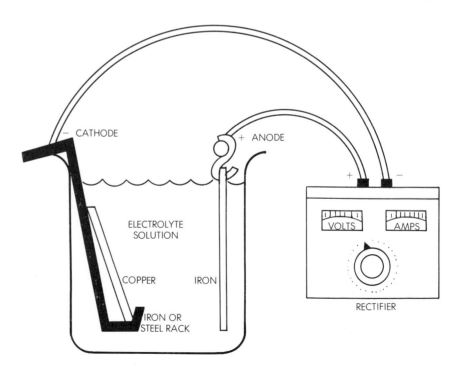

Wiring diagram for the steel-facing unit.

to the iron and copper. The iron is connected to the positive terminal (anode) and the copper to the negative terminal (cathode). When switched on, the current flows from the iron onto the electrolyte solution and to the copper, completing the electrical circuit. In the process, ions of iron are removed from the suspended iron plate, flow through the solution, and are deposited onto the copper.

## THE VAT

This should be constructed from any waterproof, nonconductive material, such as fiberglass or polypropylene, large enough to contain the largest plate to be faced. Suppliers of electroplating materials often have a variety of vat sizes in stock or can make up any specific size to order. For plating large plates it is important to keep a sufficient distance between the iron and the copper so that plating takes place over the entire copper surface at one time. If the iron immersed in the solution is considerably smaller than the copper (which is usually the case), there is a tendency for the closest section of the copper to attract more iron. Although it is possible to proceed in stages by moving the iron to even out the plating, maintaining a distance of a foot (30 cm) or more between the iron and copper will alleviate the problem and should be considered when the vat is purchased or constructed.

## THE IRON

The best iron for use in steel facing is as pure as possible and contains a minimum of carbon and only trace amounts of other metals. Traditionally, what was called Swedish wrought iron was used; however, this is no longer available and has been replaced by Armco or ingot iron. The iron may have a carbon content of between 0.02 and 0.04 percent, although iron having a carbon content as high as 0.08 percent can also be used satisfactorily. During the plating, as molecules of pure iron migrate from the iron plate into the solution, a film of carbon appears on the iron. This can be removed simply by removing the iron plate and scrubbing with a brush and clean water. The iron can then be returned to the solution.

## THE POWER SOURCE

Only direct current can be used for electroplating. A rectifier that changes alternating current to direct current is best, as both the amperage and voltage can be regulated for precise control of the plating procedure. A 6-volt, 50-amp rectifier is sufficient for plates up to $30 \times 40$ inches ($76 \times 102$ cm). A current density of approximately 0.03 amps per square inch is generally considered an ideal average, but actual current density may vary greatly, depending on the concentration of the electrolyte solution. If the ammonium chloride solution is of a higher concentration because of water evaporation or another cause, the iron will migrate faster through the solution and plating will proceed at a faster rate. For

most plates, the amperage needed for good plating is between 8 and 10 for small plates and between 20 and 25 for large plates.

After 3 or 4 minutes in the plating tank the copper should display a bright, shiny layer of deposited iron. If, after 5 minutes, very little iron is seen to be deposited, it may be that the current needs to be increased or that a more concentrated ammonium chloride solution is needed. With a freshly mixed electrolyte solution, plating at first proceeds very slowly until the solution builds up a sufficient iron reserve. Before plating for the first time it is a good idea to use a small plate as the cathode and to switch the current on for several hours to build up the iron in the solution.

## THE ELECTROLYTE SOLUTION

This is prepared with water and ammonium chloride (sal ammoniac) in the proportion of 1½ to 2 pounds for every gallon of water (180 to 240 grams per liter). To calculate the volume of the vat, pour, say, 10 gallons of water into it, then measure the height of the water on the inside of the vat. Divide the total height of the vat by this measurement, then multiply the result by the number of gallons used. Once you have ascertained how many gallons the vat contains, fill it halfway with water, weigh and pour the ammonium chloride, then add water, bringing the solution within a few inches of the top.

This electrolyte solution seldom needs changing, even with heavy use, except when it becomes contaminated with copper or a metal other than iron which would interfere with the plating. As the solution is used, the ammonium chloride changes to ferric ammonium chloride as more and more iron gets into the solution. This improves its plating characteristics. Even though a crust of iron oxide forms on the top of the solution when it is left standing

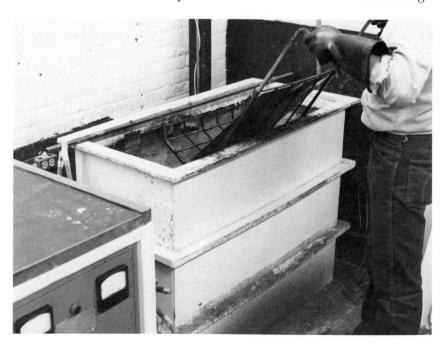

The plate is lowered into the vat. A negative clamp is then attached to the handle of the rack and the current is turned on.

for a day or so, this does not interfere with the plating process. After months of use, if it appears that the plating is proceeding slowly, additional ammonium chloride can be added to the solution. Water can be added at any time to replace that lost by evaporation.

In time a thick sludge forms on the bottom of the vat. This will not affect the plating characteristics of the solution. If any copper or other metal besides iron should fall into the tank, however, it should be removed as soon as possible; the corrosive action of the salt on the metal will eventually contaminate the solution. For this reason, the copper plate to be steel-faced should not be left in the solution when the current is off. It is also a good idea to remove the iron from the solution when not in use to avoid unnecessary corrosion of that metal.

## THE BASIC PLATING PROCEDURE

It is essential that the copper plate be absolutely clean of oil, ink, or oxidation. Remove dried ink from lines with lacquer thinner, then clean the plate with whiting and ammonia or whiting and a weak water-lye solution. The commercial copper cleaner Twinkle or a solution of water, acetic acid, and salt will remove oxidation. Before plating, the copper should hold water in a thin film over the entire surface and show no signs of beading.

After the first 5 minutes of plating, remove the plate and wash it under running water. Scrub it with some whiting, a weak lye solution, or ammonia, then rinse it. Concentrate on any areas that have not been plated, then return the plate to the vat and plate for another 5 minutes. Once the entire surface seems to be plating evenly, clean it with pumice in place of the whiting. It is important to remove the plate at 5- or 10-minute intervals for cleaning for an evenly plated surface. If a plate is left for too long, stray specks of foreign material attach themselves to the plate, and the iron adheres around each particle. A small plate is often completely plated in about 15 to 20 minutes; larger plates require an hour or longer.

Once the plating is completed, remove the plate from the bath and rinse it thoroughly on both sides with running water. Dry it immediately to prevent rusting. To dry the plate quickly, run hot water over it, then dry it with paper towels. Next, polish the plate with Putz Pomade or a similar metal cleaner. This removes the brownish-gray film and brightens the surface. Cover the plate with a film of asphaltum, oil, or petroleum jelly until it is ready to be printed. The plate should be protected in this way at all times when not in use to prevent rusting due to condensation of moisture on the plate surface.

The number of impressions that can be made from a steel-faced plate is difficult to judge accurately. It depends on the nature of the image, the basic hardness of the copper, and the thickness of the deposited iron. The average photogravure or aquatinted plate should withstand at least a hundred impressions before

additional facing is necessary. This is also determined in part by the coarseness of the ink, the amount of pressure, and the paper used, however. Inks made with earth pigments such as umbers and siennas have a slight abrasive quality which causes greater wear on the plate than carbon black ink. The first signs of wear show up in deeply aquatinted areas where the peaks of metal show the copper before light tones or along the edges of etched lines. When you first observe this, clean the plate thoroughly, then replate it without removing the previous facing; or remove the facing from the plate and face the plate anew.

## COMMON PLATING DEFECTS

The most common defect caused by plating at too high an amperage is that the edges and corners of the plate show a rough, dark deposit of iron. If the plating has not proceeded for too long, the plate may be taken out and cleaned with whiting or fine pumice, then replaced in the vat and the plating continued at a lower amperage. Areas on the copper that fail to plate usually have a slight film of grease, oil, or oxidation which prevents the iron from adhering to the surface. The copper must be thoroughly degreased and completely free of any surface oxidation. Aquatint areas and deeply etched lines often resist plating because of traces of ink still left in the plate. Once the surface areas are plated, ink can often be removed by scrubbing difficult areas with a soft paper towel, some FFF pumice powder, and a weak water-lye solution. The plating can then be continued.

## REMOVING THE IRON FROM THE COPPER

A weak solution of nitric acid and water (approximately 5 percent nitric acid, 95 percent water) is one of the best ways of removing the iron from the copper. First clean the copper thoroughly to remove any ink, grease, or oil, then immerse it in a tray containing the nitric acid solution. Within 1 or 2 minutes copper will show over the entire plate. Rinse it with clean water, then clean it with some whiting and weak lye or ammonia. The plate can then be replated if necessary or reworked.

# CHAPTER SIX

# PHOTO-SCREEN TECHNIQUES

In the past two decades, the advances made in screen-printing materials and processes have benefited both the commercial industry and the artist involved in printing limited editions. Materials, inks, and photo emulsions have been improved to the point where they are simple to use, give predictable results, and produce exceedingly fine detail. Four-color process work with 120-line screens is not uncommon. Many newer presses are completely automated and can print several thousand impressions per hour. Although the artist seldom needs or has access to production machinery of this kind, many of the newer processes can be used to advantage in printing limited editions by hand. Halftone process inks, for example, have a low buildup and are transparent and brilliant, allowing effects similar to those produced in lithography. The basic equipment needed for printing by hand is comparatively inexpensive and is not heavy or cumbersome. Various photographic procedures are also available to suit individual requirements of size, imagery, and equipment setup. These include the direct photo-screen method, in which the liquid photo emulsion is applied directly to the screen before exposure; the direct-indirect method, in which a separate sheet of gelatinized film on a plastic backing sheet is sensitized and adhered to the screen simultaneously; and the indirect method, in which a sensitized piece of film is first exposed and then adhered to the screen.

One of the great attractions of screen printing for the artist is its great versatility—from the hard-edge imagery of artists like Anuszkiewicz and Krushenick, to the large-scale photographic imagery on canvas by Rauschenberg and Warhol, to the photo-realism using complex photo screens made with a step exposure system in more than thirty colors by Audrey Flack.

All the procedures described in this chapter make use of a positive image, either photographically produced or drawn by hand on a translucent material. Having a good enlarger or access to a process camera is a definite asset. The potential for creative

experimentation in the darkroom is greater here than in any other phase of the screen-printing operation. Continuous-tone images may be posterized in graduated steps as line shots, or halftones manipulated with a variety of available screens both negatively and positively, cropped, enlarged, or reduced—all prior to transferring the images to the screen for printing.

## SCREEN FABRICS

Almost all the fabrics used in screen printing today are made of nylon or polyester. Although silk is still available, its use—except for special purposes such as direct drawing with tusche or crayon—has become impractical. Both polyester and nylon are preferable for photographic techniques because they have great chemical resistance and the ability to withstand repeated use with a variety of photo emulsions.

Screen fabrics dyed yellow or orange are specifically designed for photographic work with either the direct emulsion method or the direct-indirect system. The yellow or orange color of the fabric prevents ultraviolet light from being refracted sideways through the strands of nylon or polyester, resulting in sharper edges and better image quality.

*Nylon.* Fabric made of nylon is available only in monofilament form. This means that both the vertical and the horizontal threads of the fabric are made from single strands of nylon. Because each strand of nylon is smooth, it must be roughened and degreased before it is used to allow the photo emulsion to adhere firmly (see pages 151–152). Nylon is affected by moisture: it stretches when wet and tightens upon drying. It must therefore be stretched while wet in several stages to remove most of its initial elasticity. Stretching the fabric tightly in this way also minimizes changes in screen tension due to atmospheric humidity, a factor particularly noticeable in work with large screens. Most solvents, such as mineral spirits, turpentine, lacquer thinner, alcohol, and benzine (naphtha), can be used for cleaning nylon screens. Strong acids, however, should be avoided, because they can dissolve the fabric.

*Polyester (Monofilament and Multifilament).* Fabrics made of polyester are extremely durable and have excellent dimensional stability. They stretch tightly in a dry state and, unlike nylon, are affected very little by moisture. They are also impervious to solvents such as lacquer thinner, mineral spirits, alcohol, benzine, and turpentine, as well as strong acids and alkalies. Monofilament polyester fabric is constructed similarly to nylon; both horizontal and vertical threads are made up of single strands. It must be roughened and degreased before use in the same manner as monofilament nylon. Each strand of multifilament fabric is composed of many finer strands twisted together. This fabric combines some of the best qualities of silk, which is also a multifilament, and synthetics. Before use, polyester fabric should

be scrubbed with no. 500 silicon carbide powder (carborundum) and degreased with a trisodium phosphate solution (see page 151). Because of the nature of polyester fabric, it must be cleaned thoroughly after printing when it is to be reused in order to remove all traces of ink and emulsion from the strands of the fabric.

Screen fabrics are classified according to the mesh count per inch, mesh opening, percentage of open area, and fabric thickness. Multifilament fabrics, both polyester and silk, are also given a number followed by a single, double, or triple *X* to designate the weight of the fabric. A single *X* indicates a standard weight; *XX*, a double extra weight; and *XXX* means there are extra threads in both vertical and horizontal strands for added strength. The most commonly available weight is XX. This weight ranges from 6XX, which has about 74 strands to the inch, to 25XX, which has 196. For most work in which there is considerable detail and large open areas, a mesh of 12XX to 16XX would be satisfactory. For photo emulsions, whether direct or indirect, a monofilament fabric—either nylon or polyester—is preferable. Monofilament fabrics have a high percentage of open area, allowing greater flow of ink through the fabric and clean delineation of the dot structure in fine halftone printing. The most efficient fabric in this regard is one having a relatively high percentage of open area and a fine strand thickness. Textile printing, which requires heavy ink deposits, makes use of fabrics rated 6XX or 8XX, a mesh count of well under 100 strands per inch. The charts on the following page give a comparison of most screen fabrics.

## PREPARATION OF THE SCREEN

Perhaps the most important factor in maintaining close registration and fine detail is a tightly and evenly stretched screen. This cannot be emphasized strongly enough! Flimsily constructed wooden frames warp and bend, creating uneven tension. The larger the frame, the more substantial the frame material should be. If a great deal of printing is to be done, aluminum frames, although initially more expensive, may prove worthwhile in the long run. Some printers stretch fabric by hand and get enough tension and evenness for their requirements. For the most critical printing, however, mechanical or pneumatic stretching devices that regulate the tension are ideal. One such device is the M&M Fabric Tensioner, which is a metered and pressurized unit that guarantees optimum tension and evenness overall. This is particularly important in fine multicolor printing where the tension cannot vary from one screen to the next. This kind of unit is expensive and can be justified only in large shops where there is considerable changeover, but it is nevertheless possible to have several screens stretched professionally at very little cost.

A newly stretched screen must be thoroughly degreased and

## COMPARISON OF MESH SIZES

### Natural Silk

| Number | Mesh count per inch | Mesh opening in inches (mm) |
|---|---|---|
| 6XX | 74 | 0.0096 (0.24) |
| 8XX | 86 | 0.0076 (0.19) |
| 10XX | 105 | 0.0063 (0.16) |
| 12XX | 124 | 0.0047 (0.12) |
| 14XX | 139 | 0.0039 (0.10) |
| 16XX | 157 | 0.0035 (0.09) |
| 18XX | 171 | 0.0032 (0.08) |
| 25XX | 195 | 0.0025 (0.06) |

### Multifilament Polyester

| Number | Mesh count per inch | Mesh opening in inches (mm) | Open area (percent) | Fabric thickness in inches (mm) |
|---|---|---|---|---|
| 6XX | 74 | 0.0092 (0.23) | 44 | 0.0061 (0.15) |
| 8XX | 86 | 0.0071 (0.18) | 36 | 0.0059 (0.15) |
| 10XX | 110 | 0.0051 (0.13) | 30 | 0.0051 (0.13) |
| 12XX | 125 | 0.0045 (0.11) | 27 | 0.0047 (0.12) |
| 14XX | 137 | 0.0042 (0.11) | 26 | 0.0047 (0.12) |
| 16XX | 158 | 0.0035 (0.09) | 27 | 0.0039 (0.10) |
| 20XX | 175 | 0.0033 (0.08) | 36 | 0.0035 (0.09) |
| 25XX | 196 | 0.0028 (0.07) | 31 | 0.0033 (0.08) |

### Monofilament Nylon

| Mesh count per inch | Mesh opening in inches (mm) | Open area (percent) | Fabric thickness in inches (mm) |
|---|---|---|---|
| 74 | 0.0077 (0.20) | 34 | 0.0106 (0.27) |
| 86 | 0.0076 (0.19) | 44 | 0.0072 (0.18) |
| 109 | 0.0055 (0.14) | 37 | 0.0071 (0.18) |
| 124 | 0.0050 (0.13) | 42 | 0.0055 (0.14) |
| 140 | 0.0044 (0.11) | 38 | 0.0049 (0.12) |
| 160 | 0.0035 (0.09) | 32 | 0.0052 (0.13) |
| 180 | 0.0032 (0.08) | 31 | 0.0042 (0.11) |
| 200 | 0.0030 (0.08) | 36 | 0.0033 (0.08) |
| 235 | 0.0024 (0.06) | 31 | 0.0033 (0.08) |
| 260 | 0.0021 (0.05) | 31 | 0.0030 (0.08) |
| 285 | 0.0021 (0.05) | 31 | 0.0030 (0.08) |
| 306 | 0.0018 (0.05) | 29 | 0.0027 (0.07) |
| 330 | 0.0017 (0.04) | 34 | 0.0024 (0.06) |
| 355 | 0.0016 (0.04) | 33 | 0.0024 (0.06) |
| 380 | 0.0014 (0.04) | 30 | 0.0023 (0.06) |
| 420 | 0.0010 (0.03) | 18 | 0.0026 (0.07) |
| 457 | 0.0010 (0.03) | 21 | 0.0023 (0.06) |

### Monofilament Polyester

| Mesh count per inch | Mesh opening in inches (mm) | Open area (percent) | Fabric thickness in inches (mm) |
|---|---|---|---|
| 54 | 0.0124 (0.31) | 44 | 0.0118 (0.30) |
| 64 | 0.0106 (0.27) | 42 | 0.0094 (0.24) |
| 74 | 0.0087 (0.22) | 42 | 0.0094 (0.24) |
| 86 | 0.0075 (0.19) | 46 | 0.0073 (0.19) |
| 110 | 0.0059 (0.15) | 43 | 0.0057 (0.14) |
| 125 | 0.0051 (0.13) | 42 | 0.0049 (0.12) |
| 140 | 0.0047 (0.12) | 42 | 0.0045 (0.11) |
| 160 | 0.0038 (0.10) | 35 | 0.0047 (0.12) |
| 180 | 0.0035 (0.09) | 38 | 0.0039 (0.10) |
| 200 | 0.0028 (0.07) | 29 | 0.0045 (0.11) |
| 235 | 0.0024 (0.06) | 31 | 0.0039 (0.10) |
| 260 | 0.0022 (0.06) | 31 | 0.0030 (0.08) |
| 285 | 0.0020 (0.05) | 32 | 0.0029 (0.07) |
| 306 | 0.0017 (0.04) | 27 | 0.0029 (0.07) |
| 335 | 0.0016 (0.04) | 25 | 0.0022 (0.06) |
| 350 | 0.0012 (0.03) | 19 | 0.0029 (0.07) |
| 380 | 0.0013 (0.03) | 24 | 0.0026 (0.07) |
| 420 | 0.0010 (0.03) | 18 | 0.0026 (0.07) |

the fabric given a "tooth" to enable the photo emulsion, either direct or indirect, to adhere firmly. Although every new screen should be given this treatment, it is particularly important for monofilament fabrics because the smooth individual strands cannot hold emulsion well unless they are slightly roughened. With indirect photographic stencils where the developed stencil is pressed into the fabric from one side of the screen, roughening is extremely important to prevent particles of the emulsion from breaking away in the course of printing.

In addition to the "tooth" given to the fabric, good adhesion of the photographic stencil depends on the screen's being completely grease-free. Trisodium phosphate is one of the best chemicals to use for degreasing fabric. It breaks up the molecules of grease and oil and suspends them in water for easy removal.

One of the best procedures for both degreasing the fabric and giving it a "tooth" is as follows.

## MATERIALS AND EQUIPMENT
No. 500 silicon carbide grit (carborundum)

Trisodium phosphate (available in supermarkets under the brand names Cascade, Calgon, Electro-Sol, or Finish)

Nylon brush or clean cotton cloth

## PROCEDURE

*Step 1.* Place the screen in the sink and wet the fabric, then sprinkle some silicon carbide grit over the screen.

*Step 2.* Scrub both sides of the fabric thoroughly with the brush or a damp cotton cloth.

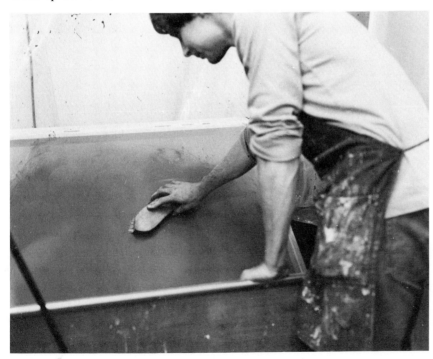

Step 1. The fabric is dampened.

*Step 3.* Rinse thoroughly, then sprinkle some trisodium phosphate on the fabric and scrub with the brush on both sides. Rinse thoroughly and dry.

Scouring powders such as Ajax or Comet are often used to roughen and degrease fabrics. These powders must be used with caution, however, because the grit they contain can shred fine synthetics, and traces of bleach or detergent remaining in the fabric can prevent rather than promote good adhesion of emulsion. If you use them, you can minimize some of their negative aspects by following the roughening and degreasing treatment with a mild acetic acid and water wash (5 percent acid, 95 percent water) and a thorough rinse with water. Ordinary white vinegar may be substituted, as it contains 5 percent acetic acid.

After a screen has been adequately treated to give it a "tooth," it is not necessary to repeat the procedure with silicon carbide; normal friction and wear on the fabric will condition it further. When printing is completed, however, and if the screen is to be reused, remove the ink from the screen with solvent, then degrease the screen with trisodium phosphate. This facilitates complete removal of the emulsion and results in a cleaner screen.

## THE DIRECT SCREEN EMULSION TECHNIQUE

The direct method, although the most economical, demands considerable skill in applying the required number of coats evenly and consistently. Too thin an application of emulsion allows the texture of the screen fabric to show and creates "sawtooth" edges. For better dot formation and overall sharpness of detail, a buildup of many thin coats is necessary so that after exposure an emulsion layer of sufficient thickness and strength remains to function independently of the screen and bridge the open mesh of the fabric.

The thickness of the stencil, which depends on the desired results, can be controlled by the number of coats of emulsion applied to the screen. For the sharpest possible images, a thicker stencil is better, with two or three additional coats applied to the exposure or bottom printing side. This also helps to avoid the "sawtooth" effect at the image edges, a condition unavoidable with thin emulsion coatings. A thicker stencil also produces a heavier ink deposit. However, this can be controlled from one screen to the next with careful and consistent applications of the emulsion.

One of the great advantages of the direct emulsion technique is its extreme durability. Because the emulsion coats both sides of the screen, it encapsulates the fabric, making an extremely tough photographic image. For this reason it is one of the preferred methods for textile printing when a single screen is often used for many thousands of impressions.

## DIRECT EMULSION COMPARISON CHART

| Brand | Sensitizer | Characteristics | Removal from Screen |
|---|---|---|---|
| Autotype Autosol Fast | Diazo | Good resolution and detail. Fast emulsion similar in speed to bichromate emulsions. Coated screens may be stored up to one month. For use with all solvent-based inks.<br><br>Development after exposure—warm water spray. | For use with nylon or polyester fabrics. To reclaim screen, remove ink with solvent, then soak screen in 5–10 percent bleach (hypochlorite) for 5 to 10 minutes. When emulsion is softened, blast from screen with pressure washer or hose and water. |
| Autotype Autosol 2000 | Diazo | Good resolution and detail. For use with all solvent-based inks. Coated screens may be stored up to three months before exposure. Biodegradable.<br><br>Development—warm water spray. | As above. |
| Autotype Autosol WR | Diazo | For use with water-based textile inks, adhesives, or printing pastes. Coated screens can be stored up to three months before exposure.<br><br>Development—warm water spray. | More difficult to remove. Use full-strength bleach or Autotype Auto-strip preparation. |
| McGraw Type IV Direct Emulsion | Bichromate | Basic emulsion for general line and halftone work. Coated screens should be used within a day of being coated. Because of dark reaction coated screens cannot be stored.<br><br>Development—warm water spray. | Use solvent to remove ink, then degreasing solution. Next, apply bleach solution as above, then a pressure spray of water. |
| Naz-Dar Encosol 1 | Diazo | General-purpose emulsion. Coated screens may be kept up to twelve months in darkroom.<br><br>Development—warm water spray. | As above. |
| Naz-Dar Encosol 11 | Diazo | 15–30 percent faster exposure times. Great solvent resistance. High screen durability. For all solvent-based inks. | Naz-Dar's STRIPP or 5 percent bleach solution as above. |
| Naz-Dar Encosol 111 | Diazo | For water-based inks. | As above. |
| Naz-Dar #32 E-Z Emulsion | Bichromate | Fast exposure time. Screens cannot be stored. Should be used within a few hours after screen coating is dry. For all solvent-based inks. | As above. |
| Ulano Fotocoat 569 and 569 CL | Diazo | 569 is purple; 569 CL is clear. Long shelf life and high resolution of detail. Coated screens can be stored (in dark) up to one month. For halftone and line work. | Solvent to remove ink, then enzyme cleaner, then bleach as above. |

| DIRECT EMULSION COMPARISON CHART (CONTINUED) | | | |
|---|---|---|---|
| Brand | Sensitizer | Characteristics | Removal from screen |
| Ulano Fotocoat 449 and 339 | Diazo | 449 is purple; 339 is white. Economical multipurpose emulsion. For all solvent-based inks. Good resolution. | As above. |
| Ulano Fotocoat 771P and 771Z | Diazo | Excellent resolution of detail. Screens are very durable for extremely long runs. For all solvent-based inks. Screens that are coated can be stored up to one month. | As above. |
| Fotocoat FX 88 | Diazo | Very fast emulsion for weaker light sources or high production. Good solvent resistance and strength. | As above. |
| Fotocoat TZ | Diazo | For all water-based inks and water dyes. Good resistance to abrasion. Good resolution of detail. | As above. |

The following procedure for Encosol I, the direct emulsion made by the Naz-Dar Corporation, is basic and can be used with most other direct emulsions, either diazo- or bichromate-based. In the coating procedure an important consideration is the viscosity of the sensitized emulsion. A lower-viscosity (more liquid) solution would deposit a thinner coating on the screen, so several more coats would be necessary to build up the emulsion to the necessary thickness. Some emulsions have a higher percentage of solid matter, making the coating thicker and requiring fewer coats.

## MATERIALS AND EQUIPMENT

Naz-Dar Encosol I Base Emulsion

Naz-Dar Encosol Sensitizer (Diazo)

Dye concentrate

Clean, tightly stretched screen

Scoop coater long enough to cover most of one side of the printing area

## APPLICATION OF ENCOSOL I (NAZ-DAR)

*Step 1.* Add the contents of the sensitizer to the emulsion and stir thoroughly. This turns the white emulsion yellow. When the solution is thoroughly mixed, add the blue dye concentrate and mix well. This turns the mixture green.

*Step 2.* Coating should be done in subdued light. With the screen propped up at an angle, fill the scoop with the emulsion and,

starting at the bottom of the screen, tilt the scoop coater slightly until some of the emulsion flows over the edge and touches the screen. Maintaining a flow of the emulsion, move the scoop coater slowly from the bottom to the top of the screen in an even, slow motion.

*Step 3.* When the coater arrives at the top of the screen, tilt it back so that extra emulsion flows back into the tray of the coater rather than running down the screen. Repeat the procedure, then coat the inside of the screen. Dry under darkroom conditions.

*Step 4.* When the first several coats are dry, give the other side of the screen at least two more coats of emulsion. If the length of the scoop coater and the size of the screen allow, apply the next layer at right angles to the previous one.

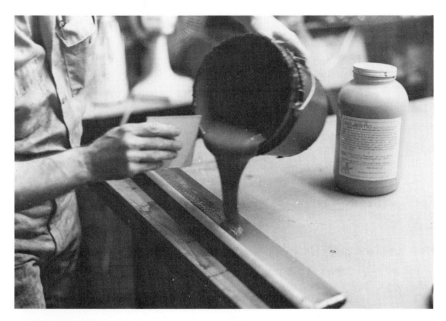

Step 2. The scoop coater is filled with emulsion.

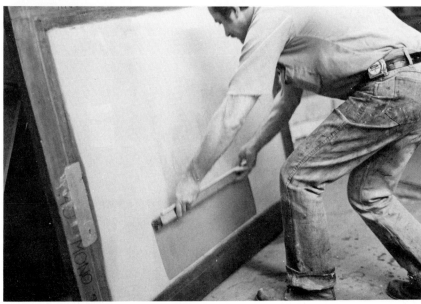

Step 2. The screen is propped up at an angle for coating with the emulsion.

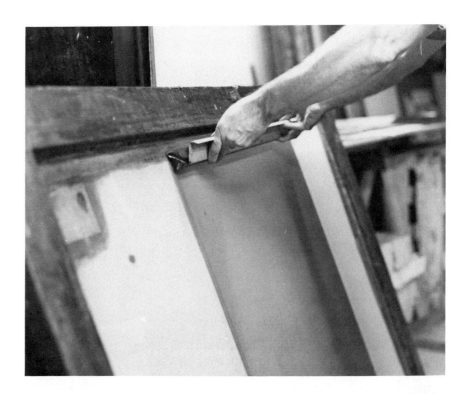

Step 3. The coater is tilted back at the end of the stroke.

*Step 5.* For exposure, a good type of vacuum frame is one that holds the entire screen. The suction draws a flexible rubber blanket firmly against the inside of the screen so that good contact is made between the positive and the emulsion coating on the bottom surface. An alternate arrangement can be used as in the photo sequence.

*Step 6.* Make test exposures to determine exposure latitude. Too little exposure will leave the exposed part tacky during washout. Overexposure will fill in fine detail. Exposure with most carbon arc, mercury vapor, pulsed xenon, or metal halide light sources should take from 3 to 8 minutes. Other light sources may need more time.

*Step 7.* Immediately following exposure, wet the screen on both sides with cold or warm (not hot) water and allow it to soak for several minutes. Then, with a spray of water, remove the unexposed emulsion from the screen. Spray from both sides of the screen until the open areas are completely free and clear. Pay extra attention to areas of fine detail.

*Step 8.* When the screen appears completely open, blot excess moisture with clean newsprint, or clear the screen of moisture with compressed air or by drying with a fan. When it is completely dry, the screen is ready to be covered around the edges with blockout stencil filler in preparation for printing (see page 171).

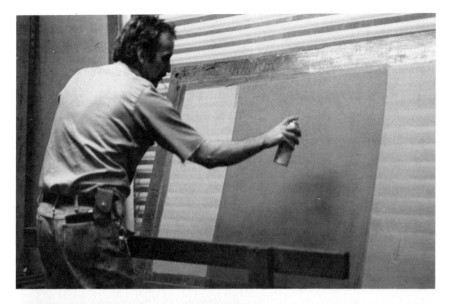

Step 5. As an alternative to using a vacuum frame for exposure, a light coat of spray adhesive is used to make the bottom of the coated screen tacky.

Step 5. The positive is then contacted to the surface; the adhesive ensures good contact between the emulsion and the positive. Exposure can then be made to any light source high in ultraviolet light.

Step 6. The screen and adhered positive are exposed to a wall of fluorescent lights. The large glass sheet has been made waterproof around the edges and forms part of the washout area with a sink and drainage underneath.

Step 7. After exposure, the unexposed emulsion is washed from the screen. At first, both sides of the screen are wetted with a spray of cool or lukewarm water with the lights off. As the emulsion begins to dissolve in the unexposed areas, the lights may be turned on for closer inspection until the whole image is clearly defined.

## REMOVING THE DIRECT EMULSION FROM THE SCREEN

The cleaning procedure is important if screens are to be used more than once. The active ingredient in removing the emulsion is bleach (sodium hypochlorite), which destroys silk, so only synthetic fabrics such as polyester and nylon can be reused after using the direct emulsion.

For thorough cleaning of a screen after printing, the following steps ensure good results.

*Step 1.* Remove the ink from the screen as soon after printing as possible—do not let ink dry hard in the screen mesh. Rub with sufficient solvent and clean rags on both sides of the screen.

*Step 2.* Next, spray the screen with warm water and degrease the screen from both sides using trisodium phosphate. This removes any further traces of ink, solvent, and grease which will interfere with complete removal of the emulsion.

*Step 3.* Brush or pour a 5 percent solution of sodium hypochlorite (common household bleach) on both sides of the screen. Let it soak for several minutes to soften the emulsion. Then, using a high-pressure spray, blast out the emulsion from the screen. In stubborn areas, apply more bleach and scrub with a stiff nylon brush, then blast out again with a water spray. Allow the screen to dry thoroughly. Examine the screen for traces of emulsion by holding it up to the light or by shining a light from behind it.

## INDIRECT PHOTO-SCREEN PROCEDURES

In the indirect system a sheet of film (usually presensitized) is independently exposed, developed, washed out, and then transferred to the screen. These films are thin, yet they have excellent mesh-bridging characteristics and produce extremely fine detail and image resolution. The thickness of the film varies, depending on the brand. Because of the thinness of the film and the manner in which it adheres to the screen (the emulsion is pressed into the

fabric from the bottom), it is considerably less durable than a screen made with direct emulsion. It is still possible, however, to get several thousand impressions from a screen made by the indirect method if it is well prepared and sufficiently taut. It is particularly important that a screen used for indirect stencils be thoroughly degreased and roughened for good adhesion. The fabric must also be tightly and evenly stretched on the frame. A screen that is too loose can cause an early breakdown of the emulsion.

Most presensitized indirect films are of the gelatin type with a polyester backing. The backing provides a support for the emulsion and prevents it from contracting as it dries after being adhered to the screen. The developer for many of these films is a dilute solution of hydrogen peroxide (1½ percent) or special preparations supplied by the manufacturer. One notable exception is a new presensitized film made by Autotype called Novastar, which is developed and washed out simultaneously using cold or warm water, then adhered to the screen. In the carbon tissue method, which is also an indirect method, the tissue must be sensitized first with potassium bichromate, sandwiched to a transparent plastic sheet, exposed, then washed out with hot water and adhered to the screen.

The following chart lists films that have been available for many years and have proven to be dependable in the resolution of fine image detail, predictable, and easy to apply. Most are of the gelatinized emulsion type.

## PRESENSITIZED STENCIL FILMS AND THEIR CHARACTERISTICS

| Presensitized film | Developer | Characteristics | Removal from screen |
|---|---|---|---|
| Autotype Superstar No. 2 | Hydrogen peroxide 1.2 percent or Autotype Powder Activator | Red, presensitized gelatin film on 0.05-mm (0.002-inch) polyester base. Excellent adhesion to all meshes, including stainless steel; capable of very high resolution and fine detail. Excellent for fine halftone printing. | Hot water and enzyme cleaner |
| Autotype Alpha Star | As above | Blue, presensitized gelatin film on 0.05-mm (0.002-inch) polyester base. Wide exposure latitude for general all-purpose work. Good adhesion to all synthetic and silk screens. | As above |
| Autotype | Water (cold or warm) | Presensitized blue synthetic emulsion film on 0.05-mm (0.002-inch) polyester base. Suited for general all-purpose work. Develops and washes out with cold or warm water. Wide exposure latitude, good adhesion, good dimensional stability. | As above |

| Presensitized film | Developer | Characteristics | Removal from screen |
|---|---|---|---|
| McGraw Colortype 4570 | Hot water developer wash-out, 110° F. (43° C.) | If kept refrigerated, maintains water-developing characteristics; otherwise develop with hydrogen peroxide (1 percent). Excellent for large stencils, display and poster work, and all short-run work except with water-based inks. | As above |
| Ulano Blue Poly and Blue Poly 2 | Ulano A & B | General all-purpose photographic film; backing either 0.05 mm (0.002 inch) or 0.075 mm (0.003 inch) | Hot water and enzyme cleaner |
| Ulano Super Prep | Ulano A & B | Green emulsion on 0.05-mm (0.002-inch) polyester base capable of very fine detail and resolution. | As above |
| Ulano HiFi Green | Ulano A & B | Same green emulsion as Super Prep but on a 0.12-mm (0.005-inch) polyester base. | As above |
| Ulano Ulanocion RX200 and RX300 | Ulano A & B or 1½ percent hydrogen peroxide | Red emulsion on 0.05- or 0.075-mm (0.002- or 0.003-inch) support. For fine detail and halftone printing, good visibility through emulsion; long run capability. | As above |
| Ulano XPM2, XPM3 | Ulano A & B or 1½ percent hydrogen peroxide | Blue emulsion on 0.05- or 0.075-mm (0.002- or 0.003-inch) support; very high resolution; good solvent resistance; good tensile strength and flexibility; good adhesion to all fabrics. | Sitk-Enzyme Cleaner; metal and synthetic-enzyme, bleach or hot water |
| Ulano HiFi Red | Ulano A & B | For very long runs needed in some commercial applications; film remains flexible during storage; converted after processing to a permanent film by heat or with C-21 conversion solvent; adheres best to silk or wire mesh. | For making permanent screens |

## MATERIALS AND EQUIPMENT

Solvent (paint thinner, lacquer thinner, or kerosene)

Rags

Trisodium phosphate (Calgon, Cascade)

Bleach (sodium hypochlorite)

Stiff nylon brush

High-pressure spray or hose

## USING PRESENSITIZED PHOTO-SCREEN FILM (ULANO BLUE POLY 2, BLUE POLY 3, HIFI GREEN)

*Step 1.* This film comes rolled in a tube with a screw top. Remove the film from the tube only under very subdued lighting such as yellow fluorescent. Unroll the film and cut a piece at least 1 inch (25 mm) larger all around than the image size. Rewrap the roll and place it back in the tube. Keep the tube tightly capped so that the film maintains its flexibility. If the film is kept outside its container, humidity should be kept around 50 percent and not lower than 35 percent.

*Step 2.* Place the piece of cut Blue Poly on the vacuum frame and place the positive in contact with it so that the positive is next to the shiny backing side. It is important that the exposure take place through the transparent backing side of the Blue Poly and not from the emulsion side.

*Step 3.* Expose the film to the light source. A simple exposure guide is presented in the accompanying table.

| Light source | Distance | Time |
| --- | --- | --- |
| Carbon arc (35 amps) | 30 inches (76 cm) | 3 minutes |
| Carbon arc (50 amps) | 36 inches (91 cm) | 3 minutes |
| Mercury vapor lamp (400 watts) | 16 inches (41 cm) | 3½ minutes |
| Quartz iodide (800 watts) | 32 inches (81 cm) | 7 minutes |
| Black-light fluorescent bulb | 4 inches (10 cm) | 5 minutes |

Step 2. Exposure.

*Step 4.* Next, mix a quantity of Ulano A&B developer according to the directions on the packages; premeasured quantities are available in pints, quarts, and gallons. Mix powder A in water not over 75° F. (24° C.). When A is fully dissolved, add the contents of package B. Powder B will not dissolve unless A is already in the solution. Place the developer solution in a glass, plastic, or enamel tray large enough to hold the exposed film. The temperature of the developer should be between 64° and 75° F. (18° to 24° C.). This operation should be carried out under subdued or safelight conditions. Place the exposed film, emulsion (dull) side up, in the developer and rock the tray back and forth so that the liquid covers the film quickly and evenly. Develop for 1½ minutes.

*Step 5.* Place the sheet of Blue Poly emulsion side up on a flat surface inclined into the sink. Flood the stencil with a weak spray of warm water (between 92° and 100° F. or 33° to 38° C.) until all the blue color is removed from the unexposed areas. Continue rinsing briefly, then flush with cold water to firm up the emulsion.

*Step 6.* On a flat tabletop place a piece of mat board or similar smooth material and cover it with a sheet of newsprint about the size of the piece of film. Place the piece of washed-out film, emulsion side up, on the newsprint. The mat board forms a surface so that the screen will make better contact with the emulsion. Lower the cleaned and degreased screen carefully so that the bottom surface of the screen contacts the emulsion. Do not use excess pressure. In this operation, the soft emulsion is pushed into the screen mesh.

*Step 7.* Blot the excess moisture from the top of the screen with clean newsprint and very light pressure. Use clean, dry sheets each time for blotting. Do not change the position of the newsprint except to turn it over once it has touched the screen, because it may pick up some of the emulsion and redeposit it on the screen in an open area. Leave the screen undisturbed for 5 minutes.

*Step 8.* Prop up the screen, and with a gentle fan of cool air allow the emulsion to dry. As the film dries, cover the edges of the screen with blockout stencil filler, going right over the edges of the clear polyester backing sheet. The blockout will then dry along with the adhered film.

*Step 9.* After the blockout and emulsion are completely dry, peel the polyester film, starting slowly at one corner. It should peel easily. If there is resistance, dry the screen further.

*Step 10.* Check the screen against a light and touch up any pinholes in the emulsion or blockout.

*Note.* A slight film of the adhesive that held the polyester backing to the emulsion may remain. This can be removed with naphtha or lacquer thinner and a soft clean cloth if necessary.

For notes on printing, see page 171.

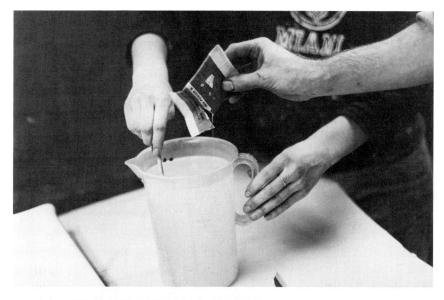

Step 4. Parts A and B of the developer are mixed.

Step 4. The tray is rocked to distribute the developer.

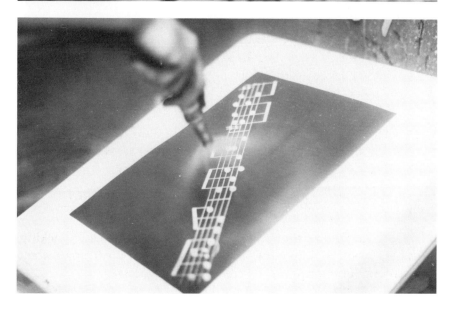

Step 5. The sheet is washed out with warm water.

Step 6. The screen is lowered onto the film.

Step 7. The screen is blotted.

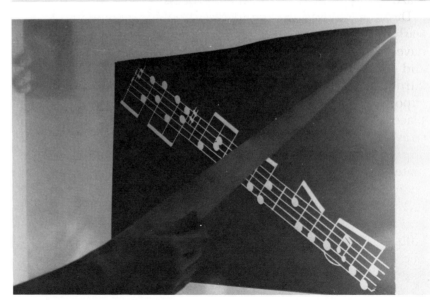

Step 8. Then the screen is allowed to dry.

## DIRECT-INDIRECT
## PHOTO-SCREEN PROCEDURE

The direct-indirect system is a method developed in the last decade for quality photographic image reproduction. It incorporates some of the best qualities of both the direct emulsion and the indirect stencil techniques. It gives high image resolution, fine detail, and exactly controlled stencil thickness and durability. The film for this process is unsensitized and laminated to a polyester backing sheet. It is cut to screen size and placed underneath the screen, emulsion side up, then a sensitizer solution (either dichromate or diazo) is poured on top and squeegeed over the surface. The emulsion is sensitized and adhered to the screen simultaneously. The screen is then exposed, washed out, and used for printing. Because several thicknesses of emulsion are available from 0.020 to 0.030 inch (20 to 30 microns), great consistency can be maintained from one screen to the next.

Two main substances are used as the sensitizing agent for almost all procedures: a diazo rosin and ammonium dichromate. Diazo rosin is supplied in a fine yellow-green powder. It is mixed with lukewarm water and added to the liquid emulsion as in the direct process or with a special coating emulsion in the direct-indirect process. Diazo powder can be stored at room temperature for six months or, if refrigerated, more than a year. Once an emulsion is mixed, it can be kept safely at room temperature for about a month and if refrigerated for several months. Screens sensitized with a diazo sensitizer may be stored in a darkened room for approximately one week before exposure and washout, or less if the humidity is high.

Ammonium dichromate, one of the other important sensitizing substances used, is a yellow-orange crystalline powder which is mixed with water. It is then added to the liquid emulsion for the direct process or squeegeed onto the film in the same way as the diazo liquid in the direct-indirect process.

Dichromate-sensitized emulsions should be exposed and washed out as soon as possible after application and after they have dried—usually within 12 hours. Screens cannot be sensitized and stored for use days later. A "dark reaction" will gradually harden the entire screen in a manner similar to a gradual light exposure. This reaction with dichromatized emulsion will take place even if the screen is kept in a darkened place and away from stray light. The shelf life of dichromate emulsions and solutions is approximately half that of diazo-sensitized emulsions. Dichromate is generally more sensitive than diazo and requires approximately half the exposure time.

The following procedure uses Autotype "Autoline" HD film and is similar to other direct-indirect systems. The HD film has a 0.05-mm polyester backing sheet and the emulsion is 18 to 20 microns (0.018 to 0.020 inch) thick. This has extremely fine resolving capability. Autoline Thick Film, which has an emulsion

33 to 36 microns (about 0.03 mm) thick, can be used where heavier deposits of ink are needed or for very long press runs.

---

### DIRECT/INDIRECT FILM COMPARISON CHART

| Direct-indirect film | Sensitizer | Characteristics | Stencil removal |
|---|---|---|---|
| Autotype Autoline HD | Diazo or bichromate with emulsion | General-purpose film capable of high resolution of detail | 10 percent solution bleach (sodium hypochlorite) high-pressure water spray |
| Autoline Thick Film | Diazo or bichromate with emulsion | Heavier film designed for printed circuits and decals—heavier ink deposit | |
| Naz-Dar Chromaline<br>Type A-100 blue 1-mil paper carrier<br>Type B-100 violet 1-mil vinyl carrier<br>Type B-150 violet 1½-mil vinyl carrier | Bichromate or diazo with emulsion | Stencil thickness of 1 or 1½ mil. Fine resolution of detail. | 5 percent bleach on both sides, then high-pressure water spray |
| Ulano Direct-Indirect<br>200R (20 microns)<br>250R (25 microns)<br>300R (30 microns) | 18 percent bichromate with coating solution | Stencil thickness of 20, 25, or 30 microns, the latter for heavy ink deposits and long runs. Diazo screens can be stored for up to one week. | 5–10 percent bleach (sodium hypochlorite), then strong-pressure spray; Ulano no. 4 Stencil Remover liquid or no. 5 paste application followed by water spray |

**Note:** With all the stencils using bichromate as a sensitizer, the film can be adhered to the screen and left for up to 24 hours prior to exposure and washout. Diazo-sensitized screens can be left protected from the light for up to one week before exposure.

---

## MATERIALS AND EQUIPMENT

Autoline HD film

15 percent solution of ammonium bichromate and water, made by mixing 15 grams (½ ounce) of ammonia bichromate crystals in 1,000 cc (33 ounces) of warm water

Measuring beaker

Autoline emulsion

Soft squeegee with rounded edges

Plastic tape

Clean, degreased screen

Scissors or single-edge razor blade for cutting film

## USING AUTOLINE HD FILM (AUTOTYPE USA)

This general procedure can be used with all types of direct-indirect film. The procedures for the Ulano and Chromaline (Naz-Dar) systems differ only in the concentration of the sensitizer and the thickness of the stencils.

*Step 1.* Unwrap the roll of Autoline film and cut a piece at least an inch or two (25 to 50 mm) larger all around than the image area. Place the cut sheet of film, emulsion (dull) side up, on a glass tabletop or smooth Formica surface. Lower the clean and degreased screen into position on the film. Cover the open ends of the screen (beyond the film area) with masking tape on the squeegee side.

*Step 2.* Prepare the sensitizer emulsion by first making a 15 percent solution of ammonium bichromate. To prepare a working solution, mix 1 part of the stock solution with 4 parts of the Autoline emulsion for maximum solvent resistance. A sensitizer-to-emulsion ratio of 1 to 6 will provide maximum detail and image definition. Stir the solution well and allow it to sit for 1 hour before use. For best results, use it within 24 hours. If stored in a refrigerator, it will last up to a week.

Step 1. Roll of Autotype Autoline HD film.

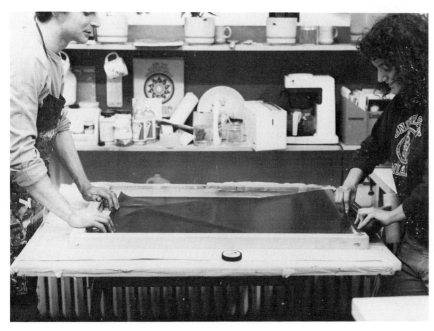

Step 1. The film is unrolled and cut.

*Step 3.* Pour some of the sensitizer into the tape at the top of the screen. The tape prevents the sensitizer from going through the open mesh.

*Step 4.* With a soft squeegee large enough to cover the film area, squeegee the sensitizer over the screen with one uniform stroke. (One stroke is all that is needed. A second stroke is recommended for thicker films.) Let the sensitizer sit for 2 to 3 minutes. Then prop up the screen and fan-dry it at a temperature no greater than 86° F. (30° C.).

*Step 5.* When the screen is dry, peel off the polyester base. If it does not strip easily from the emulsion, wait until the film has thoroughly dried, then strip the base completely from the adhered emulsion.

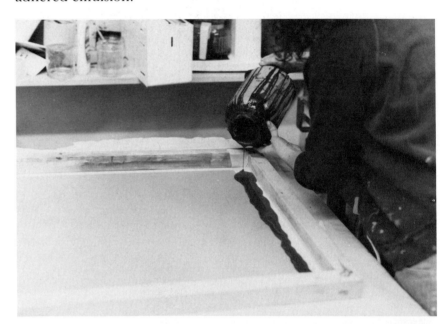

Step 3. Sensitizer is poured onto the top of the screen.

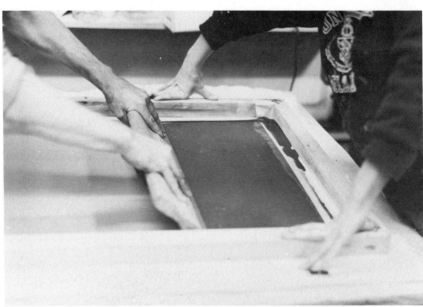

Step 4. The sensitizer is squeegeed onto the screen.

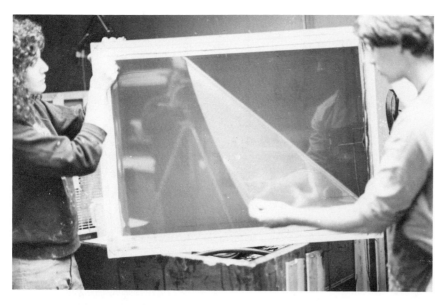

Step 5. The polyester base is peeled off.

*Step 6.* For exposure, tape the positive in position to the bottom (paper side) of the screen. Place the entire screen in a vacuum frame designed for screens. (If you have no access to the proper type of vacuum frame, a special exposure arrangement can be made for exposure from the top.)

The accompanying table can be used as a general guide for exposure times. These times are for a bichromate-sensitized screen in a ratio of 1 part sensitizer to 4 parts emulsion with a yellow- or orange-dyed fabric. For 1:6 sensitizer, increase exposure by 50 percent. If the fabric is white, decrease exposure by 30 percent. If a diazo sensitizer is used, increase exposure by approximately 50 percent.

| Light source | Distance | Exposure time |
|---|---|---|
| Arc lamp (15 amps) | 20 inches (51 cm) | 5 minutes |
| Arc lamp (50 amps) | 40 inches (102 cm) | 5 minutes |
| Mercury vapor lamp (Phillips, 125 watts) | 20 inches (51 cm) | 8 minutes |
| Metal halide 2KW (Berkey Addalux) | 40 inches (102 cm) | 3½ minutes |
| Pulsed xenon 8KW | 40 inches (102 cm) | 9 minutes |

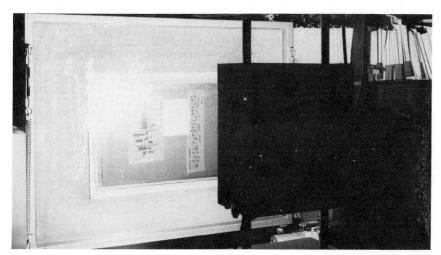

Step 6. Exposure.

LIGHT SOURCE

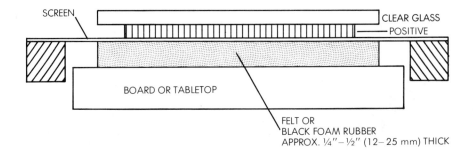

SCREEN

CLEAR GLASS
POSITIVE

BOARD OR TABLETOP

FELT OR
BLACK FOAM RUBBER
APPROX. ¼″–½″ (12–25 mm) THICK

Special arrangement for top exposure without a vacuum frame.

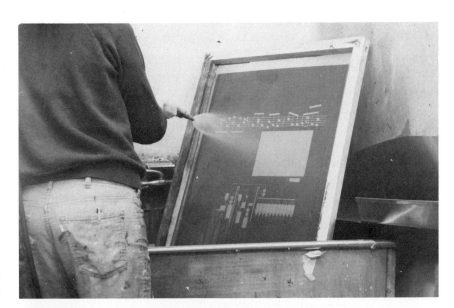

After exposure, the image is washed out with a spray of cold or lukewarm water.

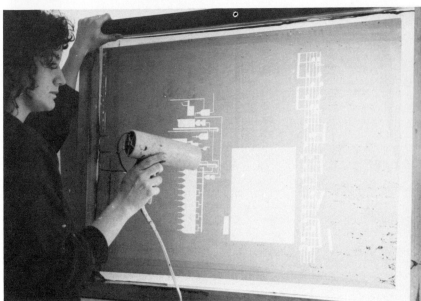

The screen can be blotted with clean newsprint or dried with a hair dryer.

## NOTES ON PRINTING

Whatever method is used for making stencils on the screen (whether one of the photographic processes or any number of hand-cut film or stencil-making techniques), other factors will greatly influence the quality of the finished product: the type of fabric and how it is stretched; the hardness and sharpness of the squeegee; the speed, pressure, and angle of the squeegee; off-contact printing; the viscosity and flow of the ink.

Off-contact printing is important for the production of sharp, crisp images. For this, the screen itself remains approximately ⅛ to ⅜ inch (3 to 10 mm) above the surface to be printed. As the squeegee is pulled across the screen, the screen is lowered momentarily along the squeegee edge where the ink is forced through the screen. The screen must be tightly and evenly stretched; otherwise the friction of the squeegee will distort the fabric and cause blurring of the image as well as premature breakup of the adhered photographic stencil film.

For the sharpest possible printing and for thin ink deposits, a sharp squeegee is important. In addition, the angle of the blade during printing should be such that the blade edge will have maximum effectiveness, as in the accompanying diagram. A softer squeegee has a tendency to deposit more ink than a harder one. A harder squeegee also allows greater pressure while maintaining the optimum squeegee angle. Softness and hardness of the squeegee blade are measured in durometers—a 50-durometer blade is soft, a 60-durometer is in the medium range, and a 70-durometer is hard.

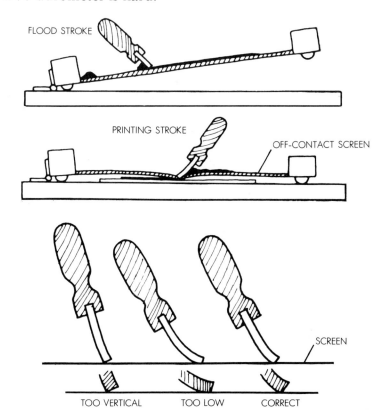

The squeegee is pulled across the screen to distribute the ink (top). The printing stroke (bottom) forces the ink through the screen.

The angle of the squeegee blade should be 45 degrees for maximum effectiveness.

The viscosity and flow of the ink and the openness of the mesh used also have a direct bearing on the speed of the squeegee travel and its effectiveness in depositing an even ink film. A thicker, more viscous ink requires a slower motion than a lighter ink which flows more easily through the mesh. The mesh itself also tempers the speed requirements: a coarser, more open mesh allows greater flow of the ink, allowing thicker and heavier deposits of ink as well as reasonably fast squeegee speed. The combination of extremely fine detail and a fine screen mesh requires an ink that has good tinting strength but a relatively low percentage of solid matter. It should also contain a vehicle that promotes good flow-through characteristics.

# CHAPTER SEVEN

# UNUSUAL PHOTOGRAPHIC PRINT PROCESSES

The techniques included in this chapter fall somewhere between purely photographic processes and graphic arts procedures. Now that photographic imagery has achieved the status it has, the dividing line between photography and printmaking remains thin indeed. In both areas the end result is the production of consistent editions. The fact that one process relies on the action of light and the other on pressurized contact has become insignificant to artists.

Most of the processes included in this chapter have achieved some measure of commercial success. Their revitalization as mediums for creative exploration, however, is a relatively recent and exciting phenomenon. And they also bridge the gap between photography and printmaking.

## CARBON PRINTING

The name "carbon printing" comes from the use of carbon tissue of the type used for photogravure. This tissue is composed of an iron oxide–pigmented gelatin on a paper backing. It is first sensitized with a potassium bichromate solution and dried. When a negative is placed in contact with it and exposed to light, the sensitized carbon tissue hardens in proportion to the amount of light that hits it. When the tissue is transferred to another material, such as watercolor paper, glass, or other support, and immersed in hot water, the unhardened gelatin is washed away, leaving only the image in continuously graduated thicknesses of pigment and gelatin. If good-quality paper is used as the support, the final image is as archivally permanent as any other form of printed work, including etchings and woodcuts.

The final carbon print is a true continuous-tone process reflecting the tonal nature of the negative. Depending on the strength of the potassium bichromate used to sensitize the tissue, a certain degree of control in the contrast can be achieved. A 3 to 4 percent potassium bichromate solution as sensitizer gives a normal-contrast print. Decreasing the strength of the solution, for example to 2 percent, increases the contrast but necessitates a longer exposure. Ammonium bichromate may also be used as the sensitizer for the carbon tissue. Because it is more active, however, it requires approximately one-third less exposure time than tissue sensitized with potassium bichromate.

## MATERIALS AND EQUIPMENT

Carbon tissue

Transfer paper (any good, smooth-finish watercolor paper such as Rives, B.F.K., Arches)

Potassium or ammonium bichromate

Two sheets of glass slightly larger than the sheet of tissue

Newsprint

Rubber squeegee

Sodium bisulfate or potassium metabisulfate

Plexiglas or ferrotype plate

## PROCEDURE

*Step 1.* Using plastic or rubber gloves, sensitize a sheet of carbon tissue by immersing it in a 3½ percent solution of potassium bichromate or a 2½ percent solution of ammonium bichromate. This solution is made by dissolving 2½ or 3½ grams (0.09 or 0.12 ounces) of bichromate in 1,000 cc (33 ounces) of water. Immerse the carbon tissue for 3 minutes in the solution which should not be above 65° F. (18° C.). The tissue will uncurl and lie flat after approximately 1 minute.

*Step 2.* Remove the tissue from the sensitizer, and squeegee or roll it out carefully onto the Plexiglas or ferrotype plate with the emulsion side down. Place it in a dark place away from stray light and allow it to dry. A fan of cool air will speed up drying. When the tissue is dry, peel it off the support.

*Step 3.* Place the sensitized tissue in a vacuum frame. Position the negative on top of the tissue so that it reads as a mirror image of the way you wish it to appear finally. Cover all areas of the tissue except the image area with light-opaque paper.

*Step 4.* Exposure tests should be made, because several factors, such as the type of light source and its intensity, the distance from the carbon tissue, the density of the negative, and the degree of concentration of the sensitizer solution, can affect exposure time. Expose the tissue and negative to a high-intensity ultraviolet light

source. Lights that generate heat must be avoided, because heat can melt the tissue.

*Step 5.* Immediately following exposure, place the paper support in a tray of cold water, 50° to 60° F. (10° to 16° C.), then the carbon tissue. Gently remove any air bubbles that may cling to the surface. Place the emulsion side in contact with the paper. Remove the tissue and paper together from the water and place them on a sheet of glass.

*Step 6.* Squeegee the two sheets together to remove any water or bubbles between them. Then put some clean newsprint underneath and on top of the tissue and add a sheet of glass on top as a weight. Leave in this state for at least 30 minutes (swabbing the back of the tissue with some denatured alcohol will assist in water penetration in the next step).

Step 5. Paper and carbon tissue are removed from the water together.

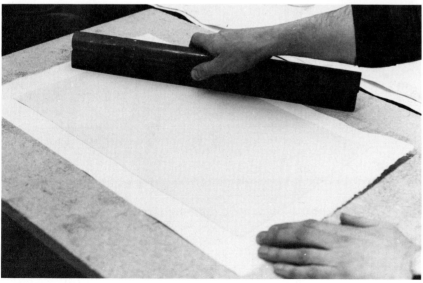

Step 6. The two sheets are squeegeed together.

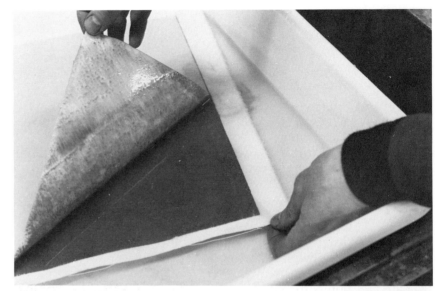

Step 7. When the dissolved pigment and gelatin ooze out, the backing will peel away from the support paper.

Step 8. When the image appears fully developed, cold water is added to the tray. The image is then lifted out to dry.

*Step 7.* Next, place the tissue and support in a tray of warm water, 100° to 105° F. (38° to 41° C.). In about 10 to 20 minutes the dissolved pigment and gelatin will ooze out from between the tissue and the support. Peel the backing paper slowly from the support paper. If you feel resistance, continue for a longer period in the warm water.

*Step 8.* When the backing paper is removed, the image will gradually become visible as more of the unexposed gelatin dissolves. Leave the tissue in the tray for 10 minutes or so, adding clean warm water of the same temperature until it appears that all the soluble gelatin and pigment have been removed. Then gradually fill the tray with cold water to firm up the emulsion.

*Step 9.* To clear the print of dichromate stain, immerse it in a tray with running cold water for half an hour or so, depending on the kind of paper support used. Because watercolor papers are heavily sized, they can withstand this treatment. More absorbent

papers might expand and impair adhesion to the transferred image. Immersion in a 5 percent solution of sodium bisulfate or potassium metabisulfite for 2 to 3 minutes will clear the bichromate stain from the paper. This should be done after the paper has had a chance to dry thoroughly; otherwise the emulsion might become too soft for safe handling. Afterward, rinse the print thoroughly with cold water and dry it by placing a sheet of waxed paper or plastic over the image side, then placing the print between blotters with a weight on top. Several changes of blotters will be necessary for the print to dry sufficiently and remain flat.

## CYANOTYPE

This process has long been in use as the commonly known blueprint process. Paper is sensitized with ferric ammonium citrate and potassium ferricyanide. When a negative or positive is exposed to light, a chemical reaction occurs. This reaction produces the permanent deep "Prussian" blue color of the final print. Remember that a negative is needed to create a positive image.

### MATERIALS AND EQUIPMENT

Ferric ammonium citrate

Potassium ferricyanide

Paper such as Arches Cover, Rives B.F.K. Watercolor, or Strathmore (*do not* use papers buffered with calcium carbonate or other alkali)

Mixing beaker

Two quart or liter storage bottles, brown glass or plastic

Photographic negative

Vacuum frame and light source high in ultraviolet light

### PROCEDURES

To prepare the sensitizing solution for coating the paper, the following A and B solutions can be mixed and added together if several sheets are to be sensitized at one time. It is best, however, to keep both solutions in separate brown plastic or glass bottles for storage. Then mix equal amounts of each when you are ready to sensitize the paper. The solution will appear as a greenish-yellow liquid when mixed; only after exposure and washout does it turn the familiar deep blue.

|  **Solution A** | | |
| --- | --- | --- |
| Ferric ammonium citrate | 20 grams (0.7 ounce) |
| Water at 68° F. (20° C.) | 100 ml (3.3 ounces) |

|  **Solution B** | | |
| --- | --- | --- |
| Potassium ferricyanide | 8 grams (0.3 ounce) |
| Water at 68° F. (20° C.) | 100 ml (3.3 ounces) |

*Step 1.* After the solution has been mixed, coat the paper in subdued light conditions by brushing the emulsion evenly over the surface or by floating a sheet in a tray large enough to take the size of paper. Papers that have very little sizing will absorb a considerable amount of the solution and may need both an increase in exposure time and a longer washing time to remove soluble salts from the fibers of the paper. Remember that once the paper has been coated, it should be dried in the dark away from stray white light of any kind. Heat does not affect the coated paper, so heated fans may be used to speed up the drying.

*Step 2.* When dry, place the sensitized paper in the vacuum frame with the negative placed on the sensitized surface so that it reads correctly. Cover the margins with opaque paper if necessary and expose. The light source may be any of the previously mentioned types, such as carbon arc, mercury vapor, pulsed xenon, flood-lamps, or a sunlamp. The exposure time depends on the brightness of the light source, the degree of absorption of the sensitizer into the paper, and the distance from the light. Tests should be made to determine optimum exposure times. Because the sensitivity of the cyanotype emulsion is not as great as with many other processes, exposure times for a 15-amp arc lamp are in the range of 5 to 8 minutes at a distance of 28 inches (71 cm).

*Step 3.* Immediately after exposure, wash the print for 5 to 10 minutes (longer for absorbent papers) in running water to clear it of unexposed salts. When the print is removed from the water, the blue color will deepen as oxidation continues during drying.

*Step 4.* Place the print between blotters and cover it loosely with plastic. This step removes a great deal of moisture from the paper but allows it to dry slowly. This slow drying promotes the development of a deeper color. Change the blotters the next day and place a weight on top to flatten the print. Another change or two of the blotters may be necessary. Once the print is dry and flattened, the resulting image is permanent.

*Note.* Because the cyanotype process has a tendency to produce a long scale gradation of values (subtle gradation between the darks and highlights), the greater the tonal range in the negative, the better the gradations in the final print. A density range of 1.7 or 1.8 will work well with this process. To increase contrast when this process is used with relatively flat negatives, add 1 ounce (30 ml) of 1 percent potassium bichromate solution to 8 ounces (240 ml) of sensitizer and use it to wash out the image. Follow with a clean water rinse.

## VAN DYKE BROWN PRINTS (KALLITYPE PROCESS)

This process has been used commercially by many printers for the production of pre-press proofs. The result is a print with a deep

brown color and an excellent range of tonalities. Certain formulas include, in addition to the chemicals listed, dissolved gelatin. This allows the sensitizer to be applied in a heavier layer with less penetration into the fibers of the paper. The following sensitizer solution is basic, however, and will work well on many different kinds of paper, preferably ones that are heavily sized such as watercolor papers or quality calligraphy papers.

## MATERIALS AND EQUIPMENT

Paper such as Arches Cover, Rives B.F.K. Watercolor Paper, Strathmore, etc. (Note: Do not use papers buffered with calcium carbonate or other alkali)

Rubber or plastic gloves

Mixing beaker

1-inch (25-mm) brush

Two quart or liter storage bottles, brown glass or plastic

Photographic negative

Vacuum frame and light source

Sodium thiosulfate

## PROCEDURE

To prepare the sensitizer, mix these chemicals separately:

### Solution A

| Distilled water | 1 liter (1 quart) |
|---|---|
| Ferric ammonium citrate | 27 grams (0.9 ounce) |

### Solution B

| Distilled water | 1 liter (1 quart) |
|---|---|
| Tartaric acid | 4.5 grams (0.2 ounce) |

### Solution C

| Distilled water | 1 liter (1 quart) |
|---|---|
| Silver nitrate | 11.5 grams (0.4 ounce) |

After each mixture has dissolved completely, mix the ferric ammonium citrate with the tartaric acid solution, then add that mixture slowly, while stirring, to the silver nitrate solution. Use rubber or plastic gloves when mixing the chemicals, because they stain badly and silver nitrate burns skin upon contact. If the chemicals are stored in a dark brown bottle at room temperature, they will last for many months.

*Step 1.* Coat the paper by brushing the sensitizer evenly over the surface. Dry in the dark with a warm-air fan to speed up drying.

*Step 2.* Cover the margins or any areas beyond the negative area that you do not wish to expose. Expose the paper under a negative for 2 to 3 minutes. A strong light source such as a carbon arc lamp is excellent.

*Step 3*. Wash in cold water at about 65° to 68° F. (18° to 20° C.) for 1 to 2 minutes.

*Step 4*. Next, fix the print in a weak (4 percent) thiosulfate and waterbath for about 4 minutes. The following diluted fixer proportion is recommended. Discard it after use.

Sodium thiosulfate    20 grams (0.7 ounce)
Water                  500 ml (17 ounces)

*Step 5*. Wash for at least 30 minutes in running water. Additional use of hypo clearing agent will be more effective in clearing the paper of fixer.

*Step 6*. Place the print between blotters and put weights on top. Change the blotters until the print is dry and flat.

## KWIK-PRINT PROCESS

The Kwik-Print process, used since 1941 for pre-press proofing, has recently taken on new significance as a fine art photographic medium. Its versatility and simplicity make it much more adaptable for creative investigations than the older gum bichromate process. These photosensitive emulsions come in a range of premixed standard process colors plus many other basic colors. When they are used with a good-quality rag printing paper or watercolor paper, the permanence of the prints is excellent. It is also possible to flow the emulsions onto clear or frosted plastic sheets to make color overlays or onto cloth for contact printing. These transparent color emulsions are manufactured by the Direct Reproduction Corporation, Brooklyn, New York, and distributed by Light Impressions Corporation, Rochester, New York (see suppliers' list). When used directly on specially prepared plastic sheets, the color emulsion is buffed down to a thin, even film, then dried, exposed, and washed out with water. Light hardens the color on the film while the unexposed areas wash away. Other colors may be added in the same way. Because multiple colors can be overlaid, the range of color combinations and variations is endless.

### MATERIALS AND EQUIPMENT

Kwik-Print colors

Sized paper, watercolor paper, or Kwik-Proof plastic sheets

Kwik-Proof Applipad plus cotton pads, or Webril wipes

Photographic negative

Vacuum table and light source

# PROCEDURE

*Step 1.* Coat the plastic by wiping on the color with a cotton pad. For large surfaces you can use the Kwik-Proof Applipad. It takes a little practice to get even coats, but an even surface is important for consistent results. A little water underneath the plastic sheet when placed on a sheet of glass or smooth Formica tabletop will keep the plastic from moving and allow even application to the edges of the sheet. This should be done in subdued light, because the color dries quickly and becomes light-sensitive upon drying.

For application on paper, the color can be brushed on with a soft, wide brush in as even a layer as possible, then dried in a darkened place. Because of the absorbency of the paper, even sized sheets, drying takes longer than with plastic. Application of the color with an airbrush on both plastic or paper is also very effective.

*Step 2.* After the sheet has dried thoroughly, place it in a vacuum frame with the negative facing the coated side. Cover other areas such as the margins with lightproof paper (goldenrod paper or rubylith masking) and expose the sheet to the light source (carbon arc, pulsed xenon, mercury vapor, or photofloods).

Step 1. Some of the Kwik-Proof sensitizer is squirted onto the plastic sheet from the squeeze bottle.

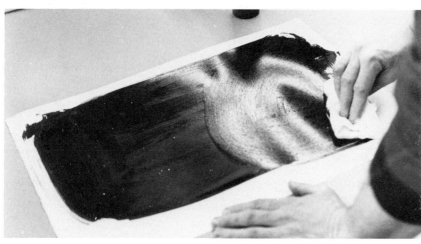

Step 1. The sensitizer is smoothed out with the cotton pad.

*Step 3.* To develop, wash in running water, then rub the surface with a sponge using light pressure. If the highlights do not clear easily, add a small amount of ammonia to the wash water, approximately 1 ounce (30 ml) to 7 ounces (210 ml) water. Flush with clean water, then dry. When the print is dry, the process may be repeated on the same sheet with the same color and negative to intensify the image or with other negatives and different colors. For ease in registering, print darker colors first, then lighter colors. Registration marks in the margins of the print with each negative can be pin-registered for more critical color registration.

*Step 4.* After washing out, paper prints can be dried between blotters to flatten them. Several changes of blotters will be necessary. A board and weights on top during the final drying ensure flatness. If the printing is done on plastic sheets, drying takes only minutes.

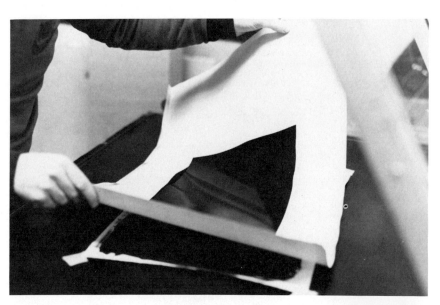

Step 2. The masked-out negative is placed in contact with the Kwik-Proof paper in the vacuum frame.

Step 3. The image is developed with a sponge and water.

## CLICHÉ-VERRE

Shortly after Henry Fox Talbot introduced the first negative-positive process for creating photographic images in 1839, a considerable number of artists began using Talbot's light-sensitive paper for making prints by a unique method. A sheet of glass was

Jean Baptiste Corot, *Les Jardins d'Horace*. Cliché-verre. The Metropolitan Museum of Art, Rogers Fund, 1922.

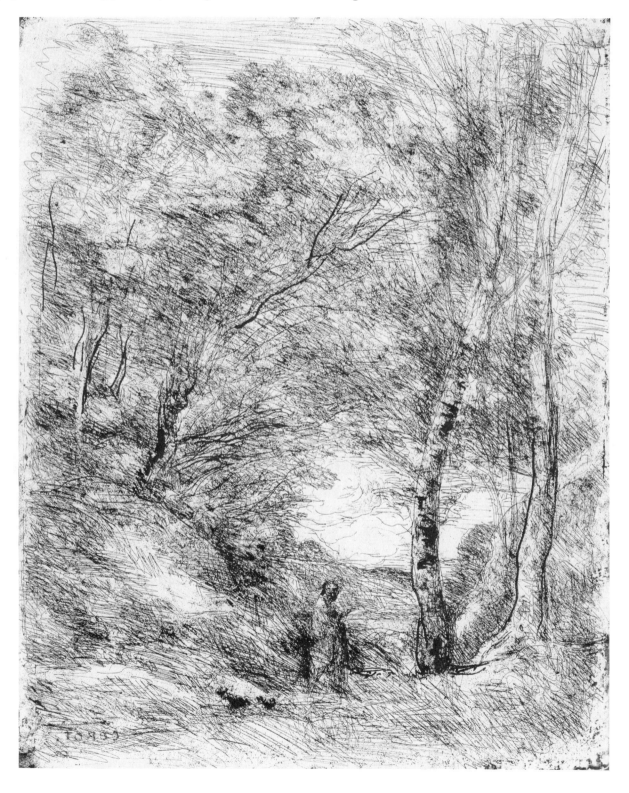

covered with a thin, even layer of black printer's ink, then dusted with a fine powder to eliminate the surface tackiness of the ink. A drawing was then made on this "ground" by scratching through the ink layer with an etching needle or other fine point. This formed a negative image on the glass. When this was placed in contact with sensitized paper and exposed to the sun, the fine lines of the drawing were reproduced positively on the paper. Although referred to initially as "photogenic etchings" or simply as "positive photographs from etchings on glass plates," this process later became known as "cliché-verre."

Although artists such as J. B. Camille Corot, George Cruikshank, Daubigny, Paul Huet, Millet, and Eugène Delacroix as well as several lesser-known artists used the cliché-verre technique, it was unpredictable and by the late nineteenth century had given way completely to direct photographic procedures made in the camera, which offered a sophisticated and controllable means of both tonal and linear reproduction. Corot in particular adapted well to the cliché-verre technique. From the time he made his first cliché-verre image—*Le Bucheron de Rembrandt*—in 1853 to those made in the last few months before his death in 1875, he produced over sixty images using the process.

Since the latter part of the nineteenth century, artists such as Man Ray, Brassai, Max Ernst, Picasso, and Paul Klee have experimented with the process, but it appears to have had only a limited appeal to them. Recently, however, with the resurgence of many older photographic techniques, artists have begun to reexplore the potential of the medium.

With the vast number of photographic emulsions currently available, the number of ways in which the cliché-verre process can be used is endless. A negative image drawn on a glass plate can be exposed not only onto ordinary photographic enlarging or contact papers but also used with the gum bichromate process, cyanotype, carbon process, salted paper, Kallitype, Kwik-Print, platinum, or almost any other photographic emulsion applied to a paper or cloth support.

# APPENDICES

# FORMULAS

## SENSITIZING SOLUTION FOR CARBON TISSUE

### Photogravure
(3 percent solution, average tonal range)

| | |
|---|---|
| Potassium bichromate | 0.1 ounce (3 grams) |
| Water | 34 ounces (1,000 ml) |

### Carbon Prints

| | |
|---|---|
| Potassium bichromate | 0.07–0.14 ounce (2–4 grams) |
| Water | 34 ounces (1,000 ml) |

*Note.* Contrast can be controlled to some degree with the concentration of the solution. A 2 percent solution produces greater contrast but requires longer exposure. A 4 percent solution needs less exposure and produces a relatively flatter tonal range. Ammonium bichromate can be used in place of potassium bichromate; it is about one-third more sensitive than potassium bichromate.

## FARMER'S REDUCER

This solution reduces the density of overexposed negatives or positives by removing minute quantities of exposed silver from the film emulsion. It works more on the heavy black portions than on the lighter areas of the film. Although it is used mostly for dot etching of halftones, it can also be used to reduce the density of continuous-tone negatives or positives.

### Solution A

| | |
|---|---|
| Potassium ferricyanide | 1.25 ounces (35 grams) |
| Water | 16 ounces (473 ml) |

### Solution B

| | |
|---|---|
| Sodium thiosulfate (hypo) | 16 ounces (454 grams) |
| Water | 64 ounces (1.9 liters) |

Mix one part of stock solution A with four parts of stock solution B. Add water to make thirty-two parts. Combine solutions A and B only when the reducer is to be used, and discard it afterward. The entire piece of film may be immersed in the solution for overall reduction, or the solution can be applied on a brush for localized etching.

## COLD TOP ENAMEL

| | | |
|---|---|---|
| Water at 185° F. (85° C.) | 160 | ounces (4,730 ml) |
| Ammonium carbonate | 3.5 | ounces (99 grams) |
| Orange shellac | 16 | ounces (454 grams) |

Dissolve the shellac by adding it slowly to the ammonium carbonate solution. Stir constantly. Heat in a double boiler arrangement for 15 to 20 minutes, stirring continuously. Cool; then add the following mixture:

| | | |
|---|---|---|
| Ammonia | 5 ounces (150 ml) | |
| Ammonium dichromate | 360 grains (24 grams) | |
| Water | 8 ounces (237 ml) | |

Allow the solution to stand for approximately 24 hours before use.

## PHOTOENGRAVER'S GLUE (FISH GLUE)

| | | |
|---|---|---|
| Glue | 3 | ounces (90 ml) |
| Water | 8 | ounces (237 ml) |
| Ammonium bichromate | 0.25 | ounce (7 grams) |

## POSITIVE BLUEPRINT FORMULA

When a positive tracing or drawing is used in the normal blueprint process, the resulting blueprint is a negative with white lines and a blue background. In this process, using the same positive drawing, the final image is also positive, with dark blue lines and a white background.

| | | |
|---|---|---|
| Ferric chloride (lump or powdered) | 1.75 | ounces (50 grams) |
| Tartaric acid | 0.5 | ounce (15 grams) |
| Gum arabic (granular) | 0.4 | ounce (10 grams) |
| Water | 17 | ounces (500 ml) |

Dissolve the gum arabic in the water first; then add the other chemicals. If the water is cold, the gum arabic will not form a solid mass and will dissolve readily if it is kept in motion by stirring.

Brush or sponge the mixture onto the paper and dry the paper in a darkroom. When exposed, the ferric ions in the areas that receive the light (the nonimage areas) are reduced to ferrous ions.

Develop the paper in a 20 percent solution of potassium ferricyanide:

| | | |
|---|---|---|
| Potassium ferricyanide | 0.7 | ounce (20 grams) |
| Water | 34 | ounces (1,000 ml) |

This converts the image areas to deep blue (ferric ferricyanide) while the nonimage areas are converted to ferrous ferricyanide, which is nearly colorless.

After development, place the print in a bath of dilute hydrochloric acid and water:

Hydrochloric acid  0.3 ounce (10 ml)
Water          34   ounces (1,000 ml)

This removes the ferrous ferricyanide from the nonimage areas; otherwise these areas would eventually turn blue. Then wash the print thoroughly in running water and allow it to dry.

## CYANOTYPE (BLUEPRINT) SENSITIZING SOLUTION

### Solution A

Ferric ammonium citrate      0.7 ounce (20 grams)
Water at 68° F. (20° C.)      3.4 ounces (100 ml)

### Solution B

Potassium ferricyanide      0.3 ounce (8 grams)
Water                        3.4 ounces (100 ml)

## VAN DYKE BROWN PRINT (KALLITYPE)

### Solution A

Distilled water          1   quart (1 liter)
Ferric ammonium citrate  0.9 ounce (27 grams)

### Solution B

Distilled water  1   quart (1 liter)
Tartaric acid    0.2 ounce (4.5 grams)

### Solution C

Distilled water  1   quart (1 liter)
Silver nitrate   0.4 ounce (11.5 grams)

## GELATIN SIZING SOLUTION FOR PAPER

Water                      approx. 1 quart (1 liter)
Gelatin (Knox unflavored)  1 ounce (28 grams)

Place the gelatin in the water (cold) and allow it to swell. Heat the mixture in a double boiler, or not over 110° F. (43° C.), until the gelatin is completely dissolved. Immerse the paper in this solution while it is still warm, then hang the paper to dry.

To harden the gelatin in order to make it less soluble for use with various sensitizing coatings, add the following to the gelatin solution and apply the resulting mixture to one surface after the initial coating has dried:

| | |
|---|---|
| Warm gelatin solution (above) | approx. 1 quart (1 liter) |
| Formalin | 0.8 ounce (24 ml) |

## PRESERVATIVE FOR GELATIN SIZING SOLUTION

Add approximately 25 drops of thymol solution—thymol dissolved in alcohol to a saturated solution—to every liter of gelatin sizing solution. Thymol is poisonous, so it must be handled with care.

## PHOTOLITHOGRAPHIC TRANSFER PAPER

This formula is an old one used for photographically transferring an image onto stone for halftone and line art as well as type.

### Gelatin Coating

| | |
|---|---|
| Gelatin | 3 ounces (84 grams) |
| Water (warm) | 3 ounces (90 ml) |

Coat this solution while still warm onto the transfer paper with a fine-pore cellulose sponge, then allow it to dry. Then sensitize this gelatin coating with the following solution:

### Sensitizer

| | |
|---|---|
| Ammonium bichromate | 2 ounces (54 grams) |
| Water | 8 ounces (237 ml) |
| Ammonia (household) | 3–4 drops |

Pour the sensitizer into a tray and float the coated side of the paper on the surface; make sure that no air bubbles have been trapped underneath. After 1 to 2 minutes, remove it and hang it to dry in the dark. It may also be taped to a board on all four edges with gummed paper tape. When dry, cut it from the tape. After exposing it to the negative, coat the surface with transfer ink diluted with turpentine to a thin, creamy consistency. Immerse the sheet in a tray of lukewarm water until all the unexposed areas have lifted; then place it in position on the stone and run it through the press under pressure.

This can also be used on counter-etched zinc or aluminum plates.

*Note.* This method could also be used for making individual prints through a photographic negative with different-colored lithographic inks instead of transfer ink in the same manner as the Kwik-Print or gum bichromate process.

## ALBUMEN SENSITIZER FOR
## LITHOGRAPHIC PLATES OR STONES

This is one of the oldest photographic processes used in lithography.

| | | |
|---|---|---|
| Albumen (powder or scales) | 1 | ounce (28 grams) |
| Ammonium bichromate | 0.5 | ounce (14 grams) |
| Distilled water | 12 | ounces (355 ml) |
| Ammonia (household) | 0.5 | ounce (15 ml) |

Mix all the ingredients together until the solids are completely dissolved. Filter the solution through filter paper before use to remove any residue from the albumen. This mixture has a shelf life of several months.

To use, coat the solution onto a plate or stone, dry it, and expose it to a negative. Coat with developing ink, or lacquer and developing ink, and allow it to dry. Wash the plate with water to remove all the unexposed coating from the nonimage areas.

## LIGHT-SENSITIVE BITUMEN (ASPHALTUM)

This old formula is historically interesting, although it contains several solvents that are seldom used today because of their toxicity.

First dissolve asphalt powder (Syrian or Egyptian) in turpentine to make a thick, syrupy mass. Place this in a larger container, add a considerable amount of ether or chloroform, and stir. A pitchlike residue will settle on the bottom. This is the light-sensitive portion. Decant the solvent and allow the mass of residue to dry. When dry, it can be broken up and powdered. The sensitive coating consists of the following:

| | |
|---|---|
| Asphalt powder (from the dry residue) | 1 ounce (28 grams) |
| Chloroform | 8 ounces (237 ml) |
| Benzol | 12 ounces (355 ml) |
| Rectified turpentine | 3 ounces (93 grams) |

This is coated onto the plate in the whirler for the most even method of coating. Then it is exposed for about 5 minutes to the arc lamp. It is then developed with rectified turpentine.

# SOURCES OF SUPPLIES

## SUPPLIES FOR INTAGLIO

### General

Dick Blick
P.O. Box 1267
Galesburg, IL 61401

Arthur Brown and Company, Inc.
2 West 46th Street
New York, NY 10036

L. Cornellisen & Son
22 Great Queen Street
London WC2
England

The Craftool Co.
1 Industrial Road
Woodridge, NJ 07075

David Davis
(Fine Arts Materials Co.)
531 La Guardia Place
New York, NY 10012

Graphic Chemical and Ink Co.
P.O. Box 27
Villa Park, IL 60181

T. N. Lawrence & Son, Ltd.
2 Bleeding Heart Yard
Greville Street, Hatton Garden
London EC1N 8S1
England

New York Central Supply Co.
82 Third Avenue
New York, NY 10003

Rembrandt Graphic Arts
The Cane Farm
Rosemont, NJ 08556

Sakura Color Products Corp.
1 Chome, 10-17 Nakamichi
Higashinari, Osaka 537
Japan

### Copper and Zinc Plates

Bridgeport Engravers Supply Co.
525 West 33rd Street
New York, NY 10001

Cronite Company, Inc.
Kennedy Boulevard at 88th Street
North Bergen, NJ 07047

C. George Co. (copper only in
   unbacked sheets)
40 Ellish Parkway
Spring Valley, NY 10977

National Steel and Copper
   Plate Co.
543 West 43rd Street
New York, NY 10036

Harold M. Pitman Co.
515 Secaucus Road
Secaucus, NJ 07094

Graphic Chemical and Ink Co.
P.O. Box 27
Villa Park, IL 60181

Rembrandt Graphic Arts
The Cane Farm
Rosemont, NJ 08556

## Inks for Etching and Lithography

F. Charbonnel
13 Quai de Montebello Court
Rue de l'Hotel Colbert
Paris 5e
France

L. Cornellisen & Son
22 Great Queen Street
London WC2
England

Cronite Company
  (etching inks only)
Kennedy Boulevard at 88th Street
North Bergen, NJ 07047

Rudolph Faust, Inc.
  (etching inks only)
542 South Avenue East
Cranford, NJ 07016

Graphic Chemical and Ink Co.
P.O. Box 27
Villa Park, IL 60181

T. N. Lawrence & Son, Ltd.
2 Bleeding Heart Yard
Greville Street, Hatton Garden
London EC1N 8S1
England

Lorilleux-Le Franc
161 rue de République
Puteaux, Siene
France

New York Central Supply Co.
82 Third Avenue
New York, NY 10003

Rembrandt Graphic Arts
The Cane Farm
Rosemont, NJ 08556

Standard Ink and Color Co.
  (etching inks only)
9 East Wesley Street
South Hackensack, NJ 07606

## Intaglio and Lithographic Presses

American French Tool Co.
Route 117
Coventry, RI 02816

Olivieri Bendini
  (etching presses only)
Via Modigliani 31
40133 Bologna
Italy

Charles Brand
84 East 10th Street
New York, NY 10003

The Craftool Co.
1 Industrial Road
Woodridge, NJ 07075

Glen Alps
6523 40th Avenue NE
Seattle, WA 98115

Graphic Chemical and Ink Co.
P.O. Box 27
Villa Park, IL 60181

Griffin Co.
2241 Sixth Street
Berkeley, CA 94710

Hunter Penrose, Ltd.
7 Spa Road
London SE16 3QS
England

Martech Ltd.
P.O. Box 504
Bayside, NY 11361

A. Paolini (etching presses only)
Via Sasso 51
61029 Urbino
Italy

Reinhold Breisch
  (etching presses only)
Machinen und Pressenbau
7441 Neckartenzlingen
Württemberg
Germany

Rembrandt Graphic Arts
The Cane Farm
Rosemont, NJ 08556

Sakura Color Products Corp.
1 Chome, 10-17 Nakamichi
Higashinari, Osaka 537
Japan

Takach-Garfield Press Co.
3207 Morningside Drive N.E.
Albuquerque, NM 87110

## SUPPLIES FOR PHOTOGRAVURE

**Carbon Tissue**

McGraw Colorgraph Co.
175 West Verdugo Avenue
Burbank, CA 91503

Autotype USA Ltd.
P.O. Box 267
Parkchester Station
Bronx, NY 10462

Autotype USA
1380 Brummel Avenue
Elk Grove Village, IL 60007

**Ferric Chloride (Acid-Free)**

Philip A. Hunt Chemical Corp.
P.O. Box 2090
Fairfield, NJ 07006
(48° Baumé Blue Label Roto-Iron
    No. 840363)

## SUPPLIES FOR LITHOGRAPHY

Sources of photographic plates and chemicals of the type mentioned in this book and others are listed under "Graphic Arts Suppliers" in the yellow pages. Most of the companies listed here under "Supplies for Intaglio—General" also handle some of these items as well as lithographic supplies in general.

## SUPPLIES FOR SCREEN PRINTING

Advance Process Supply Co.
6900 River Road
Pennsauken, NJ 08110

400 West Noble Street
Chicago, IL 60622

3101 San Jacinto
Houston, TX 77004

570 McDonald Avenue
Brooklyn, NY 11218

268 Eddystone Road
Downsview
Toronto, Ontario
Canada

Autotype USA
P.O. Box 267
Parkchester Station
Bronx, NY 10462

Colonial Printing Ink Co.
180 East Union Avenue
East Rutherford, NJ 07073

Naz-Dar Co. of New York
33 Lafayette Avenue
Brooklyn, NY 11217

Naz-Dar Co.
1087 North Branch Street
Chicago, IL 60622

Naz-Dar Co. of Michigan
12800 Woodrow Wilson
Detroit, MI 48238

Naz-Dar of California
2832 South Alameda
Los Angeles, CA 90058

Naz-Dar Canada, Ltd.
925 Roselawn Avenue
Toronto 19, Ontario
Canada

## PHOTOGRAPHIC CHEMICALS

Photographers' Formulary, Inc.
P.O. Box 5105
Missoula, MT 59806

Chemical supply houses usually have in stock such items as gum arabic, gelatin, and albumen in addition to chemicals.

## MISCELLANEOUS SUPPLIES

Artco Chemical Corp.
P.O. Box 1646
Wayne, NJ 07470
(This firm carries fish glue—photoengraver's glue—cold top enamel, PVC coating, and other photoengraving materials.)

TALAS (Technical Library
   Associates)
104 Fifth Avenue
New York, NY 10011
(This firm carries many chemicals, adhesives, tapes, and papers used in the restoration of books and the preservation of archival materials.)

# GLOSSARY

**actinic light.** Chemically active light from arc lamps, mercury vapor lamps, and photofloods that hardens light-sensitive plate-coating solutions.

**additive plate.** In lithography, a photographic plate to which a lacquer emulsion is added during processing.

**albumen.** The colloid derived from the white of eggs used for certain bichromated sensitizers in photomechanics.

**albumen process.** A photomechanical procedure in which a coating of bichromated albumen is used as a sensitized surface. Images are made on this surface by exposure under a line or halftone negative. The inked image is subsequently developed with water.

**aluminum plate.** A thin sheet of aluminum used in lithography for both surface-type and deep-etch offset plates.

**ammonium dichromate (ammonium bichromate).** A salt formed by neutralizing chromic acid with ammonia, used in photolithography as a sensitizing agent.

**anastigmatic lens.** A photographic lens developed in the late 1800s from rare glass which produces sharp images on a flat field from edge to edge. Earlier astigmatic lenses produced images that were less sharp at the edges and often distorted the image.

**animal-sized.** Describes paper that has been sized with a gelatin solution.

**anodized aluminum plate.** In lithography, a grained plate whose surface has been treated electrolytically to harden it and to impart a microscopic grain upon the existing mechanical grain. This surface then becomes more water-receptive and more durable.

**antihalation backing.** A layer, usually a dye or colloidal silver, on photographic films that protects the emulsion from reflex halation.

**aperture.** The lens opening, expressed as an $f$-number, that admits controlled amounts of light into a camera. Its size is variable, regulated by an iris diaphragm.

**aquatint.** An intaglio printmaking process in which rosin or asphaltum powder is used to produce a tonal or textural surface on a metal plate.

**artist's proof** (*épreuve d'artiste*). A print set aside from the edition for the artist's use.

**asphaltum.** A naturally occurring mixture of hydrocarbons and complex derivatives, used as an acid resist or protectant in photomechanics. In lithography, asphaltum is used to make the printing image on a press plate permanently ink-receptive.

**Autoscreen (film).** A photographic film that incorporates a halftone screen. When exposed to a continuous-tone image, it automatically produces a dot pattern as though a halftone screen were used in the camera.

**Baumé hydrometer.** An instrument, invented for industrial use by Antoine Baumé, that was designed to determine the specific gravity of liquids.

**bichromate solution.** Potassium bichromate crystals dissolved in water, used to sensitize carbon tissue.

**bitumen.** See *asphaltum*.

**Black Light.** The trade name for a fluorescent tube manufactured by General Electric which produces light rich in the ultraviolet region. It is used in some gravure processes to expose continuous-tone positives on carbon tissue.

**blanket.** Pressed or woven wool felts used on an etching press to apply a cushioning pressure to the paper.

**blueprint.** A photographic print, usually made by contact with a negative, on paper, glass, or metal, which serves as a guide for the artist making "keyed" art for multicolor printing. It is also used as a method of checking layout and imposition.

**brayer.** A hand roller used to apply ink to a stone, plate, or block.

**bridge.** A device that protects the image areas of a plate or stone from contact with the hand during drawing. In silk screen, a band that prevents floating parts of a solid stencil from falling off the screen.

**burin (graver).** A tool for engraving metal or wood that has a square or lozenge-shaped steel shaft attached to a wooden handle.

**burning in.** In photography, the procedure for exposing one part of an image more than another. In photo-etching, the heating of an emulsion to adhere it firmly to the metal.

**burnisher.** In intaglio, an oval tool used to polish and smooth a plate. In relief printing, any device for pushing the paper against an inked block in order to pick up ink and produce the print.

**burr.** In intaglio, the ridge of metal which the engraving or drypoint tool casts up on either or both sides of a line. In engraving the burr is usually removed, whereas in drypoint it remains on the plate and creates the characteristic fuzzy edges of the lines.

**calcium carbonate ($CaCO_2$—whiting).** A filler and coating agent produced by the reaction of lime and carbon dioxide or as a by-product in the manufacture of caustic soda (lye). The main component of lithographic stone.

**calotype.** A paper negative process introduced by Fox Talbot in 1840 and later called "talbotype."

**camera back.** The back of the camera which holds the photographic material. In a darkroom process camera the camera back holds the plate holder, the ground glass, and the halftone screen.

**camera copy board.** The part of a process camera where copy to be photographed is placed. Frequently it has a hinged glass cover to hold copy flat and can be tilted to the horizontal position for placement of copy.

**carbon tissue.** A special gelatin-coated paper used for photogravure and in some photo-screen procedures. The name derives from the fact that early tissues used carbon black pigment finely dispersed in the gelatin. Now most carbon tissue contains either iron oxide or a burnt sienna pigment as the coloring agent.

**carborundum (silicon carbide).** An abrasive in solid or powder form used to sharpen woodcut tools and to grain stones for lithography.

**cellulose acetate.** A plastic material used to protect drawings or as a drawing surface, commonly known as acetate.

**chrome plating.** The electrolytic process of plating chromium onto the surface of an etched gravure cylinder or plate to give it greater durability in the printing press.

**chromolithography.** A term coined in the nineteenth century for a color lithography technique that was used almost exclusively for reproducing paintings and watercolors.

**circular screen.** A halftone screen in a circular shape, which enables the camera operator to obtain the proper screen angles for color halftones without disturbing the copy.

**cliché-verre.** The French term for glass print, or a print made photographically from an image scratched through a light-resistant emulsion on a sheet of clear glass.

**cold top.** A light-sensitive resist that is whirled, sprayed, or rolled onto the surface of a copper plate or cylinder but not baked after application. It is used to engrave an image by the direct transfer process, or as an etching resist.

**collagraph.** A print made from an image built up with glue and sometimes other materials.

**collodion.** A substance composed of guncotton (an explosive nitrocellulose mixture) dissolved in alcohol or ether and used in the wet collodion process. Collodion was formerly used with potassium bromide for coating glass plates; the plate was then sensitized with silver nitrate and exposed, developed, and fixed after it had set on the glass but not dried.

**collotype.** A printmaking technique in which a thick piece of ground glass is coated with a thin layer of silicate of potash, then coated with a bichromated gelatin and dried in darkness. Exposure is made under a photographic negative; the gelatin becomes insoluble in direct proportion to the tones of the negative. After exposure, the plate is washed and dried, then flowed with a solution of glycerin and water, which the gelatin absorbs inversely to the exposure or hardening by light. Ink sticks to this gelatin surface in proportion to the hardening action of the light through the negative.

**color correction.** Improving color rendition by such methods as masking, dot etching, and re-etching on screened or continuous-tone separation negatives, or on halftone printing plates.

**color process work (process color).** A reproduction of color made by means of photographic separations.

**color sensitivity.** The sensitivity of different film emulsions to various portions of the light spectrum.

**color transparency.** A photograph in color made on transparent film, such as Kodachrome, Ektachrome, or Agfa Color.

**color wedge.** A tone scale showing graduated tones in primary printing colors, with or without density readings.

**commercial film.** Photographic film, usually insensitive to red light (orthochromatic), that can reproduce a long range of tone values.

**condenser system.** A pair of convex (positive) lenses in an enlarger whose interfaced relationship enables them to gather light from the source and direct it uniformly over the negative for projection through it.

**contact frame (printing frame).** A vacuum or pressure-back frame in which photographic materials are exposed.

**contact positive.** A positive made from a negative in a contact frame. Its tone values are the same as those of the copy; negative values are exactly the opposite of those of the copy.

**contact print.** A photographic copy made by exposing a sensitized emulsion in contact with a transparency, a negative, or a positive.

**contact screen.** A film magenta or gray screen used to make a screen negative or positive by contact exposure in a contact printing frame.

**continuing reaction.** In an exposed light-sensitive emulsion or coating, the chemical reaction that occurs between exposure and development.

**continuous-tone positive.** The positive used in the carbon tissue process for exposing the tone areas to create a transfer material. After development, the transfer material becomes the resist for etching the image into the copper surface. It is used in conjunction with a screen positive or a conventional gravure screen.

**continuous-tone separation.** A color separation or negative from a color copy in the continuous-tone stage before screening.

**contrast.** Tonal comparison or highlights and shadows in an original or reproduction; the tonal difference in detail.

**contrast range.** The amount of variance between highlights and shadows. The difference (on a positive) after subtracting the top highlight density reading from the deepest shadow on the densitometer.

**conventional gravure.** Gravure made by using a conventional crossline screen and a continuous-tone positive with all cells or dots uniformly square. After etching, a variable tonal range is achieved in the print.

**conventional screen.** A crossline screen with rulings that can vary from 60 to 300 lines per inch, used to screen the line and solid areas of a design. Opaque dots are square and separated by clean transparent lines. The ratio of dot to clean line can be 1 to 1 or up to 5 to 1, depending on the product.

**counter-etching.** Cleaning a grained offset metal plate with a weak acid solution to remove dirt and oxides before coating without damaging the grain.

**crevé.** In etching, an area in which the acid has eaten away the metal surface between closely spaced lines.

**crossline screen.** A standard halftone (glass) screen on which the opaque lines cross each other at right angles, forming transparent squares or "screen apertures."

**current density.** The amount of current on a unit area of the immersed part of the base cylinder or anodes in the plating bath, measured as amperes per square foot, amperes per square inch, or amperes per decimeter.

**cyanotype.** A process used to make blueprints. The paper is sensitized with a mixture of ferric ammonium citrate and potassium ferricyanide. When exposed, the ferric ions are partially reduced to ferrous ions. As the paper is washed with water, the ferrous ions react with the ferricyanide ions of the potassium ferricyanide to produce ferrous ferricyanide. This is an insoluble, deep blue-colored compound that makes the characteristic color of blueprints.

**dampening solution (fountain solution, dampening etch).** A solution of water, gum arabic, and various types of etches used to wet lithographic press plates.

**dark reaction.** In light-sensitive plate coatings, the hardening action that takes place without light, which is greater with high humidity and temperature.

**deep etch.** In photolithography, a process of platemaking or a type of printing plate. Deep-etch plates are made by contact photoprinting of line and halftone positives on grained metal plates sensitized with special solutions. The printing areas of the plate are etched into the sensitized surface to hold the image.

**degreasing.** Removing grease and oil from the surface of a plate. Solvent degreasing is accomplished by immersion in liquid organic solvent; vapor degreasing takes place when solvent vapors condense on the parts being cleaned.

**densitometer.** An electrical instrument designed to measure optical density or tonal values. There are two general types: visual and photoelectric.

**density.** In photography, the quantity of metallic silver or dye per unit area in negatives and positives. Often confused with *opacity*.

**desensitize.** In lithography, to make the nonimage areas of a lithographic plate nonreceptive to ink through chemical treatment of the metal. In photography, to decrease the color sensitivity of a photographic emulsion to facilitate development under comparatively bright light by means of an agent applied after exposure.

**developer, development.** In photography, the chemical agent and the process for rendering photographic images visible after exposure to light. In lithography, the agent and process of removing the unhardened bichromated coating; with a surface-type plate, of the nonimage areas; with a deep-etch plate, of the image areas.

**developing ink.** In photolithography, a greasy liquid applied to plate images to protect them and keep the surface ink-receptive while the plate is being developed, etched, and gummed.

**developing pad.** A pad, usually a plush-covered wooden block, that is used to work the developing solution over the surface of a deep-etch lithographic plate.

**diazo rosin.** An organic compound, consisting in part of two nitrogen atoms bonded together, which is used as a sensitizing agent on lithographic plates and in screen emulsions.

**dimensional stability.** The ability of paper or film to maintain its size despite changes in moisture content.

**direct halftone.** A halftone negative made by direct exposure of an object through a halftone screen.

**direct lithography.** The method of printing lithographically by direct transfer of ink from plate to paper by means of a direct rotary press. It is distinguished from an offset press, which has an intermediate offset cylinder between plate and paper.

**direct photography.** The making of halftone images by photographing the object to be reproduced rather than by rephotographing a continuous-tone picture of the object.

**direct separation (screen separation).** A separation negative made with a halftone screen.

**drier (siccative).** A substance added to inks to hasten drying.

**dry lay-down.** A method of transferring carbon tissue to a cylinder or plate in which the tissue remains dry.

**drypoint.** An intaglio technique in which a sharp needle is used to scratch the plate, creating a burr that yields a characteristic soft and velvety line in the final print.

**duotone.** A two-color halftone reproduction from a monochrome original. It requires two halftone negatives for opposite ends of the gray scale at proper screen angles.

**edition.** A set of identical prints, authorized for distribution and sometimes numbered and signed, pulled by or under the supervision of the artist.

**electroplating.** The electrodeposition of a metallic coating on an electrode in order to impart to a surface properties or dimensions different from those of the base metal.

**emulsion.** A mixture of two mutually insoluble liquids in which one liquid is finely dispersed in the other. In photography, a gelatin or collodion solution holding light-sensitive salts of silver in suspension, used as the light-sensitive coating on glass photographic plates.

**emulsion speed.** The degree of sensitivity to light. The time factor in sensitivity of light. The amount of moisture picked up by lithographic plate-coating solutions affects their speed of action; a 30 percent change in humidity can make the speed of a solution twice as fast.

**engraving.** An intaglio technique in which the image is produced by cutting a metal plate directly with a sharp engraving tool. The incised lines are inked and printed with heavy pressure.

**enlarger.** An apparatus for projecting light through a negative so as to expose light-sensitive paper and print the image larger or smaller than the negative.

**etching.** An intaglio technique in which a metal plate is first covered with an acid-resistant ground, then worked with an etching needle. The metal thus exposed is "eaten" in an acid bath, creating depressed lines that are later inked and printed.

**etching press.** An intaglio printing press consisting of two large cylinders and a sliding bed. The bottom cylinder supports the bed, where the inked plate and the paper are placed; the top cylinder presses the paper against the plate.

**ethylene glycol.** A secondary alcohol commonly used as antifreeze in car radiators. Small amounts, when mixed with water, break surface tension and act as a wetting agent. Used in such substances as Kodak's Photo-Flo solution for reducing drying spots on negatives.

**exposure.** The effect of light on photosensitive materials. Also, the product of light intensity and the time during which it affects a photosensitive material.

**exposure latitude.** The degree of exposure variance possible without detriment to image quality.

**exposure meter.** An instrument that measures light intensity and provides a calculator for determining proper exposure. It is calibrated for different emulsion speeds.

**extender.** A substance used to weaken or extend a printing ink, usually clear or transparent white.

**false biting (foul biting).** In etching, the accidental pitting by acid of areas on the plate that have been covered with ground.

**ferric chloride.** A salt of iron which acts as a mordant for copper, zinc, and other metals. Used for photogravure and increasingly in other etching processes.

**ferrotype.** A flat plate with a highly polished glazed surface on which gelatin carbon tissue is squeegeed to dry. The polished surface imparts a high gloss to the carbon tissue. Also used for glossy photographic prints. Plastic sheets are now used in place of metal.

**filter.** A dyed gelatin or glass device placed in the lens barrel of a camera between the photographic film and the copy to separate the colors. A red filter is used for a blue negative, a green filter for a red negative, and a blue filter for a yellow negative. A black negative can be made through an amber-colored filter or by using combination exposures through the red, green, and blue filters.

**fixing.** The process of dissolving out any undeveloped silver halide from a negative or positive emulsion to make a photographic image permanent. The most commonly used agent is sodium thiosulfite (hypo).

**flash.** The exposure to light of photosensitive material through a clear opening in the negative setup to create a flat tone in that area on the positive. The density of the area is controlled by the length of the exposure.

**flat.** In lithography, the assembly of photographic negatives or positives on goldenrod paper, glass, or vinyl acetate for exposure in a vacuum frame in contact with a sensitized metal press plate.

**flat etching.** The chemical reduction of the silver deposit in a continuous-tone or halftone plate, brought about by placing it in a tray containing an etching solution.

**focal length.** The distance between the optical center of a camera lens and the point at which an object image is in sharp or critical focus.

**focal plane.** The surface (plane) on which camera images transmitted by a lens are brought into sharpest focus, the surface represented by the light-sensitive film or plate.

**focus.** The point at which parallel light rays are made to cross after passing through a lens.

**fountain solution ("the water").** A solution of water, gum arabic, and other chemicals used to dampen lithographic plates to keep the nonprinting areas from accepting ink.

**gelatin.** An animal-derived protein which in its pure form is clean and colorless. It is used as a carrier for silver salts in photographic film, as the main substance in carbon tissue for photogravure, and in some screen emulsions.

**gelatin resist.** A layer of gelatin bearing a pattern of thick and thin areas corresponding to the highlight

and shadow areas of a piece of copy. After the carbon tissue is laid down, the paper backing is removed by hot water, and the developed gelatin is dried and ready for staging and etching. During etching, it resists the penetration and etching action of the etchant in all areas except those representing tone values of copy.

**glacial acetic acid.** Concentrated pure acetic acid ($CH_3COOH$).

**glare.** The effect of unwanted stray light on a photographic lens, causing light areas or spots on the film during exposure.

**glue** (bichromated). In lithography, used for the glue deep-etch platemaking process.

**goldenrod flat.** The assembly and positioning of lithographic negatives or positives masked out with goldenrod paper for exposure in contact with a light-sensitized press plate. The goldenrod paper beneath the image areas is cut away before the flat is reversed to place the emulsion side of the negatives to the emulsion on the metal plate. The flat is also used to make a blueprint of a form for checking imposition. Sometimes referred to as a form.

**goldenrod paper.** A yellow-orange paper that is semitransparent but blocks ultraviolet light.

**grain.** The distribution of silver particles in photographic emulsions and images. Also, the roughened or irregular surface of an offset printing plate.

**graining.** Subjecting the surface of a lithographic metal plate to the action of an abrasive. Graining imparts greater water retention to the otherwise nonporous surface.

**gravure screen.** A screen used to make halftones for gravure printing, consisting of a grid of clear lines with an opaque background.

**gray scale.** A graduated strip of standard gray tones, ranging from white to black, placed at the side of the original copy during photography to measure tonal range. For color-separation negatives, it determines the color balance or uniformity.

**ground glass.** In view and reflex cameras, a plate of glass frosted on one side to provide a translucent screen capable of stopping light rays to reveal an image formed on the focal plane that is visible on the other side.

**gum arabic.** A gum obtained from acacia trees, used in all branches of the graphic arts. In lithography, gum arabic solutions are used to desensitize or remove any affinity for ink in the nonprinting areas of the plate. It also forms a large part of the fountain solutions used on lithographic presses.

**gum stencil.** An acid-resistant stencil formed in deep-etch platemaking in noncopy areas of the plate when gum arabic is a constituent of the coating solution. The stencil protects nonimage areas while image areas are developed and etched.

**halation.** The reflection of light from the back side of the photographic film base, causing unsharp negative images. Halation is normally caused by light bouncing through and being reflected by the molecular particles in the emulsion beyond the area of its initial impact with the photosensitive material.

**halftone.** Any photomechanical printing surface and impression made from it in which detail and tone values are represented by a series of evenly spaced dots of varying size and shape; the dot areas vary in direct proportion to the intensity of the tones they represent.

**halftone gravure.** A gravure process using a screen formation similar to letterpress or offset, wherein dots vary in size from full dot in shadows to progressively smaller dots down through middle tones to pinpoint highlight dots.

**halftone negative.** A screened processed photographic film in which the dark dense area represents the light area of the positive or artwork and the light transparent area of the negative represents the dark area of the positive or artwork.

**halftone positive.** A photographic positive in which the halftone dots correspond in size to the tone values of the continuous-tone positive or copy.

**hand proof.** In offset lithography, a proof made with a hand proof press on which inking, dampening, and taking the impression are done manually.

**hard (dot).** A halftone dot, negative or positive, characterized by a sharp, clean-cut edge. In photography, the term *hard* denotes excessive contrast.

**high contrast.** The relationship of highlights to shadows on a negative, whether continuous-tone or halftone. In such a negative the highlights are very black and the shadows very open.

**highlight.** An area of copy in which there is meant to be an impression of brightness or intense light, hence little or no ink in that area of the reproduction. Also, the darkest area on a negative and the lightest tone on a positive.

**highlight dots.** The small dots in the lightest areas of a screened image, representing the lightest areas of the copy.

**highlight halftone.** A halftone reproduction in which the highlights are devoid of dots for accentuation of contrast.

**hydrometer.** An instrument designed to determine the specific gravities, and hence the strengths or densities, of liquids.

**hygrometer.** An instrument designed to measure the moisture content of gelatin or paper, or to measure the amount of moisture or humidity in the air.

**hypo.** An abbreviation for sodium thiosulfate, also named sodium hyposulfite, a chemical compound used in fixing baths to dissolve the undeveloped silver salts remaining in an emulsion after development.

**impression number.** The number of a print in an edition. The first three prints in an edition of one hundred would be numbered 1/100, 2/100, 3/100.

**ink-receptive.** Having an affinity for greasy ink in preference to water.

**intaglio.** A method of printing from a plate or cylinder in which the image is engraved below the surface of the printing plate; the gravure method.

**isopropyl alcohol.** A secondary alcohol used in several lithographic and intaglio platemaking operations. It is usually denatured, which means that a compound has been added to make it poisonous and unfit for consumption.

**lacquer.** A protective coating consisting of a rosin and/or a cellulose ester dissolved in a volatile solvent, sometimes with pigment added.

**latent image.** Silver halide crystals in an emulsion rendered developable by exposure to light, but not visible until developed.

**lay-down.** The act of transferring carbon tissue (image) to a plate.

**light sensitivity.** The ability of a substance to change chemically when exposed to light.

**line copy.** Copy suitable for reproduction without a screen, composed of lines or dots as distinguished from copy composed of continuous tones. Lines or dots may be small and close together so as to simulate tones, but are still regarded as line copy if they can be faithfully reproduced without a screen.

**lines to the inch.** Crossline halftone screens are made up of opaque lines ruled at right angles to each other. Some screens have more or fewer lines to the inch than others and are classified accordingly. The 120- and 133-line screens are the ones most commonly used. In large-size work the screen ruling may be as coarse as 40 lines to the inch; in very fine detail work screens with 250 lines or more to the inch are successfully used. The number of dots to the square inch is the square of the lines to the inch of the screen. A 133-line screen, for example, produces 17,689 dots per square inch.

**litho crayon.** A pencil-shaped stick composed of soap, tallow, shellac, wax, and lampblack used to execute crayon sketches on grained paper, to draw directly on lithographic stone and metal plates, and as a delicate staging medium in halftone relief etching.

**lithography (offset).** A printing process using thin metal printing plates having a flat or plane surface on which the area to be printed is made receptive to grease (ink) and the nonprinting areas are made to repel ink by a thin film of moisture. Basically, the inked image is transferred to a rubber blanket and from the rubber blanket to the surface of the material to be printed on.

**long.** A term used to describe the consistency of lithographic inks. Inks are called *long* if they become stringy when tapped between the fingers, *short* if the ink breaks off short like lard. Both long and short inks can be either stiff or soft.

**magenta screen.** A patented film screen, dyed magenta, having a lenticular screen formation made of soft-focus dots that create a screened negative from which a screen positive is made.

**make-ready.** On an offset press, the adjusting of feeder, grippers, side guide, and pressure between plate and offset blanket cylinder, putting the plate on the press and ink in the fountain, to be ready to run the press.

**masking.** Applying masks, such as camera-back masking or contact masking, to color-correct a set of separation negatives.

**mercury vapor lamp.** An enclosed light source that contains mercury, sometimes used to expose sensitized plates.

**mezzotint** (*manière noire*). An intaglio image-making technique in which the plate is worked from dark tones to light. The surface is first roughened with a mezzotint rocker or roulette so that, if inked, it would print a rich, solid black. The areas that are not to print are then burnished and flattened to produce various grays and white.

**mezzotint screen.** A tonal screen for halftone photography, employing a random pattern of dots.

**micron.** The millionth part of a meter; the standard of measuring gravure cells; 25.4 microns equal one 0.001 inch.

**middle tones.** Tones or values that fall between highlights and shadows, usually representing 30 percent to 75 percent values of copy.

**mil.** Short for 0.001 inch.

**moiré.** Undesirable patterns occurring when reproductions are made from halftone proofs or steel engravings, caused by conflict between the ruling of the halftone screen and the dots or lines of the original.

**monotone.** Black-and-white copy or its photographic counterpart. A single-color reproduction of any type of artwork.

**mordant.** An acid or salt having a corrosive action on metal.

**Mylar.** The trade name for a polyester plastic made by Dupont with high tensile strength and good dimensional stability.

**negative, line.** A negative photographic image made from a black-and-white piece of artwork or from a line positive. It is made by projection or by a contact method on a high-contrast photosensitive material.

**negative, screened.** In the gravure process, to make a screened positive, a negative containing the image of the continuous-tone positive, but formed by halftone dot cell walls, is made from the continuous-tone positive. It may be made by projecting a positive image in a camera through a halftone screen onto a photosensitive material, or by exposing

through a magenta or gray contact screen onto photosensitive material by the contact method. Screened positives are made from screened negatives.

**negative, separation.** One of the photographic negatives made in the color-separation process by camera projection, contact, or electronic scanning. It represents in negative form the tonal values of one of the basic colors contained in the copy. For example, the yellow separation negative contains, in negative form, all of the yellow in the artwork that is obtainable by the color-correction process being used. Its function, in conjunction with each of the other separation negatives, is to reproduce the full color range of the artwork.

**negative-working.** Refers to lithographic plates that require a negative to make a positive printing image.

**newsprint.** A grade of paper containing about 85 percent groundwood and 15 percent unbleached sulfite. These proportions vary among paper manufacturers, but the general characteristic is a coarse and absorbent finish. Basis weight is between 30 and 34 pounds for 500 sheets 24 by 36 inches (61 by 91 cm).

**nitric acid.** A corrosive substance ($HNO_2$) used in etching.

**nonblinding.** In lithography, refers to a lacquer that when applied to a plate causes good ink receptivity, as opposed to *blinding*, a term used to describe an area that refuses to take ink.

**offset.** Wet ink transferred from one sheet to another in a load of freshly printed sheets. Also, lithographic images printed on an offset press.

**offset lithography.** See *lithography*.

**opaque.** Not permitting the passage of light. In photography, a nontransparent pigment applied to certain areas of negatives to prevent passage of light through them. In lithography, a water-soluble solution used to cover light pinholes or to alter negatives.

**orthochromatic.** Refers to a film or plate coated with a light-sensitive emulsion that is sensitive to yellow and green as well as blue and violet in the color spectrum, but not to red.

**overprinting.** In lithographic printmaking with surface plates, a method of combining line and halftone images on a plate by exposing a second negative on an area of the plate previously exposed to a different negative.

**panchromatic.** Refers to photographic materials that are sensitive to all visible spectral colors, including red.

**paste drier.** A type of ink drier used in lithographic inks, usually a combination of lead and manganese.

**penetration.** The ability of a liquid (ink, varnish, or solvent) to be absorbed into the paper or other printing substrate.

**perchloride of iron.** Another name for ferric chloride ($FeCl_3$).

**pH.** A scale of 0 to 14 used to express the acidity or alkalinity of solutions, determined by their hydrogen ion content. A pH value of 7 is considered neutral, solutions of a lower value are considered acid, and those with a pH higher than 7 are alkaline.

**photographic proofs.** Photographic prints made from negatives or positives.

**photogravure.** An intaglio printing process in which the image has been placed on the plate by photographic means using carbon tissue.

**photolithography.** The branch of lithographic printing in which photography is employed for production of the image on the final printing surface. The original printing surface was lithographic stone, but it has been almost completely displaced by thin and flexible sheets of metal (zinc, aluminum, stainless steel, bimetallic plates, polymetallic plates) that have a grained surface for retention of moisture. The oldest photolithographic procedure still in practical use is the albumen process, in which light-hardened and inked images of bichromated albumen serve as the actual printing surface. Deep-etch plates are a modern form of photolithographic surface, as are bimetallic and plastic plates.

**photo resist.** Any light-sensitive coating or emulsion used to transfer an image to a gravure cylinder which, after developing and drying, becomes acid-resistant.

**photosensitive.** Refers to photographic, transfer, and other materials that have been coated with a chemical compound that is capable of change upon exposure to light, such as photographic films and papers or carbon tissue.

**photo silk screen.** A technique for the transfer of photographic images to a stencil for screen printing.

**pinholing.** The failure of a printed ink or coating to form a complete film, evidenced by small holes in the solid print area.

**pinpoint light source.** A very small point of light used to make contact negatives or positives.

**pin registration.** A method of lining up a set of two or more films in a camera back, or for layout or stripping, by prepunching them to an exact pin setting.

**plate.** A general term used to describe several items of the gravure and other graphic arts processes, including negatives, positives, letterpress engravings, and offset printing plates.

**plate tone.** A visible trace of color in nonimage areas of an intaglio print, produced by leaving a thin film of ink on the plate after wiping.

**platinic chloride.** A salt of platinum used in early experiments in etching copper for photogravure. Because of its cost, it was replaced by ferric chloride.

**positive.** A transparent photographic film—continuous-tone, line, or halftone—that carries the

same pattern of highlights and shadows as the original copy, if monotone. If color, the positive carries these values as represented by its respective color, whether yellow, red, blue, or key.

**positive print.** Any type of photographic print made from a negative.

**positive-working.** Refers to lithographic plates that require a positive to make a positive printing image.

**postbaking.** Heating an intaglio plate on which an emulsion has been coated to eliminate residual solvents or moisture.

**posterization.** In serigraphy, a photographic technique for producing sharp and dramatic images by making variable exposures of a continuous-tone image.

**potassium bichromate.** Crystals dissolved in water used as the sensitizer for carbon tissue and as a basis for other light-sensitive coatings.

**powderless etching.** A copper etching process in which the etchant contains a filming agent that protects the sides of the dots or cells during the etching process.

**process.** The type of printing work that requires the use of panchromatic photographic materials and color correction as opposed to orthochromatic materials, and implies continuous-tone copy as opposed to line copy. Also commonly used to indicate the number of colors necessary in a reproduction, such as four-color process, three-color process, etc.

**process camera.** A camera designed specifically to reproduce color process work.

**process colors.** Yellow (lemon), magenta (cold red), and cyan (blue green), so selected because when combined they produce black and when used in various strengths and combinations they make it possible to reproduce thousands of different colors with a minimum of photography, platemaking, and presswork.

**process lens.** A highly corrected photographic lens for line, halftone, and color photography. In lithography, it is used for line and halftone photography, continuous-tone and color separation for line.

**progressive proofs.** Proofs made from the separate plates used in color process work, showing the sequence of printing and the result after each additional color has been applied.

**projection printing.** A system of lenses and lamps that can be used to project an image on a sensitized plate, so that it may be larger or smaller than the projected negative or positive. Used for large halftone work on some types of lithographed posters.

**proofing.** Frequently used instead of *proving*, denoting the operation of pulling proofs of plates for proofreading, revising, trial, approval of illustrations, and other purposes preliminary to production printing. In lithography, print proofs (photoprints) are used to check layout and imposition when plates are made from flats and colors.

**proof press.** A printing machine used to make proofs. It usually has most of the elements of a production machine but not for automatic sustained production. An offset proof press has provision for transferring printed image to the offset blanket and from that to the paper.

**pulsed xenon lamp.** A stroboscopic light source.

**Putz Pomade.** A metal polish used by finishers and some platers to clean and polish copper after etching or tooling.

**quartz lamp.** A type of light source used for illuminating camera copy boards.

**rag wiping.** A technique for removing ink from the surface of an intaglio plate with a soft rag just before printing.

**rectifier.** A device that converts alternating current into direct current.

**reducers (ink).** Materials used to reduce the body viscosity or strength of an ink. It may be a clear or pigmented extender, a varnish, or a solvent blend.

**register.** The fit of one color to another, or of one positive or negative to another carrying the same image. The printed result, a set of positives or negatives, or a set of cylinders or flat plates, is described as being in or out of register. "In register" indicates a proper fit. "Out of register" indicates a poor fit.

**register mark (crossmarks).** A small design, usually in the form of crossed fine lines, etched in the same relative position on each cylinder or plate in a set to establish a proper fit or register between printing cylinders or plates.

**relief.** A printmaking technique in which the image is printed from a raised surface, usually produced by cutting away the nonimage areas.

**residual.** The very thin film of plate coating always left on the metal of a lithographic plate after development. Post-treatment of the plate with various solutions removes this film and better prepares the nonprinting areas of an albumen plate after development.

**resolution.** The degree of sharpness and detail in a color copy or in the printed result.

**retouching.** All hand, chemical, or dye reduction or add-on systems used to correct the tonal values of a negative or positive to the proper densities required for the engraving method to be used and for the etching specification desired.

**rolling up.** In lithography, inking the finished plate without taking a proof or impression. It is usually done by hand to protect the image or to render inspection easier.

**rotogravure.** The process of printing on a rotary press from a design of cells or wells recessed or

etched below the surface of a copper-plated cylinder.

**roulette.** A tool with a special burr or wheel that is pressed or rolled on the copper printing surface of a gravure plate or cylinder to create a grain tone.

**safelight.** In photography, the special darkroom lamp emitting illumination in which sensitized materials can be handled without danger of fogging by the action of light.

**screen.** Crossed fine lines used to convert a continuous-tone image into a screened image suitable for etching and printing. The number of lines per inch varies considerably, depending on the reproduction process. Most publication and packaging gravure printing is done in 150 lines per inch, but finer or coarser screens can also be used.

**screen, halftone.** A special film screen used to break up a continuous-tone image into various-size dots. Tonal gradations are obtained by controlling the size of the dots. The larger the dot, the darker the area; the smaller the dot, the lighter the area. In the gravure process, further control of tone reproduction is achieved by varying the depth of the dots or cells etched into the printing plate through the use of a continuous-tone positive which is registered with and printed into the light-sensitive resist, such as carbon tissue. Gravure halftone dots vary in size and depth, thus controlling the quantity of ink held in each cell.

**screen angle.** The angle at which the crosslines of a magenta, conventional, or other screen are positioned in relation to the horizontal axis of the copy or cylinder. Also, the angle at which the screen is exposed on sensitized carbon tissue or in the halftone negative or positive. This is to avoid an objectionable moiré pattern.

**screen negative.** See *halftone negative*.

**screen positive.** See *halftone positive*.

**screen ratio.** The ratio of the area occupied by lines to the area of white space in a screen.

**scumming.** In lithography, the picking up of ink by the press plate in nonprinting areas, basically because spots do not remain desensitized.

**sensitivity guide.** A narrow, calibrated continuous-tone gray scale. In the platemaking operation, the gray scale is exposed on the sensitized press plate along with the rest of the work. The number of steps in the scale showing as solids on the developed plate determine the sensitivity of the plate coating and measure the tonal values reproduced on the plate.

**sensitize.** To make chemically sensitive to light.

**sensitized carbon tissue.** Carbon tissue that has been immersed in a solution of potassium bichromate, making it sensitive to actinic light.

**sensitizer.** A chemical compound (salts of iron, silver, and chromium, as well as diazo compounds and dyes) used to render photographic surfaces sensitive to light and color. In lithography, also used in plate coatings to make them light-sensitive.

**separation.** In color photography, the isolation or division of the colors of an original into their primary hues, each record or negative used for the production of a color plate. In lithography, direct separations are made with a halftone screen; indirect separations involve continuous-tone separation negatives and screened positives made from these.

**serigraphy (silk screen).** A printing technique in which a squeegee is used to force ink directly onto a piece of paper or canvas through a stencil containing the image.

**shadow.** The darkest areas of an original, negative, and reproduction.

**shore durometer.** An instrument for measuring the hardness of rubber rollers.

**silhouette halftone.** A halftone illustration plate from which the screen surrounding any part of the image has been cut or etched away.

**silhouetting.** Opaquing out the background around a subject on a halftone or a continuous-tone negative. On a positive this can be achieved by staging the subject and by flat-etching the background until it is entirely transparent.

**silicon carbide.** See *carborundum*.

**silk screen.** See *serigraphy*.

**silver print.** A photographic print on paper that has been sensitized with silver chloride salts.

**sizing.** A gelatin or starch solution used to coat paper to improve its strength and lessen its absorption.

**snake slip.** Finely compressed pumice sticks used to remove small image areas from a lithographic stone or plate.

**snakestone (water-of-Ayr stone).** An abrasive stone quarried in Scotland, used to erase and polish work on lithographic stones.

**sodium hypochlorite.** Common household bleach.

**soft dot.** When the halation around the edge of the dot is excessive and almost equals in area the dot itself, the dot is called soft. When the amount of halation is so slight as to be barely noticeable and the dot is very sharp, the dot is called hard.

**spectral sensitivity.** The rate of response of a photographic material to a particular range of the spectrum, usually expressed as a wavelength range.

**spotting.** A step in print finishing to eliminate white spots on the print surface. Also, touching up holes or tiny blemishes on negatives or positives with retouching dye. Also, covering spots on developed carbon tissue or a cold top resist with asphaltum prior to etching.

**spray coater.** A machine for spraying a thin coating of light-sensitive resist onto a cylinder or plate.

**staging.** Applying asphaltum or other acid-resistant material on the nonprinting areas of a cylinder or plate prior to etching to protect them from the etchant. The asphaltum is usually applied by hand with a small brush but sometimes with an airbrush or ruling pen.

**steel facing.** The process for adding pure iron to a metal intaglio plate by electrodeposition.

**stencil.** A means of blocking the passage of ink through the nonimage areas of a screen. A stencil can be made of paper, glue, tusche, shellac, or a variety of other materials.

**stipple.** Lights and shades on originals and reproductions produced or translated by irregularly spaced dots instead of lines and cross-hatchings. A technique used for getting tone by hand methods on lithographic plates.

**stop bath.** A dilute solution of acetic acid that chemically neutralizes the developer, thus stopping its action, in negatives and prints prior to their transfer into a fixing bath.

**stopping out.** In photomechanics, the application of opaque to photographic negatives; staging of halftone plates during relief etching; protecting certain areas of deep-etch plates by applying gum solution prior to the application of plate bases, so that no ink-attracting medium will be deposited on the protected areas.

**stripping.** The act of positioning or inserting copy elements in negative or positive film to a unit negative; the positioning of photographic negatives or positives on a lithographic flat for form imposition.

**subtractive plate.** In lithography, a presensitized plate from which the nonprinting portions are removed after exposure.

**surface plate.** One of the two basic types of lithographic press plates; a colloid image is formed on the light-sensitized metal plate by the action of actinic light through photographic negatives. The albumen plate is the most common form, but there are others, including photopolymer plates.

**tack.** The resistance to splitting of an ink film between two separating surfaces—stickiness. Also, the quality of adhesion of an offset blanket; when the blanket has been used to a point that the rubber starts to disintegrate, the blanket is said to be tacky.

**tarlatan.** Sheer, heavily sized cotton fabric, used for rag wiping of intaglio plates.

**tints.** Various tones (strengths) of a solid color. Photographic (halftone) tints are stock developed film (negative and positive) in various strengths of tone and usually 133-line screen.

**tone density.** The optical density of a tone area. With halftones, the overall density, which takes into account both the dots within the tone area and the spaces between them.

**tone scale (tone wedge).** A step wedge showing graduated tones from shadow to highlight with densitometer readings for each of eight or ten steps, or more if necessary.

**transfer.** The act of transferring an image to the copper surface of a plate or cylinder.

**transfer ink.** In lithography, an ink containing beeswax, tallow, and pigment, used to transfer an image from one stone to another or from a stone to a plate.

**translucent.** Partially transparent. The ability of a substance to permit the passage of light but diffuse it in the process.

**transparency.** A monochrome or full-color photographic positive or picture on a transparent support, the image intended for viewing and reproduction by transmitted light. In photography, the light-transmitting power of the silver deposit in a negative. The inverse of *opacity*.

**transparent inks.** Inks that when printed one over the other produce additional colors.

**trisodium phosphate.** The active ingredient in such degreasing and spot-removing preparations as Calgon and Cascade.

**tusche.** A grease-based drawing material containing wax, tallow, soap, shellac, and lampblack, used for lithographic images and some types of stencils.

**ultraviolet (UV).** Beyond the violet, as the invisible rays of the spectrum lying outside the violet end of the visible spectrum.

**undercutting.** In etching or aquatint, the lateral biting of the acid in areas covered with ground.

**vacuum printing frame.** A frame used to print carbon tissue in contact with a positive, or to expose negatives or positives in contact with each other. Such frames have a glass cover and rubber hose attached to draw out air by means of a vacuum pump, or with channels running under the film to flatten out or draw it down firm and flat.

**Van Dyke print.** A silver print or photographic image made on inexpensive photographic paper sensitized with a mixture of iron and silver salts; a brown print. Frequently used in offset lithography as a proof from a negative.

**vellum.** A translucent paper that can be used in many photographic processes; commonly used as a high-grade tracing paper.

**Velox print.** A chloride printing paper made by the Eastman Kodak Co., sometimes erroneously used as the name for similar developing papers.

**vignette.** An original piece of copy, halftone printing plate, or impression in which the background or a portion of the illustration gradually shades off until the lightest tones or extreme edges appear to merge with the paper on which they are printed.

**viscosity.** Resistance to flow; the opposite of fluidity.

**wash drawing.** A drawing made by a brush in washes with a single pigment of black or dark color soluble in water, to be reproduced by the halftone.

**washing out.** Removing an image coating that has been applied to the plate, such as developing ink or asphaltum, with turpentine or another solvent.

# BIBLIOGRAPHY

## GENERAL WORKS

Brunner, Felix. *A Handbook of Graphic Reproduction Processes.* Taufen: Arthur Niggli Ltd., 1962.

Heller, Jules. *Printmaking Today.* New York: Holt, Rinehart and Winston, 1972.

Ross, John, and Romano, Clare. *The Complete Printmaker.* New York: The Free Press, 1972.

Saff, Donald, and Sacilotto, Deli. *Printmaking: History and Process.* New York: Holt, Rinehart and Winston, 1978.

## INTAGLIO

Banister, Manly. *Etching and Other Intaglio Techniques.* New York: Sterling, 1970.

Brunsdon, John. *The Technique of Etching and Engraving.* New York: Reinhold, 1967.

Buckland-Wright, John. *Etching and Engraving.* London: Studio, 1953.

Chamberlain, Walter. *The Thames & Hudson Manual of Etching and Engraving.* London: Thames & Hudson, 1972.

Eastman Kodak Company. *Photofabrication Methods with Kodak Photosensitive Resists.* Rochester, NY: Kodak Corporation.

Edmondson, Leonard. *Etching.* New York: Reinhold, 1973.

Faithorne, W. *The Art of Graving and Etching,* 2d ed. London, 1702. Reprinted, New York: Da Capo, 1968.

Gross, Anthony. *Etching, Engraving, and Intaglio Printing.* London: Oxford University Press, 1970.

Hayter, Stanley William. *New Way of Gravure,* rev. ed. New York: Watson-Guptill, 1981.

Hind, Arthur. *A History of Engraving and Etching.* New York: Dover, 1963. Originally published, Boston: Houghton Mifflin, 1908.

Leaf, Ruth. *Intaglio Printmaking Techniques.* New York: Watson-Guptill, 1976.

Lumsden, E. S. *The Art of Etching.* New York: Dover, 1962.

Pyle, Clifford. *Etching Principles and Methods.* New York: Harper & Row, 1941.

Reed, Earl H. *Etching: A Practical Treatise.* New York: Putnam, 1914.

Sternberg, Harry. *Modern Methods and Materials of Etching.* New York: McGraw-Hill, 1949.

Trevelyan, Julian. *Etching: Modern Methods of Intaglio Printmaking.* New York: Watson-Guptill, 1964.

Wright, J. B. *Etching and Engraving.* London: Studio, 1953.

## PHOTOGRAVURE

Bennett, Colin N. *Elements of Photogravure,* 2d ed. London: Technical Press, 1935. Reprinted, Bunnell, Peter, *Nonsilver Printing Processes.* New York: Arno Press, 1973.

Blaney, Henry R. *Photogravure.* New York: Scovill, 1895.

Cartwright, H. Mills. *Photogravure.* Boston: American Photographic Publishing Co., 1939.

Cartwright, H. Mills, and MacKay, Robert. *Rotogravure: A Survey of European and American Methods.* Lyndon, KY: Mackay Publishing Co.

Denison, Herbert. *A Treatise on Photogravure.* Rochester, NY: Visual Studies Workshop, 1974.

Kraft, James N. "An Historical and Practical Investigation of Photogravure." M.F.A. thesis, University of New Mexico, 1969.

*McGraw Colorgraph Systems for Gravure Etching.* Burbank, CA: McGraw Colorgraph Corp., 1966.

Rothberg, Samuel W. *Photogravure Handbook.* Chicago: Rye Press, 1976.

*Technical Guide for the Gravure Industry.* New York: Gravure Technical Association.

## LITHOGRAPHY

Antreasian, Garo Z., and Adams, Clinton. *The Tamarind Book of Lithography: Art and Techniques.* New York: Abrams, 1971.

Cumming, David. *A Handbook of Lithography,* 3d ed. London: A. & C. Black, 1948.

Halbmeier, Carl. *Senefelder: The History of Lithography.* New York: Senefelder Publishing, 1926.

Hartsuch, Paul J. *Chemistry of Lithography.* Pittsburgh: Graphic Arts Technical Foundation, 1961.

Jones, S. *Lithography for Artists.* London, 1967.

Knigin, Michael, and Zimiles, Murray. *The Contemporary Lithographic Workshop Around the World.* New York: Reinhold, 1974.

*The Lithographer's Manual.* Pittsburgh: Graphic Arts Technical Foundation.

Reed, Robert F. *Offset Lithographic Platemaking.* Pittsburgh: Graphic Arts Technical Foundation, 1967.

————. *What the Lithographer Should Know About Ink.* Pittsburgh: Graphic Arts Technical Foundation, 1966.

————. *What the Lithographer Should Know About Paper.* New York: Lithographic Technical Foundation, 1961.

Soderstrom, Walter. *The Lithographer's Manual.* New York: Waltwin Publishing, 1937.

Twyman, Michael. *Lithography: 1800–1850.* London: Oxford University Press, 1970.

## PHOTOGRAPHIC PROCESSES

Bunnell, Peter C. *Nonsilver Printing Processes.* New York: Arno Press, 1973.

Cox, R. J. *Non-silver Photographic Processes.* New York: Academic Press, 1975.

Crawford, William. *The Keepers of Light.* Dobbs Ferry, NY: Morgan and Morgan, 1979.

Denison, Herbert. *A Treatise on Photogravure.* Rochester, NY: Visual Studies Workshop, 1974.

Eaton, George T. *Photo Chemistry in Black-and-White and Color Photography.* Rochester, NY: Kodak Corporation, 1957.

―――. *Photographic Chemistry.* Hastings-on-Hudson, NY: Morgan and Morgan, 1965.

Eder, Josef Maria. *History of Photography.* New York: Dover, 1978.

*The Focal Dictionary of Photographic Technologies.* New York: Prentice-Hall, 1973.

Gassan, Arnold. *Handbook for Contemporary Photography.* Rochester, NY: Light Impressions, 1977.

*Gelatin.* New York: Gelatin Manufacturers Institute of America, 1973.

Gernsheim, Helmut and Alison. *The History of Photography.* New York: McGraw-Hill, 1969.

Hedgecoe, J., and Langford, Michael. *Photography: Materials and Methods.* London: Oxford University Press, 1971.

Horenstein, Henry. *Black and White Photography.* Boston: Little, Brown, 1974.

James, Thomas H., and Higgins, George C. *Fundamentals of Photographic Theory.* Hastings-on-Hudson, NY: Morgan and Morgan, 1968.

*Kwik-Print Newsletter.* Brooklyn, NY: Direct Reproduction Corp., 1976.

Langford, Michael J. *Advanced Photography.* New York: Amphoto, 1972.

―――. *Basic Photography.* New York: Amphoto, 1965.

Lietze, Ernest. *Modern Heliographic Processes.* New York: D. Van Nostrand, 1888. Reprinted, Rochester, NY: Visual Studies Workshop, 1974.

*Procedures for Processing and Storage of Black-and-White Photographs for Maximum Possible Permanence.* Grinnell, IA: East Street Gallery, 1970.

Rexroth, Nancy. *The Platinotype 1977.* Arlington, VA: Violet Press, 1977. Distributed by Light Impressions, Rochester, NY.

Swedlund, Charles. *Photography: A Handbook of History, Materials and Processes.* New York: Holt, Rinehart and Winston, 1974.

Tollis, Hollis N., and Zakia, Richard D. *Photographic Sensitometry.* Hastings-on-Hudson, NY: Morgan and Morgan, 1969.

Wade, Kent E. *Alternative Photographic Processes.* Dobbs Ferry, NY: Morgan and Morgan, 1978.

Wall, E. J., and Jordan, Franklin I. *Photographic Facts and Formulas*, 4th ed. Garden City, NY: American Photographic Publishing Co., 1975.

Wilson, Thomas A. *The Practice of Collotype.* Boston: American Photographic Publishing Co., 1935.

### Ambrotype

Bunnell, Peter. *The Collodion Process and the Ferrotype. Three Accounts.* New York: Arno Press, 1973.

### Carbon and Carbro

Anderson, Paul L. "Special Printing Processes." In *Handbook of Photography* by Keith Henny and Beverly Dudley. New York: Whittlesey House, 1939.

Burton, W. K. *Practical Guide to Photographic and Photomechanical Printing.* London: Marion & Co., 1887.

Marton, A. M. *A New Treatise on the Modern Methods of Carbon Printing.* Bloomington, IN, 1905.

Tennant, John. "The Carbon Process." *The Photo-Miniature* no. 17, 1900.

Wall, E. J., and Jordan, Franklin I. *Photographic Facts and Formulas*, 4th ed. Garden City, NY: American Photographic Publishing Co., 1975.

### Cyanotype

Brown, George E. *Ferric and Heliographic Processes.* London: Dawborn & Ward, 1899.

Jones, Bernard Edward. *Cassell's Cyclopedia of Photography.* London: Cassell, 1911. Reprinted, New York: Arno Press, 1974, pp. 66–68, 397–98.

Kosar, Jaromir. *Light-Sensitive Systems.* New York: John Wiley & Sons, 1965.

### Gum Printing

Anderson, Paul L. "Special Printing Processes." In *Handbook of Photography* by Keith Henny and Beverly Dudley. New York: Whittlesey House, 1939.

### Kallitype

Brown, George E. *Ferric and Heliographic Processes.* London: Dawborn & Ward, 1899.

### Oil and Bromoil

Mayer, Emil. *Bromoil Printing and Bromoil Transfer.* Boston: American Photographic Publishing Co., 1923.

Mortimer, F. J., and Coulthurst, S. L. *The Oil and Bromoil Processes.* London: Hazell, Watson & Viney, 1909. Reprinted, Bunnell, Peter, *Nonsilver Printing Processes.* New York: Arno Press, 1973.

Tennant, John A. "Oil and Bromoil Printing." *The Photo-Miniature*, March 1910.

Whalley, Geoffery E. *Bromoil and Transfer.* London: Fountain Press, 1961.

**Platinum and Palladium**

Wall, E. J., and Jordan, Franklin I. *Photographic Facts and Formulas*, 4th ed. Garden City, NY: American Photographic Publishing Co., 1975.

**Salted Paper**

Tennant, John A. "Albumen and Plain Paper Printing." *The Photo-Miniature*, December 1900.

## SCREEN PRINTING

Auvil, Kenneth W. *Serigraphy: Silk Screen Techniques for the Artist.* Englewood Cliffs, NJ: Prentice-Hall, 1965.

Biegeleisen, J. I. *Screen Printing: A Contemporary Guide.* New York: Watson-Guptill, 1971.

Chieffo, Clifford T. *Silk Screen as a Fine Art: A Handbook of Contemporary Silk Screen Printing.* New York: Reinhold, 1967.

Gardner, Andrew B. *The Artist's Silkscreen Manual.* New York: Grosset & Dunlap, 1976.

Kinsey, Anthony. *Introducing Screen Printing.* New York: Watson-Guptill, 1968.

Kosloff, Albert. *Ceramic Screen Printing.* Cincinnati: Signs of the Times, 1962.

———. *Photographic Screen Process Printing.* Cincinnati: Signs of the Times, 1968.

———. *Screen Printing Techniques.* Cincinnati: Signs of the Times, 1972.

Marsh, Roger. *Silk Screen Printing for the Artist.* London: Tiranti, 1968.

Russ, Stephen. *Practical Screen Printing.* London: Studio Vista, 1969.

Saff, Donald, and Sacilotto, Deli. *Screenprinting: History and Process.* New York: Holt, Rinehart and Winston, 1979.

Schwalback, M. V. and J. A. *Screen Process Printing.* New York: Reinhold, 1970.

Steffen, Bernard. *Silk Screen.* London: Pitman, 1963.

Stephenson, Jessie B. *From Old Stencils to Silk Screening: A Practical Guide.* New York: Scribners, 1953.

# INDEX

Edited by Barbara Wood
Designed by Jay Anning
Graphic production by Lesley Poliner
Text set in 11-point Baskerville